WITNESSING *the* ROBBING *of* THE JEWS

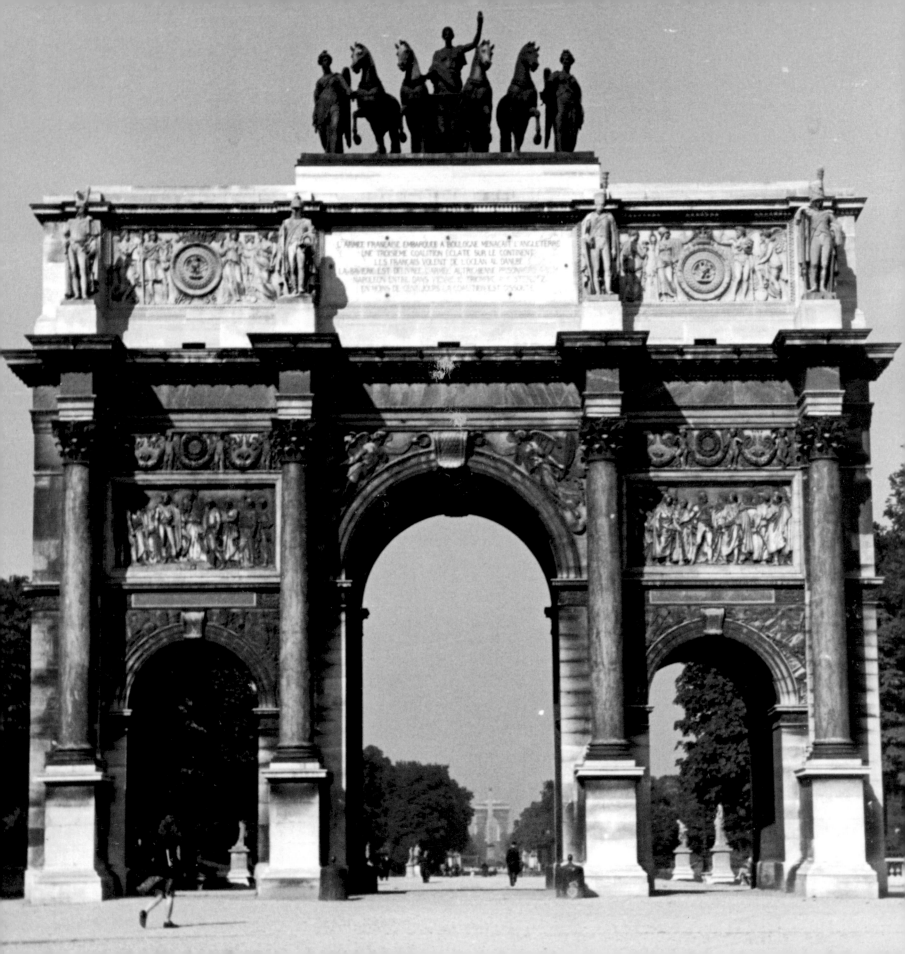

WITNESSING *the* ROBBING *of* THE JEWS

A Photographic Album, Paris, 1940–1944

SARAH GENSBURGER

Translated by Jonathan Hensher *with the collaboration of* Elisabeth Fourmont

INDIANA UNIVERSITY PRESS *Bloomington & Indianapolis*

This book is a publication of

Indiana University Press
Office of Scholarly Publishing
Herman B Wells Library 350
1320 East 10th Street
Bloomington, Indiana 47405 USA

iupress.indiana.edu

The paper used in this publication meets the minimum requirements of the American National Standard for Information Sciences—Permanence of Paper for Printed Library Materials, ANSI Z39.48–1992.

Manufactured in the United States of America

Library of Congress Cataloging-in-Publication Data

Gensburger, Sarah.
 [Images d'un pillage. English]
 Witnessing the robbing of the Jews : a photographic album, Paris, 1940–1944 / Sarah Gensburger ; translated by Jonathan Hensher with the collaboration of Elisabeth Fourmont.
 pages cm
 "This book focuses on an album containing eighty-five photographs preserved in the Federal Archives of Koblenz"—Chapter 2.
 First published in French by Editions Textuel in 2010.
 Includes bibliographical references and index.
 ISBN 978-0-253-01733-8 (cloth : alkaline paper) — ISBN 978-0-253-01744-4 (paperback : alkaline paper) 1. World War, 1939–1945—Confiscations and contributions—France—Pictorial works. 2. World War, 1939–1945—Destruction and pillage—France—Pictorial works. 3. Jewish property—France—History—20th century—Pictorial works. 4. World War, 1939–1945—Deportations from France—Pictorial works. 5. Holocaust, Jewish (1939–1945)—France—Pictorial works. 6. Jews—France—History—20th century—Pictorial works. 7. Paris (France)—History—1940–1944—Pictorial works. I. Bundesarchiv (Germany) II. Title.
 D810.C8G2813 2015
 940.53'181320944361—dc23
 2014047766

1 2 3 4 5 20 19 18 17 16 15

For Hubert Gensburger, my dad

In memory of Denise Weill

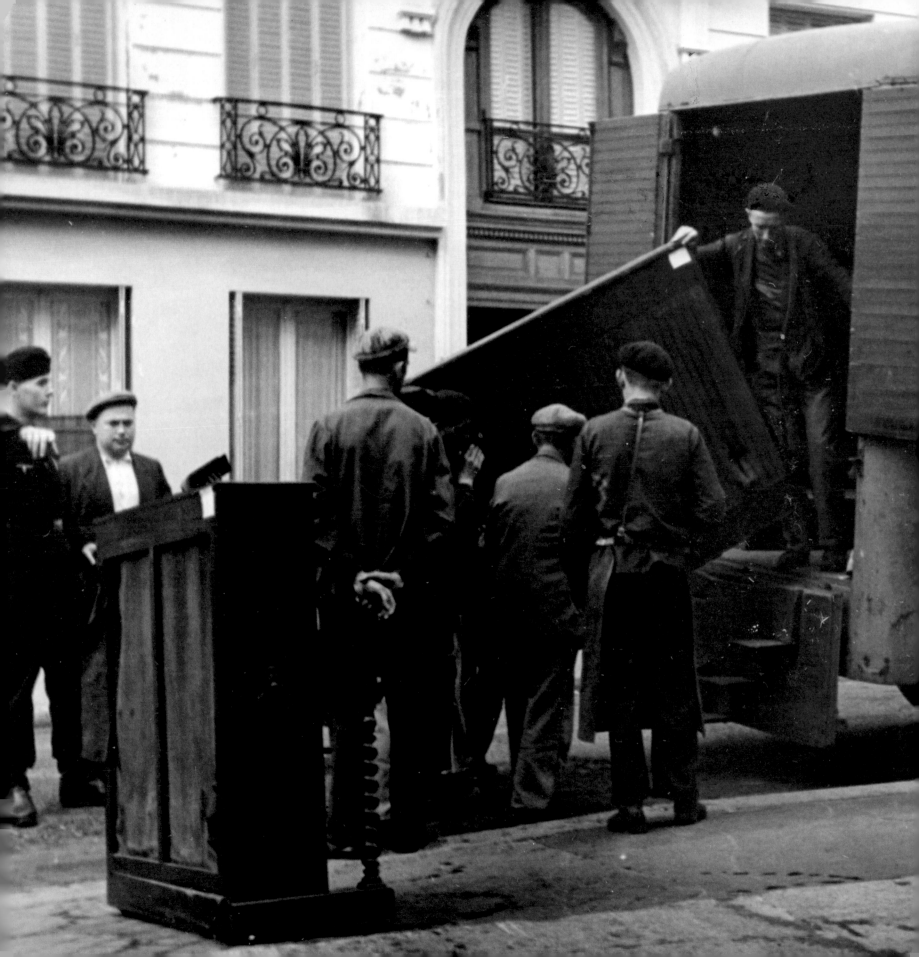

CONTENTS

ACKNOWLEDGMENTS

My warmful thanks go first to Denise Weill and the members of the Austerliz-Lévitan-Bassano association, who trusted me.

I am grateful to Floriane Azoulay and Jean-Marc Dreyfus, who first told me about these pictures.

Many people helped me in the research: Isabelle Backouche, Michèle Cohen, Patrick Eveno, Guillaume Fonkenell, Jordan Gaspin, Wolf Grüner, Christina Kott, André Krol, Isabelle Le Masne de Chermont, Jakub Limanowski, Manon Lenoir, François Michaud, Elizabeth Royer, Dimitri Salmon, and Miriam Ticktin. Thank you.

A special thanks, and a lot more, to Renaud, who encouraged me to have this book translated into English.

WITNESSING *the* ROBBING *of* THE JEWS

1

PARIS, CAPITAL OF PLUNDER

S ince the late 1990s, the question of the looting of the possessions of the Jews of Europe as part of the Holocaust has not only risen steadily up the legal agenda but also gained increasing prominence both in the media and as a subject of academic research. This upsurge in historical attention has occurred across the whole of what was formerly Nazi-occupied Europe.[1]

It is, nevertheless, the case that, with the exception of the special case constituted by the Reich itself, Western Europe has to date been the subject of the greatest number of studies.[2] And of all the countries within it, France and especially its capital, Paris, constituted the heart of the looting of Jewish property. The center of the art world before the war, Paris fired the Nazis' greed while the considerable number of the Jews of France promised to deliver richer plunder than in neighboring countries.

The chronology, geography, and administrative organization of this anti-Semitic looting in France, often described by the generic term of "spoliation,"[3] is now well known. Yet to date no overall account of this complex process has been produced,[4] for such an undertaking presents a number of difficulties. Owing to its highly composite nature, the study of the looting of the Jews of Paris requires expertise in such disparate areas as art history and the organization of the internment camps, alongside specialist knowledge of both the French administration and the Nazi organs of power, of industry and the market in second-hand goods, not to mention the geography of both Paris and the Reich. Before going back over the photographic traces left by the looting, and the ways in which historians have tended to use these visual sources, we will therefore first attempt to retrace exactly how this vast enterprise of plunder was implemented in the streets of Paris.

In France, the looting process began with the arrival of German troops in the country's capital on June 14, 1940. Its first targets were artworks owned by Jewish collectors. By this time, in Germany and Austria, cultural goods owned by Jews had been declared "without master" and confiscated on a massive scale by the regime. On June 6, 1939, Hitler gave Hans Posse, a profes-

1. Accounts of this process exist for various national contexts: the Soviet Union (see Arad, "Plunder of Jewish Property"), Poland (see Dingell, "Property and Seizures"), Romania (see Ancel, "Seizure of Jewish Property in Romania"), and the Netherlands (see Aalders, *Nazi Looting*). For a comparison between France and the USSR, see Heuss, *Kunt and Kulturgutraub*. The looting of the Jews and the restitution of the plunder are now beginning to interest a wide variety of academic fields, from law (Dowd, "Nuremberg") to media studies (Hutton, "Legacies of the Second World War").

2. For an overview of this research, see Nicholas, *The Rape of Europa*; Dean, *Robbing the Jews*; and Dean, Constantin, and Philipp, *Robbery and Restitution*.

3. Since the setting up in 1997 of the Mission d'étude sur la spoliation des juifs de France (Study Mission on the Spoliation of Jews in France), also called the "Mattéoli Mission" after its president, Jean Mattéoli, the use of the term "anti-Semitic spoliation" (*spoliations antisémites*) has become routine in the French context. It has come to denote not only spoliation in the strict sense of the term, that is to say legal theft carried out by the Vichy government, but also the systematic looting through which the German authorities seized property belonging to Jews (see Andrieu, "Ecrire l'histoire des spoliations antisémites").

4. This is evident in the extremely disparate nature of the thematic reports published by the Mattéoli Mission in 2000. See http://www.culture.gouv.fr/documentation/mnr/MnR-matteoli.htm.

sional art historian and director of Dresden's art museum, the job of setting up a museum of art in Linz, the Austrian city where Hitler spent his childhood. This museum was to be the symbol of Germany's cultural greatness.[5] With the whole apparatus of the state and virtually unlimited funds at his disposal, Hans Posse embarked upon on a very active "acquisitions" policy. Looted Jewish property would form its principal source. From 1939 to 1945, the Linz museum alone would account for the theft of no fewer than 8,000 paintings.[6] Yet this only represents a small fraction of the booty amassed by the Reich. Hitler and his grandiose project would not be the only recipients of the paintings that were stolen from Jews. For although polycracy was one of the Nazi regime's defining characteristics,[7] it was particularly in evidence in the process through which this artistic looting was carried out, a phenomenon more pronounced in Paris than anywhere else on account of the city's status as the artistic capital of the world.

As had also been the case in 1914, the invasion of France and the beginning of the Nazi occupation saw the immediate creation of a department for the protection of works of art, the Kunstschutz.[8] Its position quickly became rather awkward. On June 30 Hitler gave the order to "safeguard" artworks and historical documents belonging to Jews. Otto Abetz, the German ambassador in Paris, had already drawn up lists of the city's most important Jewish collectors. On July 6, he forced through the first confiscation. Concerned about the implications of this for the honor of the Wehrmacht, which had pledged to respect the Hague convention,[9] both the city's military commander and the Kunstschutz refused to assist him. In the meantime, Reichsmarschall Goering had sent his own emissaries to the French capital. The large collections assembled by Jewish connoisseurs were already attracting covetous glances from many quarters. In late August 1940, the embassy finally managed to lay its hands on some of them, including the collection held by the Rothschild family in their mansion on the Faubourg Saint-Honoré. The precious hoard was stored in the German embassy on the rue de Lille. However, this power struggle between different German authorities officially came to an end in September 1940, when Hitler placed the looting of "Jewish collections" under the sole authority of the Einsatzstab Reichsleiter Rosenberg (Reichsleiter Rosenberg Taskforce, or E.R.R.), the department in charge of dealing with property declared "without master." Alfred Rosenberg was one of Nazism's most fervent ideologues, and his teams immediately set about systematically tracking down the artistic wealth accumulated by Jews not only in France but also Belgium and the Netherlands. However, their activities would focus in particular upon Paris.[10] A former Red Cross official, Colonel Kurt von Behr was the leading figure in this period, a man who found that the looting allowed him to satisfy both his greed

5. Petropoulos, *Art as Politics in the Third Reich.*

6. Nicholas, *The Rape of Europa,* 66.

7. Feldman and Seibel, *Networks of Nazi Persecution.*

8. Kott, *Préserver l'art de l'ennemi?*

9. According to the terms of article 46 of the Hague convention, signed on 18 October 1907, belligerents agree to respect private property.

10. Le Masne de Chermont and Schulmann, *Le pillage de l'art en France.*

and his ambition. He therefore quickly had to find somewhere not only to store, catalog, and package his loot but also display it, as he was expecting visits from a select group of connoisseurs: the Nazi leadership. Chief among them were the Führer himself, along with his representative Hans Posse, but also Goering.

Where better to do this than in a museum, and what museum could be more prestigious than the Louvre? Jacques Jaujard, the director of France's national museums and as such also the head of the Louvre, knew all about the heritage that the Germans intended to "safeguard." Many of the Jewish collectors in question were patrons of the Louvre, and some of them had in fact placed their collections in the museum's care at the outbreak of war in order to protect them from bombing and other dangers. Hoping to avoid the transfer of these treasures to the Reich,[11] Jacques Jaujard agreed to what was being requested. From October 6, 1940, onward, three rooms in the Department of Oriental Antiquities that, along with most of the Louvre's buildings, had been evacuated in September 1939,[12] were assigned to the activities of the E.R.R. What is customarily referred to as the "Louvre sequestration" would involve up to 200 crates of looted artworks and as many as six rooms in total.[13] However, at the end of October, having realized that he would be powerless to prevent these artworks' departure for the Reich, Jacques Jaujard refused permission for an extension of this repository inside the Louvre.

The E.R.R. then turned its attentions toward the Jeu de Paume gallery, situated in the nearby Tuileries gardens. In peacetime, this held temporary exhibitions. In 1940, owing to the reduced activities of France's national museums, its rooms stood empty. On November 1, the stolen collections held in the Louvre were transferred here. The finest pieces were put on show immediately, in anticipation of Goering's visit on the 3rd. The Reichsmarschall came back for a longer tour on November 5. Thoroughly satisfied with what he saw, he gave his blessing to the work of the E.R.R. Straight away, before he even left Paris, he gave a set of orders regarding the future use of these "artworks transported to the Louvre." These would, in descending order of priority, be transferred to the collection of the Führer, to Goering's own collection, to the depots of the E.R.R., and, lastly, to the collections of German museums. The rest would be sold on the international market. From this date until 1944, the Reichsmarschall would visit the Jeu de Paume on no fewer than twenty-one occasions to take his pick in person. An enormous choice was on offer. Lorries made regular deliveries to the Jeu de Paume, dropping off property seized directly by the E.R.R. from important Jewish collectors. Artworks were also being brought in by the Devisenschutzkommando, a department specializing

11. There could have been some ambiguity in the attitude of certain French museum officials with respect to the protection of Jewish collections: should they be preserved in order to return them to their Jewish owners or rather preserved in order to be preserved, that is to say, in order to enrich the nation's collections? See Karlsgodt, *Defending National Treasures*.

12. For an account of this exodus, see Rayssac, *L'exode des musées*.

13. These details are given in the letter dated 18 October 1941, from Georges Contenau, curator of the Department of Oriental Antiquities, to Jacqueline Bouchot-Saupique, secretary to Jacques Jaujard: Archives des Musées Nationaux (hereafter cited as AMN), B2 Administration. For an account of the everyday life of the staff of France's national museums under the Occupation, see Polak and Dagen, *Les carnets de Rose Valland*.

in safecracking, and the various branches of the Dienststelle Westen, an organization tasked with the looting of ordinary apartments "abandoned" by Jews, a process that began in January 1942.[14]

Indeed, 1942 saw the looting of "Jewish goods" take on entirely new proportions. Now generalized and truly systematic, it marked the culmination of the gradual exclusion of Jews from economic and social life that had begun in 1940.

As they had already done so inside the Reich, on arriving in France the Nazi occupiers set about "definitively erasing Jewish influence within the French economy." As early as October 18, a German order would give a definition of "Jewish companies," make it obligatory to declare them, and instruct that they be placed under provisional Aryan administration until their sale could be organized. Aryanization was under way.[15] On May 28, 1941, a final order blocked the accounts of Jewish companies that did not yet have a provisional administrator and made any commercial dealings with them illegal. The first mass arrest of Jews took place on the 14th of the same month.

Aryanization was thus originally a German policy. Yet it would eventually be carried out by Vichy. Indeed, whereas the German approach to looting was arbitrary and unregulated, Vichy put in place a whole legal arsenal to facilitate the legalized theft of property from its Jewish owners. On October 3, 1940, the date of the adoption of the first Statute on Jews, the government of the French state excluded numerous Jews from public life, including 3,500 civil servants who were sacked within a few months. Nevertheless, as the occupiers gradually made clear their intention to take ownership of Jewish properties and belongings in the occupied zone, the Vichy authorities began to worry about seeing part of the national economy fall into German hands.[16] They decided to develop their own policy in line with a particularly French form of anti-Semitism less concerned with racial extermination than with putting an end to the supposed grip exercised by Jews over society. The SCAP—Service de contrôle des administrateurs provisoires (Supervisory Office for Provisional Administrators)—was formed on December 9, 1940. It became part of the Commissariat Général aux Questions Juives the following June. The French law of July 22, 1941, gave the final order for all Jewish possessions to be placed in provisional administration.[17] While the German measures only applied in the Occupied Zone, Aryanization now covered France in its entirety and extended to property of any type. It is thought today that around 50,000 individual possessions became subject to aryanization orders. It may indeed be argued, then, that "aryanization has not been given the prominence it deserves within Vichy's anti-Semitic policy" and that "far from being a minor point," aryanization was "an essential element" of the collaborationist agenda.[18] Notwithstanding the fine of one billion francs imposed on the Jews by the German de-

14. Between the date of its creation in 1942 and the end of the Occupation in 1944, the Dienststelle Westen would transfer no fewer than 1,369 paintings into the hands of the E.R.R. (Le Masne de Chermont and Schulmann, *Le pillage de l'art en France*).

15. Verheyde, "Propriété bafouée et réorganisation."

16. On the rivalry between the various French and German departments, see Baruch, "Perpetrator Networks and the Holocaust"; and Seibel, "A Market for Mass Crime?"

17. Prost, Skoutelsky, and Étienne, *Aryanisation économique et restitutions.*

18. "Mission d'étude sur la spoliation des Juifs de France," 56.

cree of December 17, 1941, which was paid exclusively to the Occupiers, the French state also made a substantial profit from this anti-Semitic looting.[19]

One area, however, fell outside Vichy's remit: the contents of apartments lived in by Jews, be they owners or simply tenants. From 1942 onward, these would be systematically looted by the German authorities alone, the pursuit of economic gain going hand in hand with the implementation of racial extermination. For the decision to murder the Jews of Europe had been made at the end of 1941.[20] On December 18, 1941, having in the meantime, in addition to his post at the head of the E.R.R., been made Reichsminister of the Occupied Eastern Territories, Alfred Rosenberg sent Hitler a note requesting that his staff be allowed to empty apartments no longer lived in by Jews. His explanation for this request was that there was a lack of suitable goods in the territory newly conquered by the Reich in the East that had been placed under his control. Hitler signaled his agreement on the 31st. This operation was christened Möbel Aktion—Operation Furniture. It would in time cover not only France but also Belgium and the Netherlands, albeit to a lesser extent. The resulting booty was meant to be distributed among the civilian population of the Reich who had either suffered from Allied bombing or had recently moved East to settle in the newly conquered territories. At first, the operation was run by the E.R.R. itself. Then, on March 25, 1942, it was put under the control of the Ministry for the Occupied Eastern Territories, also run by Rosenberg. A dedicated department was duly set up in Paris: the Dienststelle Westen, or Western Service. The closely intertwined nature of the widening of the looting and the implementation of racial extermination is made starkly clear by the fact that, just two days later, the first deportation convoy left France with 1,112 Jews on board.

On April 17, 1942, Kurt von Behr took over the running of the Dienststelle Westen, while still provisionally retaining his position within the E.R.R. until at least the first few months of 1943. This new looting operation would require not only new premises but also major new transport capabilities, for the volume of objects concerned would be considerable. Several storage depots were set up. As had been the case with the Louvre, Jacques Jaujard was unable to prevent the requisitioning of the Musée National d'Art Moderne, located on the quai de Tokyo.[21] From October 1942 onward, the Dienststelle Westen stored pianos in the basement of the building,[22] going so far as to

19. Aglan, "L'aryanisation des biens sous Vichy." In the specific case of the money and possessions surrendered by Jews entering Drancy camp, the picture is more complex. This constitutes what the Mattéoli Mission described as "*de facto spoliation*." The fate of these possessions varied according to whether they were confiscated before or after July 1943, when the camp passed from French to German control. See Wieviorka, *Les biens des internés des camps de Drancy*; and Wieviorka and Laffitte, *A l'intérieur du camp de Drancy*.

20. Roseman, *The Villa*.

21. For instance, the occupation of the Musée Camondo in Paris was also considered. See AMN RC 2, letter from J. Jaujard to Dr. Mobius, 24 December 1942. Jaujard's intervention seems to have been effective in this case. See his letter dated 11 January 1943.

22. AMN, L2 MNAM 1934–1945, file "Protestation contre le dépôt de mobilier installé par les Allemands dans les sous-sols du Musée d'Art Moderne"(Protest against the furniture depot set up by the Germans in the basement of the Musée d'Art Moderne), letters from J. Jaujard to Dr. Mobius dated 27 and 31 October 1942.

construct a "fully-enclosed and glazed timber-built office."[23] More depots were set up in premises on the rue Scribe, rue Fresnel, and avenue Foch and at the Porte de Versailles. Books and musical scores were collected on the rue de Richelieu. Warehouses were also opened in the neighboring suburbs: at Aubervilliers for furniture and Pantin for carpets.[24] Operation Furniture had the capital in its grasp. Across the three countries in question, the Dienststelle Westen would in total empty 69,619 homes, load 674 trains, and seize currency to the value of 11,695,516 reichsmarks. With 38,000 homes affected, Paris was the place where the majority of its activity was concentrated.

For his transportation needs, von Behr called on French removal companies. Since May 1941, in line with the Vichy regime's corporatist policy, these had been brought together under a central Comité d'Organisation des Entreprises de Déménagement et de Garde-Meubles (Organizational Committee for Removal and Storage Businesses, or COEDGM). From February 25, 1942, onward its members received daily requests from the Dienststelle Westen, to the extent that the committee finally decided to create a Department for Jewish Requisitions and Removals. It was therefore French civilians who not only emptied the apartments no longer lived in by Jews but also brought this plunder back to depots in order for it to be packed before being sent to Germany and, finally, took it to the railway stations from which the convoys would leave for the Reich, supposedly in order to distribute the plunder among the German population. For the work of packing these objects into crates, von Behr could only draw on a very limited workforce, composed for the most part of wounded soldiers. From July 1943, he therefore decided to rent his workforce from the SD (Sicherheitsdienst, or Security Service) of Drancy, the main transit camp in France for Jews awaiting deportation.[25]

Here, the interests of von Behr and those of the camp authorities at Drancy converged, as the camp had just passed out of the control of the French authorities and into the hands of the Germans. In July 1943, Aloïs Brunner was expecting a massive influx of detainees over the summer. Keen to reduce numbers in the camp, he rented out prisoners who were classified as temporarily "nondeportable" to the Dienststelle Westen. For, as soon as he had taken up his position at the head of the transit camp, Brunner had set about categorizing the detainees according to the system of classification established by the Nazi regime. Jews who were "spouses of Aryans," along with "half-Jews" or "*mischlinge*," would remain in France because there was disagreement at the highest levels regarding their exact status and what to do with them,[26] while the Jewish wives of French Jewish prisoners of war would also be kept in France as hostages.[27] These three categories made up the majority of the workforce rented out to Operation Furniture.

23. AMN, L2 MNAM 1934–1945, file "Protestation contre le dépôt de mobilier installé par les Allemands dans les sous-sols du Musée d'Art Moderne," letter from Pierre Ladoué, director of the museum, to J. Jaujard dated 28 May 1943.

24. Archives de Paris (hereafter cited as AP), 2 ETP/5/3/00 4.

25. From August 1941 until August 1944, Jews awaiting deportation were interned in the buildings of the cité de la Muette housing estate in Drancy, on the northern outskirts of Paris. Sixty-five thousand out of the 76,000 Jews deported from France passed through it (Rajfus, *Drancy;* and Klarsfeld, *Le calendrier de la persécution des Juifs en France*).

26. Stoltzfus, *Resistance of the Heart.*

27. Christophe, *From a World Apart.*

Between 1943 and 1944, three buildings in Paris served the dual function of depots for the Dienststelle Westen and satellites of the main camp of Drancy.[28] On these three sites, Jewish detainees were forced to sort through the goods and possessions taken from apartments that had supposedly been "abandoned" by their Jewish owners. The first of these labor camps was situated at 85–87 rue du Faubourg Saint-Martin in the capital's 10th arrondissement, near the Gare du Nord. It had been a large furniture store called Lévitan, the owner of which was Jewish. Placed under an aryanization order, the building was requisitioned in 1943. Its first inmates arrived on July 18 of that year. The second camp, which opened in November 1943, was a four-story building on the complex belonging to the Entrepôts et magasins généraux at 43 quai de la Gare in the 13th arrondissement, near the new Bibliothèque Nationale.[29] The third was set up in March 1944 in the mansion belonging to the Cahen d'Anvers family at 2 rue Bassano in the 16th arrondissement, just off the Champs Élysées.[30] Having been aryanized and requisitioned, the building had been occupied from August 1943 onward, although it was at first used purely as a storage depot.

Lévitan, Austerlitz, and Bassano are the names most commonly used to refer to these Parisian satellite camps of Drancy, whether by the German authorities in charge of them or the Jewish workers imprisoned within them. For these detainees, being assigned to work in the capital in this way meant better living conditions than those they had experienced in Drancy. Food was less scarce and the disciplinary regime less harsh. In theory, internment in these satellite camps was also a way of escaping final deportation to certain death in the East. For the vast majority of their inmates, the Parisian camps thus constituted a place of temporary shelter. However, detainees were still, administratively speaking, held by the main camp of Drancy. As was typical throughout the Nazi bureaucracy, the threat of arbitrary reprisals was ever present. Every time there was an escape or an act of insubordination, several detainees would be brought back to the main camp and deported. At least 795 people were placed in these camps between July 1943 and August 1944. Twenty percent of them would be deported. Out of a total of 166 deportees, 64 would be sent to Bergen-Belsen and 102 to Auschwitz. In August 1944, the remaining 80 percent were taken back to Drancy, from where Aloïs Brunner intended to organize a final deportation convoy. In the end, this never happened, and the inmates of the Parisian satellite camps were liberated from Drancy on August 18, 1944, following the departure of the camp's German administration. The majority of these slave laborers thus escaped deportation and survived the war.

28. Dreyfus and Gensburger, *Nazi Labor Camps in Paris.*

29. The library's proximity to Austerlitz inspired W. G. Sebald (Sebald, *Austerlitz*); on the role played by photographies in his work, see Olin, *Touching Photographs.*

30. Assouline, *Le Dernier des Camondo.*

2

LOOKING AT THE PAST, WITNESSING HISTORY

The Koblenz Album

T he work of retracing the exact sequence in which the events outlined above occurred was begun in the immediate postwar period with the work of "historian-witnesses,"[1] such as Joseph Billig.[2] Progress was nevertheless quite limited in these early years. By contrast, the last fifteen years or so, following on from the work of the Mattéoli Mission, have seen the publication of a growing number of works on the looting of the Jews in France. This expanding body of research has established both the chronology and geography of this anti-Semitic spoliation, as well as identifying its actors and assessing its scale. In doing so, they have started to formulate new questions, looking in particular at the motivations of the actors concerned, both German and French.[3] Cleaving to the classical distinction between functionalism and intentionalism, they have sought to develop a precise understanding of the linkage between opportunism and ideology, between the quest for economic gain and the implementation of racial extermination, which lies at the very core of the looting process. In 2005, the controversy surrounding Götz Aly's book *Hitler's Beneficiaries*,[4] in which the author emphasized the pursuit of financial profit, showed just how thorny this issue remains, especially in a French context.[5] This new research, varying greatly in its scale and scope, draws on an ever-wider range of sources, some of them never previously studied, and employs many innovative methodological approaches. However, it has so far paid no attention to archival images, which have been used merely for the purposes of illustration. Yet in a very real sense, such photographs constitute documents that can help us understand precisely how the actors involved in this looting actually saw their work, thus perhaps enabling us to grasp the famous "Nazi gaze" spoken of by Susan Crane.[6]

Indeed, for several years now, the history of the Holocaust has been undergoing a "visual turn."[7] Contrary to certain popular misconceptions, "the Holocaust was being visually represented by

1. This is the term ("*historiens-témoins*") used by Claire Andrieu (Andrieu, "Ecrire l'histoire des spoliations antisémites").

2. Billig, *Le Commissariat général aux Questions juives*.

3. A special issue, edited by Anne Grynberg, offers an overview of the variety of research currently being carried out in this field (*Cahiers du judaïsme* 2009). It follows on from such recent work (given here in purely alphabetical order) as Bruttmann, *Persécutions et spoliations des Juifs*; Doulut, *La spoliation des biens juifs*; Douzou, *Voler les Juifs*; Dreyfus, *Pillage sur ordonnance*; Goschler, Ther, and Andrieu, *Spoliations et restitutions*; Jungius, *Der verwaltete Raub*; Le Bot, *La fabrique réactionnaire*; Le Masne de Chermont and Sigal-Klagsbald, *A qui appartenaient*; and *Revue d'histoire de la Shoah*. See also the proceedings of the conference "Pillage des œuvres d'art. Connaître et réparer" (Musée d'Art et d'Histoire du Judaïsme, Paris, 14–15 September 2008) and the ongoing research by the Historical Committee of the Commission for the Compensation of Victims of Spoliation led by Anne Grynberg and Johanna Linsler. For an overview of historical studies, see Andrieu, "Ecrire l'histoire des spoliations antisémites."

4. Aly, *Hitler's Beneficiaries*.

5. For a broader approach, see Gruner, *Jewish Forced Labor*.

6. Crane, "Choosing Not to Look."

7. This may be seen in studies ranging from Sybil Milton's pioneering work (1986) to the special issue of the *American Historical Review* (2010) entitled "Representing the Holocaust." Some of the first works in this perspective were Hoffman, "Fotografierte Lager"; Hellman, *The Auschwitz Album*; Keller, *The Warsaw Ghetto*; and Grossman, *With a Camera in the Ghetto*. This visual turn has also clearly influenced research on other atrocities; see Allen et al., *Without Sanctuary*; and Hughes, "The Abject Artefacts of Memory."

victims, perpetrators, and bystanders even as it was happening; the 'Holocaust' has never not been represented."[8] However, these studies of the many surviving images of the Holocaust have up until now focused almost exclusively on the direct traces of the extermination constituted by images of bodies, whether those of the victims or the perpetrators:[9] "ordinary men, extraordinary photos."[10] While the present book fits alongside these numerous new studies, its focus is not just on the representation of people in images but also that of objects, in the hope that such an approach may tell us something about the meaning held by the looting of Jewish goods for those who actually implemented it. This shift in emphasis is all the more justified given that photography was put to large-scale use in the identification, processing, and sending back to Germany of the thousand of artworks stolen from their Jewish owners by Alfred Rosenberg's staff in Paris.[11] *Ordinary Objects: Ordinary Photos?* would, in many ways, have been another fitting title for this book.

This book focuses on an album containing eighty-five photographs preserved in the Federal Archives of Koblenz under the shelfmark B 323-311.[12] This album contains only pictures, with no captions whatsoever, except for on its first page, where the transmittal memo to preserve these photographs has been pasted. This letter indicates that the album was created in 1948 by Erika Hanfstaengl, a member of the staff of the Munich Collecting Point. From May 1945, as the advancing Allies came across works of art and other looted objects, they began assembling these in temporary depots, or "Collecting Points," situated in Düsseldorf for the British zone, Baden-Baden for the French zone, and, most importantly, Munich, Wiesbaden, and Offenbach for the American zone.[13] In Munich, experienced teams made up for the most part of art historians would work until 1950 to identify this property and return it to its rightful owners. Placed under the dual authority of the U.S. Army—through its Monuments, Fine Arts, and Archives Section—and the German administration of the Land of Bavaria, they employed numerous Germans alongside their American staff.[14] This is how Erika Hanfstaengl, a German art historian who had worked for the *Kulturkommission* set up by Himmler in Italy, ended up working for the Allies' artistic restitution service, the personnel of which were ordered to classify these photographs.[15] The objective was, where possible, to assist in

8. Farmer, "Going Visual," 115.

9. Didi-Huberman, *Images in Spite of All*; and Chéroux, *Mémoire des camps*.

10. Milton, Levin, and Uziel, "Ordinary Men, Extraordinary Photos."

11. Each object seized by the E.R.R. was cataloged and photographed. These photographs were sometimes collected in albums by the E.R.R. in order, for instance, to be presented to Hitler so that he could choose from the selection of paintings on offer. Tens of thousands of images produced in the context of this work are today held in the Koblenz archives, series 323 (Grimsted, *Returned from Russia*).

12. Floriane Azoulay and Jean-Marc Dreyfus first made me aware of the existence of this album. I owe them my thanks.

13. Smyth, *Repatriation of Art*.

14. Kurtz, *America and the Return of Nazi Contraband*.

15. I would like to thank Isabelle Le Masne de Chermont and Christina Kott for their help in identifying Erika Hanfstaengl. She was described in these terms by the Office of Strategic Services Art Looting Investigation Unit (OSS ALIU), who compiled a list of Germans involved in the looting of artworks that may be consulted at http://www.sagerecovery.com/looted-art/resources/red-flag-list.htm.

the identification of the property they show. The staff of the Collecting Points had the massive task of assembling and classifying any archival documents that might help in the restitution process. While their activity mainly concerned works of art, the owners of which may well not have been Jewish, they also dealt with the wider question of "Jewish goods," whose legitimate owners had in most cases been murdered.[16] The mainly anonymous nature of the objects visible in these photographs, and as a result their apparently limited usefulness as far as the restitution of property was concerned, explains why these photographs were not examined by the teams until 1948. In this year, however, it had just been announced that the American restitution operation in Germany would soon be winding down.[17] It was now most urgent that all the documents held in the various depots of the Munich Collecting Point that might help in this effort should be brought together and consulted. Crate no. 21004, which held all the photographs placed in the album, had been in American hands since the end of the war. The existence of the photos in the Munich archives had supposedly been revealed by Dr. Helga Eggemann, a former employee of the E.R.R. in Paris,[18] which probably explains why, until only very recently, the Koblenz archives had indexed the contents of this album as "Photos of the E.R.R. Paris. Transport—Camps."[19]

The request to sort through the pictures pasted on the first page states that the photographs had been captured in Paris in a warehouse used by the Germans in the context of Operation Furniture. The letter does not, however, specify who brought them to Munich. One possible candidate is James J. Rorimer. A curator at New York's Metropolitan Museum of Art in civilian life and a lieutenant in the U.S. Army, he was posted to the Seine region after the D-Day landings with the task of gathering any information and documents that might help track down the works of art seized by the Germans in the French capital.[20] Once this process had been completed, he set off for Munich with his haul in order to organize the operations of the Monuments, Fine Arts, and Archives Section.

During his stay in Paris, he met Rose Valland and, with her, visited the E.R.R headquarters and four of its warehouses, including Lévitan, which was one of the depots used for Operation Furniture in the French capital. Rorimer was aghast when he realized that the Nazis had not only taken paintings but also Jews' everyday belongings.[21] He took a picture of the portion of this ordinary

16. Nicholas, *The Rape of Europa*; and Kurtz, *America and the Return of Nazi Contraband*, 165–166.

17. Its activities would eventually cease in 1950 (Kurtz, *America and the Return of Nazi Contraband*, 143–185).

18. On her responsibilities, see Office of Strategic Services Art Looting Investigation Unit APO 413 U.S. Army, consolidated interrogation report no. 1, 15 August 1945, "Activity of the Einsatzstab Rosenberg in France," consulted at http://www.lootedart.com/MN51KY845251; and OSS ALIU, list of German collaborators.

19. Since the initial research that would eventually form the basis of the present book, this description has been modified, leading to a new set of errors and misunderstandings, as we shall see. The album is currently presented as a collection of images showing "Möbel Aktion—Paris."

20. Kurtz, *America and the Return of Nazi Contraband*, 74–78; Rorimer, *Survival*; and Edsel, *The Monuments Men*.

21. Rorimer, *Survival*; and Valland, *Le Front de l'Art*.

plunder that was still in Paris in August 1944.[22] It may well have been Rorimer, then, who brought crate no. 21004 from Paris to Germany.

Before these pictures were transported to Bavaria and arranged in their current form in 1948, however, somebody must, by definition, have taken them. The album does not say who this was. The place where they were found after the Liberation suggests that they were collected, if not necessarily produced, by Germans posted in Paris working for the various departments involved in the looting. In this respect, there is nothing particularly remarkable about them. From 1933 onward, photography was regularly used by the Nazi regime, not only, as is well known, for propaganda purposes but also simply in order to document its activities. The E.R.R. had a team of photographers, but it was not unusual for regular soldiers to be given a camera, more often than not a Leica.[23]

The album consists of 172 pages of black A4-size paper. The photographs vary in size, but all have an untrimmed white border that contrasts with the black of the lightly textured paper. One picture follows another with no caption or explanatory commentary, with one photograph being placed on each double-page opening of the album. The images are arranged according to just one principle: taxonomic classification.

A first, introductory selection of photographs shows five different views of the capital. The purpose here is obviously to introduce the city in which these actions took place, given that the majority of the other photographs in the album have been taken indoors. The pictures are then grouped together according to the types of objects or activities they show, namely views of loading/unloading of lorries (five), loading/unloading of trains (nine), crates (fifteen), textiles (fifteen), toys (two), tools (two), kitchen utensils (twelve), lamps (two), wireless sets (two), clocks (two), furniture (twelve), and pianos (two). This is the order in which the reader encounters these various themes; these thematic "chapters" are not labeled or captioned in any way.[24] Their presentation relates to the Central Collecting Points' task of restoring objects to their owners. The album begins with the least recognizable objects (those still in crates) and finishes with the most easily identified (period furniture and pianos).

However, this method of organizing the images takes no account of the process of looting itself, in particular with respect to the variety of places in which the pictures were taken and the range of German organizations involved. The taxonomic eye of the album's creators brings out, first and foremost, the quantitative aspect of the plunder. It thus emphasizes the pursuit of an ideological objective above and beyond the desire for economic gain: the sheer mass of looted goods echoes the countless existences destroyed in the Final Solution. Yet is this interpretative logic imposed by the album merely an artifact created by its compilers, or is it to some extent already present within the original documents themselves, namely the photographs it contains? Answering this question will involve deconstructing the album by replacing this initial perspective with a new reading. In order to

22. National Gallery of Art, 28MFAA-J 11-4, I-14; and 15 F, "Paris/Pavillion 60/Foire Paris/Furnishings taken from 46 boxcars destined for Germany."

23. Denoyelle, *La photographie d'actualité*; and of course the Auschwitz Album case (Hellman, *The Auschwitz Album*).

24. Again excepting the page pasted in at the beginning, the album does not include any words, whether chapter headings or captions of any sort.

tell history through these photographs we must understand and locate the multiple gazes involved in our readings of them, in addition to those that originally produced them.

For my part, this also means reflecting upon how I myself initially reacted to these eighty-five photographs. When I first saw these images, I instinctively began looking in the background, behind the objects themselves, to see if I could recognize any of the detainees whom I had previously either encountered in the archives or, in some cases, met personally. For it had been at the request of Denise Weill and the Amicale des anciens internés des camps annexes de Drancy dans Paris (Association for former detainees of the satellite camps of Drancy in Paris), of which she is the general secretary, that Jean-Marc Dreyfus and I began retracing the history of the satellite camps of Drancy involved in Operation Furniture. Following the debates sparked by the creation of the Mission d'étude sur la spoliation des Juifs de France, some former internees now felt ready to give their testimony.[25]

Between 2001 and 2003, while preparing the book that Jean-Marc Dreyfus and I would later publish on this subject, I met a number of former detainees. They gave me access to various private papers, chief among them their collections of correspondence. The peculiar status of these places of imprisonment meant that it was in fact possible for inmates to receive and send parcels and letters. At first, I had the powerful impression that many of the eighty-five pictures in the album before my eyes had been taken with the express intention of illustrating the accounts contained in these letters. It was this unsettling experience that sowed the seeds of this book. The photographs seemed to me at first to possess a degree of efficiency and clarity lacking in the textual accounts alone. For instance, during the interviews that I carried out with former detainees, many of the interviewees told me of their impression of having been "submerged" beneath the constant inflow of crates being unloaded from the arriving lorries. Yet the piles of crates visible in these images were not quite what I had imagined. They revealed both more and less than I expected.[26] I therefore decided to retrace my steps or, rather, start my journey afresh in the opposite direction, until I reached its beginning.

Owing to the highly personal nature of the relationship that I established from the outset with a number of images from the album, the decision to work on these eighty-five photographs made it possible to establish a dialogue between two strands of research that up until now have remained largely separate.[27] On the one hand are various researchers who approach images as sources and are highly critical of the predominantly illustrative use made of visual documents by most historians.[28] For them, the crucial thing is to establish the "truth," in almost material terms, of the doc-

25. A very small number of them had previously related their experiences (Fabius, *Un lever de soleil;* and *Le Monde Juif*). For the reason of this silence, see Gensburger, "Essai de sociologie de la mémoire").

26. Hirsch and Spitzer, "Incongruous Images."

27. Staines, "Knowledge, Memory and Justice"; Thomas, "The Evidence of Sight"; and Brink, "Secular Icons."

28. Stuk, *Photographing the Holocaust;* Lewis, "Documentation or Decoration?"; Rossino, "Eastern Europe through German Eyes"; Hüppauf, "Emptying the Gaze"; Shneer, *Through Soviet Jewish Eyes;* Delage and Grynberg, "La Shoah."

ument; a "truth" seen as essentially univocal.[29] On the other are a growing number of historians who consider these images of the Holocaust as vectors, by their very nature polysemic, of contemporary representations of the past that are not confined to the materiality of the document:[30] the image beyond the image, the "afterimage," as some have described it.[31] Sarah Farmer has summed up this issue with admirable clarity: "the first implication of the 'visual turn' has been to challenge historians to look, find, see, and interpret visual sources. The next step is to explore the relationship between the visual, the spoken word, and the text."[32] For my part, since I had already, so to speak, written this history before finding the images that show it, right from the start I found myself in a position to see just what these images were able to tell me that the historical account of the past alone could not. The aim of this book is thus to bring together these two historical perspectives on images that have so far rarely engaged in dialogue with one another.

So my first aim would not be to illustrate the looting committed by the E.R.R. and the Dienststelle Westen but rather to retrace, and thus also tell, the story of these events based on the eighty-five images assembled in the Koblenz album. Second, this approach involves taking into account the resonance that these photographs necessarily have for the viewer today. While the piles of shoes evoke social representations of the "Canada" section of Auschwitz and the works by artists, such as Christian Boltanski,[33] that these have inspired, the stands filled with goods that detainees were forced to set up and man recall, by contrast, the daily routine of Parisian department stores. The following pages are an attempt to read the Koblenz album while taking into account these many different gazes, which all constitute different routes into the "reality" that is presented to our eyes. The inherently contradictory nature of the Holocaust, an experience that is described as impossible to relate, yet is simultaneously made visible in the many photographs of the event that have in fact survived, brings into particularly sharp focus the question of the contemporary use of images to create a narrative of the past.

The present book therefore treats these images like any other form of testimony, as fragments of traces of the past at most, and not as sacred remains containing a truth to be revealed, nor strategically manipulated media wh29-count both of their power and of the contemporary perceptual frameworks of the researcher.[34] Showing a photograph, even in order to decode it, involves accepting from the outset the idea of being unable to control what is said therein. An image always tells us something more or, to some extent, something other than what linguistic discourse alone, subject

29. On the wider question of the medium of photography and its relation to truth, see Barthes, *Camera Lucida*; Becker, "Do Photographs Tell the Truth?"; Keilbach and Wächter, "Photographs, Symbolic Images"; and Sontag, *On Photography*.

30. Zelizer, *Visual Culture and the Holocaust*.

31. Mitchell, *The Reconfigured Eye*; Young, *At Memory's Edge*; Joshua Hirsch, *Afterimage*; Langford, *Suspended Conversations*; and Marianne Hirsch, *The Generation of Postmemory*.

32. Farmer, "Going Visual," 122. For discussion of this idea unrelated to Holocaust issues, see Mitchell, *Picture Theory*.

33. Such as his *La Réserve du Musée des Enfants I* (1989), Musée d'Art moderne de la ville de Paris.

34. Freedberg, *The Power of Images*.

as it is to intellectual control, can signify. This conviction lies behind the decision to reproduce the album in its entirety, with all the images in their original order. It is hoped that this editorial choice will enable each reader to bring his or her own perspective to these photographs, in advance of or at least in parallel with the historical "facts" provided by the historian. This decision is also a response to the moral concerns raised by the increasing banalization of images of the Holocaust,[35] for several photographs from the album have already been reproduced in a variety of contexts, accompanied by captions that are without exception misleading, if indeed they are present at all. This book aims to let these images once more speak for themselves.

In addition to my contact with Jean-Marc Dreyfus, who, along with Floriane Azoulay and others, first brought this album to my attention, two other encounters have helped me put a critical distance between myself and these images. From late 2006 to early 2007, I looked through these photographs almost every day in the company of Michèle Cohen, artistic director of the advertising firm BETC Euro RSCG, which has its offices in the building that used to house the Lévitan department store. Our conversations led to a first exhibition entitled Retour sur les lieux. La spoliation des Juifs à Paris (Return to the scene. The looting of the Jews in Paris) held in spring 2007 in the passage du Désir (85–87 rue du Faubourg-Saint-Martin). In 2008, the Louvre Museum asked me to comment on five photographs from the album as part of an exhibition entitled Le Louvre pendant la guerre. Regards photographiques, 1938–1947 (The Louvre during the war. Photographic perspectives, 1938–1947), which ran from May to August 2009.[36] The comments made to me by Guillaume Fonkenell, who as the official historian of the Louvre curated this exhibition, were also of great help to my subsequent research. Michèle and Guillaume thus participated in the genesis of this book and were, in many ways, its first readers.

35. Zelizer, *Remembering to Forget*; Liss, *Trespassing through Shadows*; Sontag, *Regarding the Pain of Others*; Crane, "Choosing Not to Look"; and Olin, *Touching Photographs*.

36. Two major exhibitions of recent years have inspired some of these reflections on the place of images in the writing of the past: "War of Extermination: Crimes of the Wehrmacht, 1941 to 1944," Hamburg Institute for Social Research, 1995; and "The Memory of the Camps: Photography of the Nazi Concentration and Extermination Camps (1933–1999)," Hôtel de Sully, Paris, 2001. See also the Mémorial de la Shoah exhibition "Regards sur les Ghetto," 13 November 2013–28 September 2014.

3

THE PHOTOGRAPHS

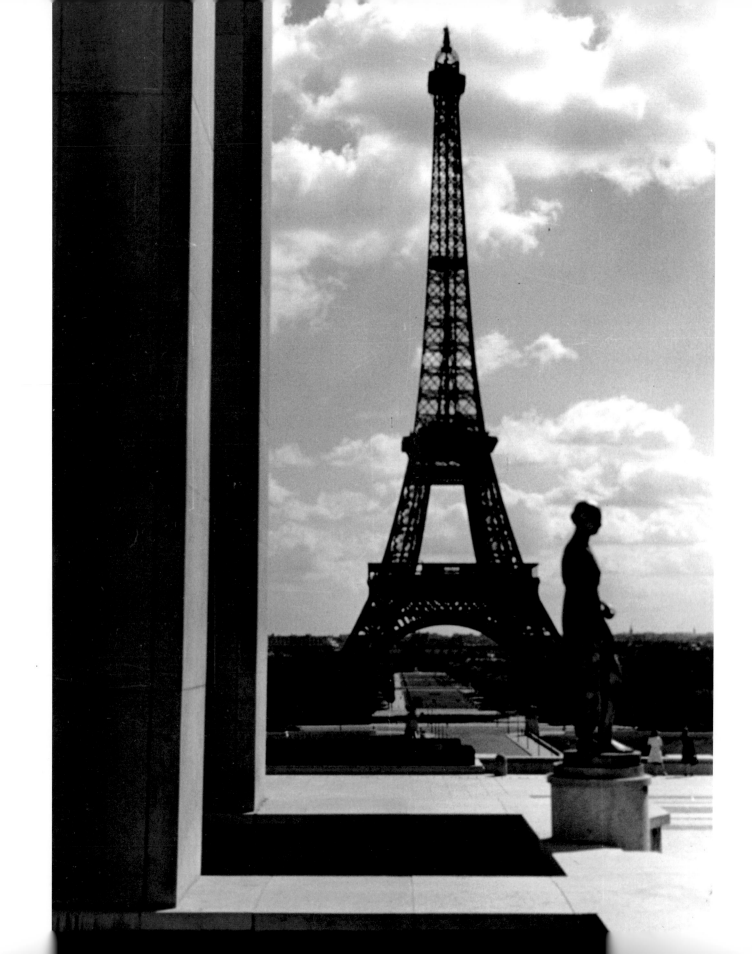

B 323-311 N° 1

These events are taking place in Paris, so what clearer way to show this than a picture of the Eiffel Tower? This image opens what appears to the reader as the first "chapter," which consists of five views of the capital acting as a scenic backdrop to the rest.

While this photograph has something of a picture-postcard quality, it does in fact depict, by implication at least, the geographical and administrative center of the German looting of Jewish property. It was taken from the steps of the esplanade du Trocadéro, which is at the end of the avenue d'Iéna. At the beginning of 1941, the Einsatzstab Reichsleiter Rosenberg (E.R.R.) set up its offices at number 54 of this same street, a building that had been confiscated from its Jewish owners, Yvonne and Pierre Gunzburg.[1] When the Dienststelle Westen was created in spring 1942, it too moved in. The latter organization then widened its grip on the neighborhood, occupying the mansion at 2 rue Bassano, which was virtually next door, and requisitioning the basement at the Musée National d'Art Moderne on the quai Tokyo just a few meters away.

The same goes for the offices of the Department for Jewish Requisitions and Removals of the Organizational Committee for Removal and Storage Businesses (COEDGM). Its director, Eugène Grospiron, moved this new department into the offices of his own company, located at 55 avenue Marceau, just around the corner from 54 avenue d'Iéna. In a very real sense, then, this neighborhood at the foot of the Eiffel Tower housed the headquarters of the looting of Jewish property between 1941 and 1944.

1. Several depots were also opened in Place des Etats-Unis, nearby (see Polack and Dagen, *Les carnets de Rose Valland*).

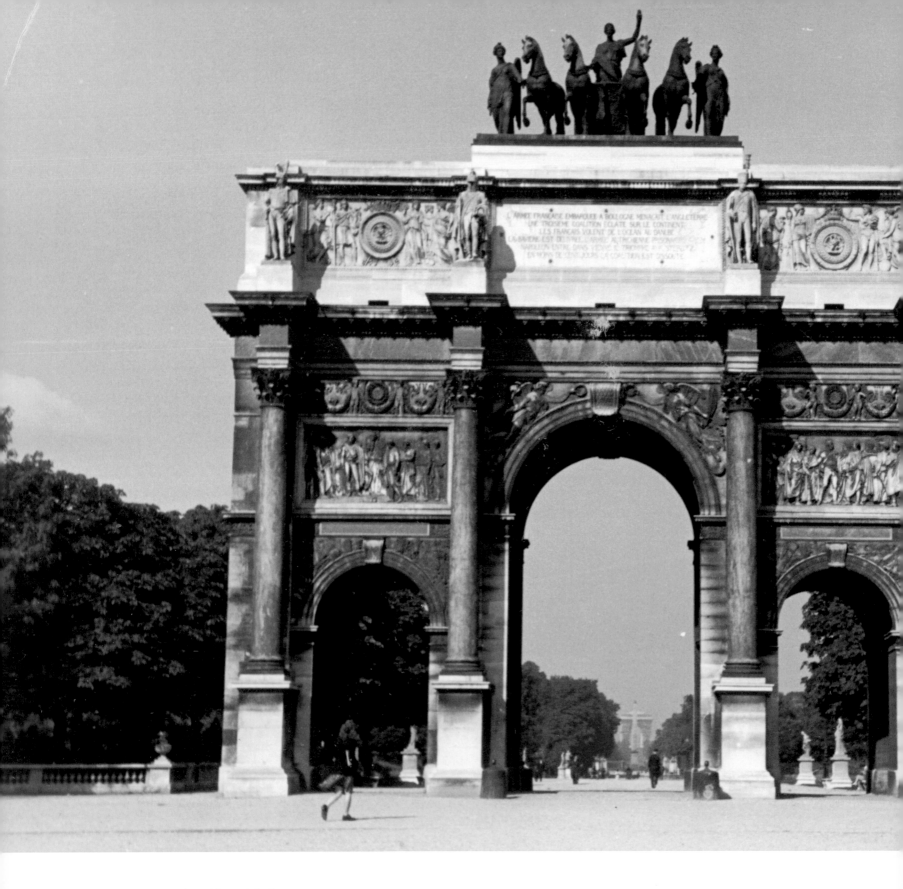

Witnessing the Robbing of the Jews

B 323-311 N° 2

This photograph also has a rather picture-postcard look. The Arc du Carrousel in front of the Louvre remains one of the sights that no foreigner visiting the capital and its famous museum today can miss. Between 1940 and 1944, this monument was also located at the heart, or rather at the center of the looting of the great Jewish-owned art collections. This photograph was taken at the exact midpoint between the two main sites where looted artworks were held in the city: the Jeu de Paume and the Louvre sequestration.

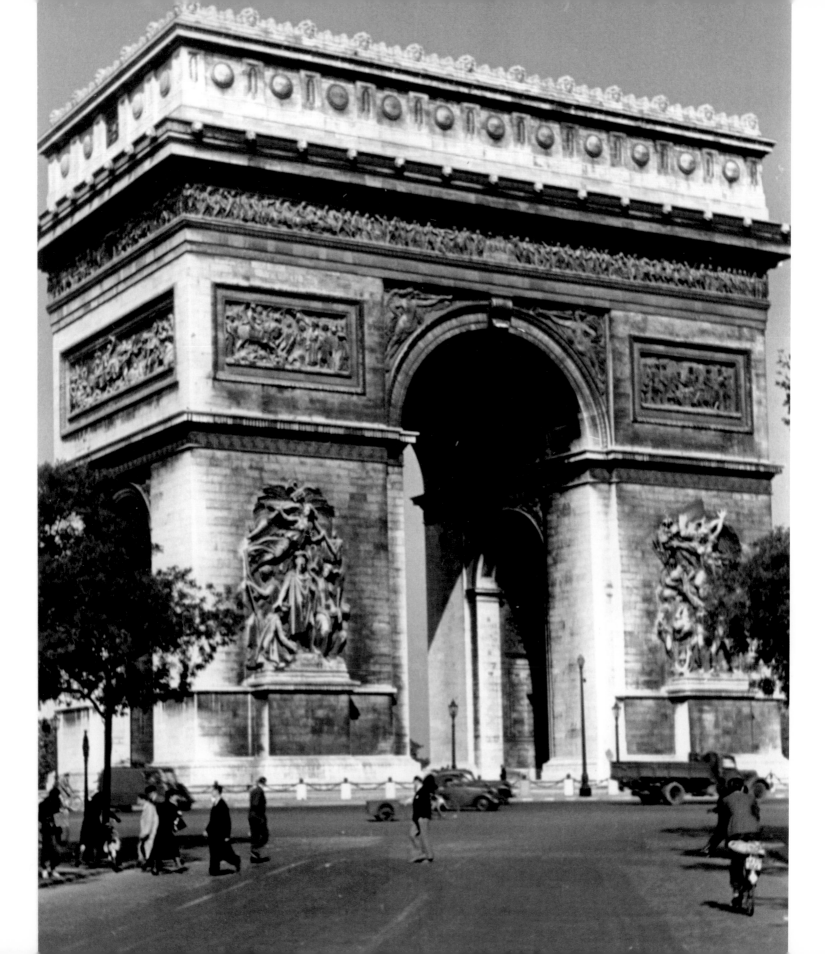

B 323-311 N° 3

This view of the Arc de Triomphe brings us back where we started, in the vicinity of the place de l'Étoile, although this time at the other end of the avenue d'Iéna. The arrangement of this section of the album seems to suggest that, with the unmistakeable exception of the Eiffel Tower, the teams of the Munich Central Collecting Point did not know exactly where to place the sites featured in these photographs on a map. Just as, further on, photographs of saucepans will be placed next to each other, here these two pictures of arches are grouped together.

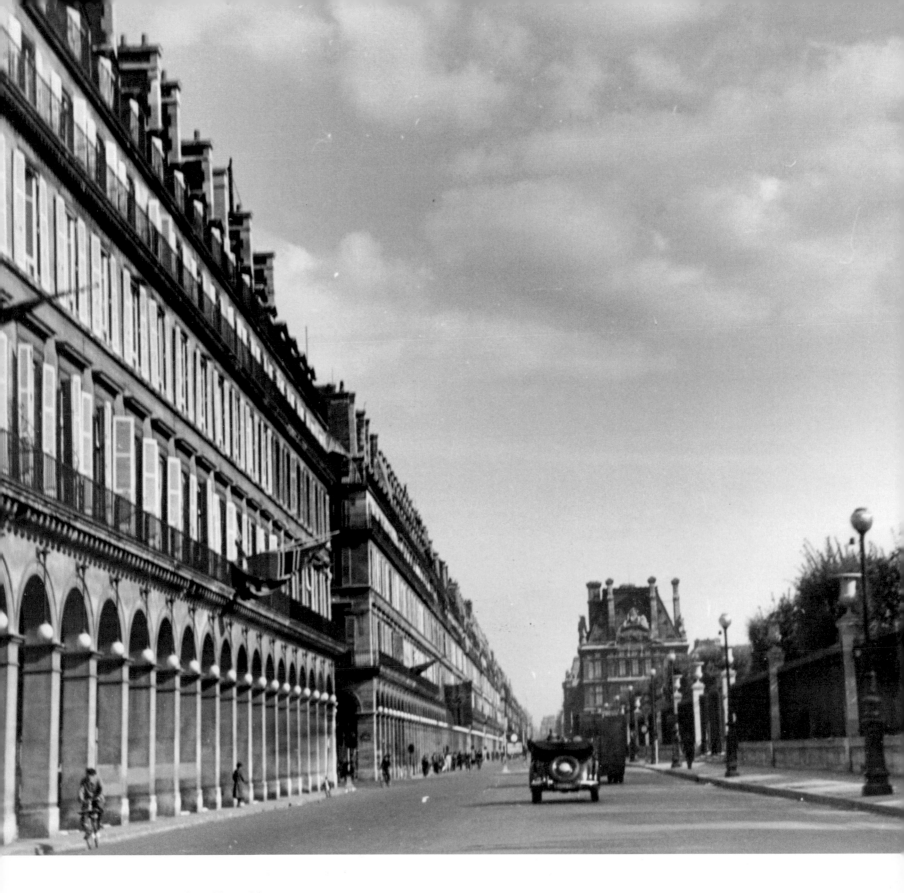

Witnessing the Robbing of the Jews

B 323-311 N° 4

The arches give way to wide avenues, with cars and people. The rue de Rivoli between the Arc du Carrousel and la Concorde is shown here, while the place de la Concorde appears in the next picture. The first five photographs of the album thus show us what the members of the E.R.R. would see on their daily journeys from their headquarters to their main places of work. The mark visible in the center foreground of the next picture suggests that this photograph was taken during one of these journeys, from inside a vehicle. The front car is the same as in picture no. 5. Apart from the picture of the Eiffel Tower, the other images in this section are also taken on major thoroughfares. The reader can thus look again at these five photographs, this time in the order they would appear if one followed this route on the ground: 1 / 3 / 5 / 4 / 2.

However, it is important here to look at the structure of the album with a critical eye. Although the clothes worn by passersby and the light levels in these five photographs do look similar, it is, first and foremost, the act of grouping them together performed by the staff of the Munich Central Collecting Point that gives an appearance of unity to these five views of the capital.

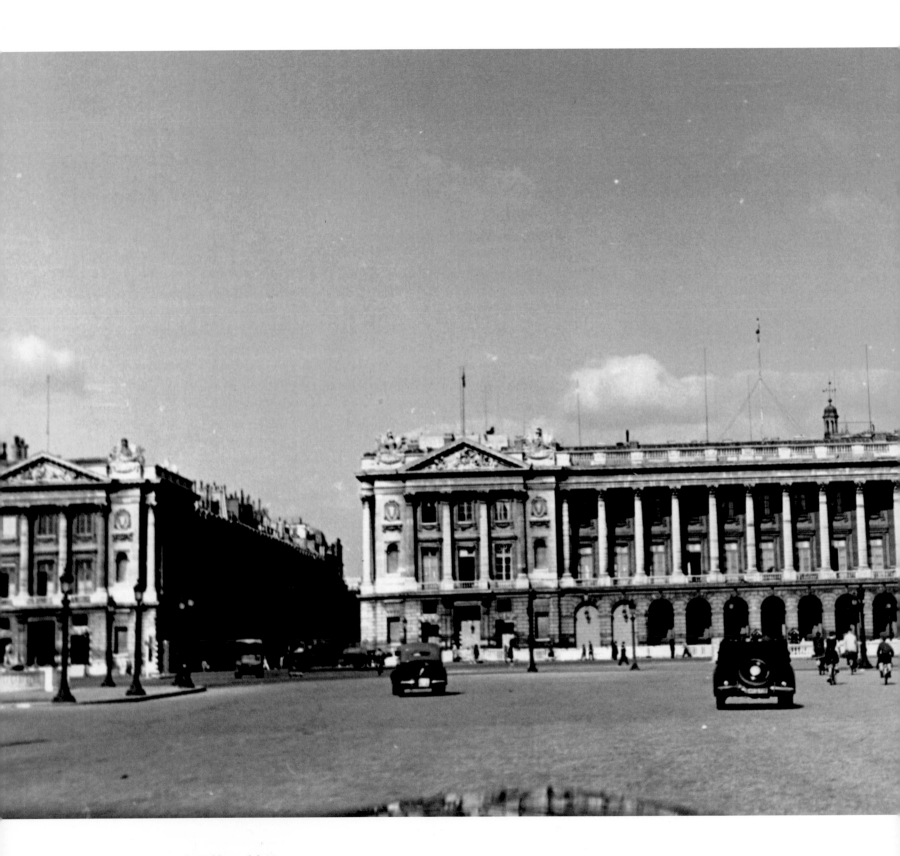

Witnessing the Robbing of the Jews

B 323-311 N° 5

It is, therefore, impossible either to identify the author or authors of these photographs with any certainty, or likewise to establish the dates on which they were taken. However, since the one thing that these pictures have in common is that they show locations in Paris linked to the looting of artworks, the hypothesis that these topographical views were taken by members of the E.R.R. is not an unreasonable one.

In 2007, these photographs were removed from the album in which they were originally pasted in order to be digitized.[2] This process revealed the name of Helene Petraschek-Lange written in pencil on the back of the picture of the Arc de Triomphe. The woman in question was a painter from northern Germany. Was she in Paris between 1940 and 1944? Was she linked to the leadership of the E.R.R.? Was she the author of the five Parisian views that open the album?

Whether or not this is the case, the reason why these images have the look of souvenir photographs is most likely because this is exactly what they represented for the person who had kept them in the office in Lévitan where they would be found in 1944; might they also have been seen as such postcards by the person, possibly James R. Rorimer, who found them and took them with him to Germany?

2. In June 2009, I learned from Christina Kott that the photographs preserved under shelfmarks B 323-311 nos. 1–85 had now been mounted on sheets of white A4 paper bound into a volume, generally with two photographs per page. The archives' conservator Philip Möckel explained to me that it had been decided to remove the pictures from the original album for conservation reasons, as the black paper contained unacceptable levels of acidity. I would like to thank Jakub Limanowski for having assisted me on this visit.

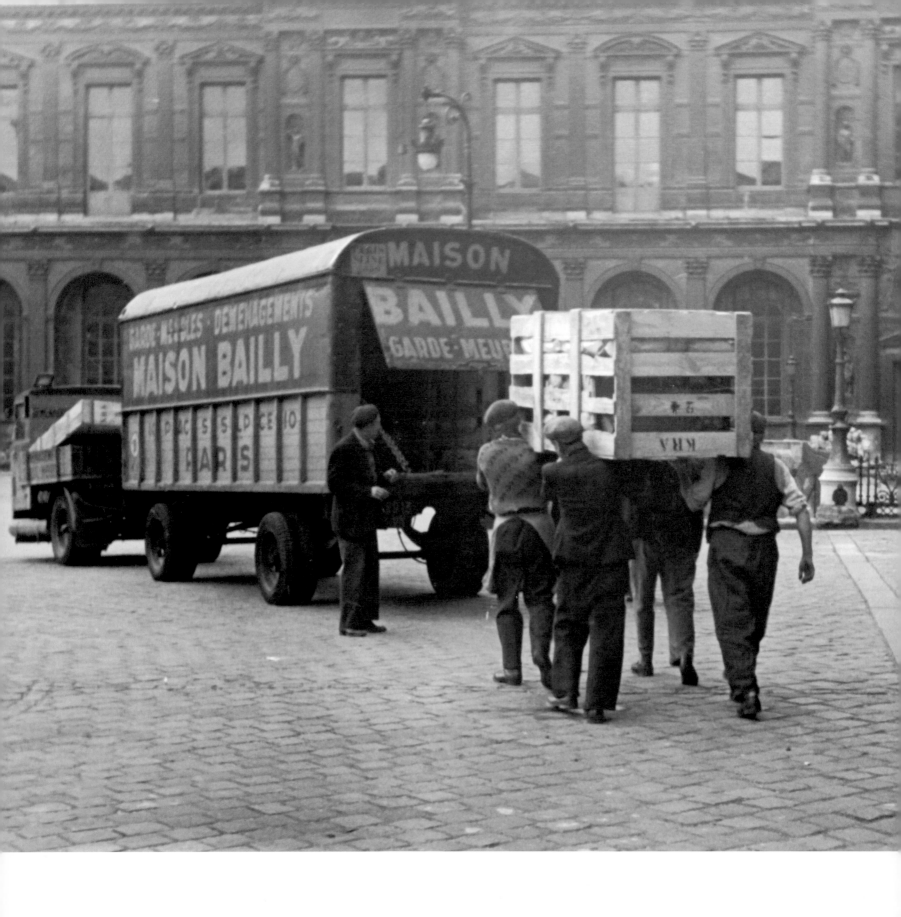

B 323-311 N° 6

This image opens what the reader implicitly understands to form the second chapter of the album. Apparently, the staff of the Munich Central Collecting Point decided that the next theme to be shown would be the loading of lorries. This second section comprises a total of five photographs.

The sculptures and architectural details allow us to identify where this photograph was taken: in the Cour Carrée, one of the courtyards of the Louvre. In autumn 1940, several rooms in the museum that were then standing empty were occupied by the E.R.R. The only way into these rooms was via an entrance off the Cour Carrée, and the action shown here is occurring in front of this doorway. A piece from the Kraemer family's collection—identifiable from the initials "KRA" stamped on the crate in the foreground—is leaving the repository. Two destinations are possible: either the Jeu de Paume museum in Paris or a train to Germany. Most of the works stolen from Jewish collectors would in fact end up in the various depots of the E.R.R., the main one being the castle of Neuschwanstein in Bavaria. The finest pieces were shipped to Carinhall, Goering's private residence, or added to the collections of the Pantheon of German Culture that Adolf Hitler had decided to construct in Linz. Where, one finds oneself wondering, is this crate going?

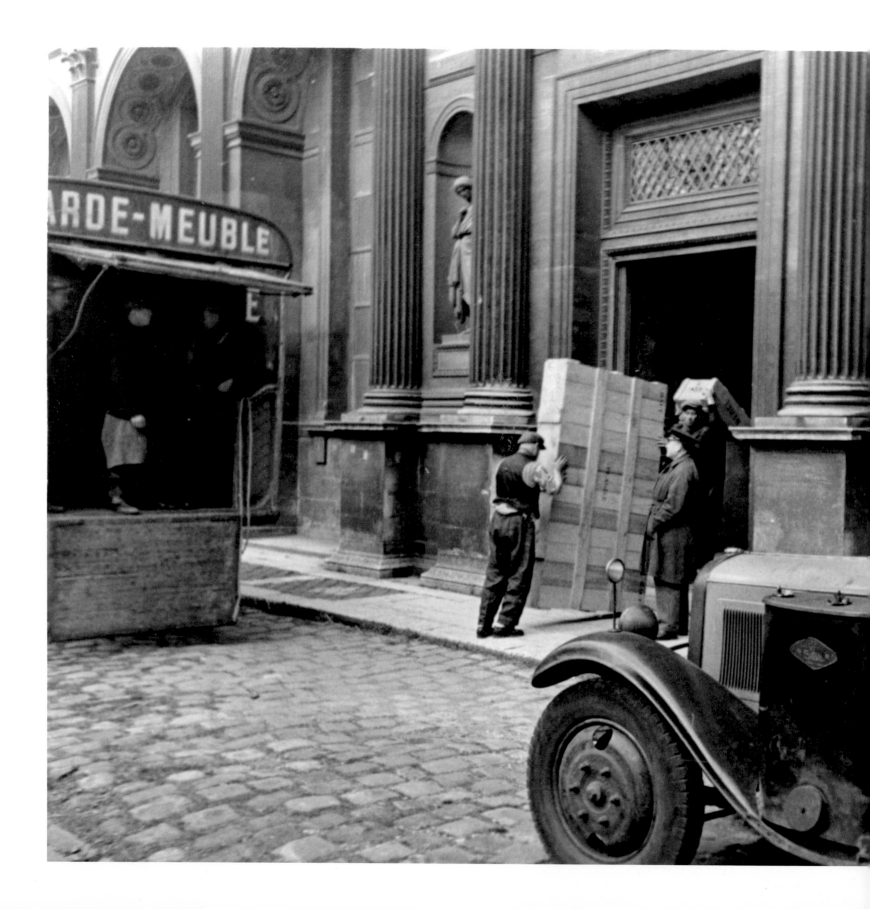

B 323-311 N° 7

Another view of the Cour Carrée at the Louvre.

Fearing espionage, the E.R.R. tried to avoid using French museum employees. A shortage of suitable staff, however, meant that they had to rely on the employees of the Musées nationaux to carry out the tasks of security and building maintenance. The figure in the center wearing a smock is one of these museum employees.

The French security staff working in the Louvre sequestration would regularly supply Jacques Jaujard with information on what was going on inside. At the beginning, he hoped that he would actually be able to prevent the works stolen from their Jewish owners from being taken to Germany. Whenever possible, these employees would draw up lists of the crates entering and leaving the rooms they were guarding.[3] However, Jaujard quickly realized that he would be powerless to keep these cultural treasures from leaving the country. He did not even manage to prevent the seizure of works that had been left in the care of the Musées nationaux by their Jewish owners when war was declared. Like the 130 crates containing the David–Weill collection that were taken on April 11, 1941 by the E.R.R. from the repository at the Château de Sources, fourteen collections belonging to Jews that were being stored in the evacuation repositories of the Musées nationaux would in the end be confiscated by the Germans.[4]

Jacques Jaujard and Rose Valland—another member of the staff who, once she had been transferred to the Jeu de Paume, would spy tirelessly on the E.R.R.—nevertheless hoped to be able to assist in the restitution of these collections once the end of the war that they so longed for finally came.[5] In her memoirs, Valland pays tribute to the help provided to her in this endeavor by Louis Deforges, a guard at the Louvre sequestration, and Gaston Petite, his immediate superior.[6] The figure in this image could be one of these two men.

3. For a description of how the sequestration functioned, see AMN, R 32.2 subfile 4, box 1, "Note sur les collections séquestrées," 20 February 1941.

4. Rayssac, L'exode des musées.

5. The position of some other members of the administration of the Beaux-Arts was rather more ambiguous, See Karlsgodt, Defending National Treasures; and AP, Perotin, 3314/71/1/3, file 762.

6. Valland, Le Front de l'Art, 82–83.

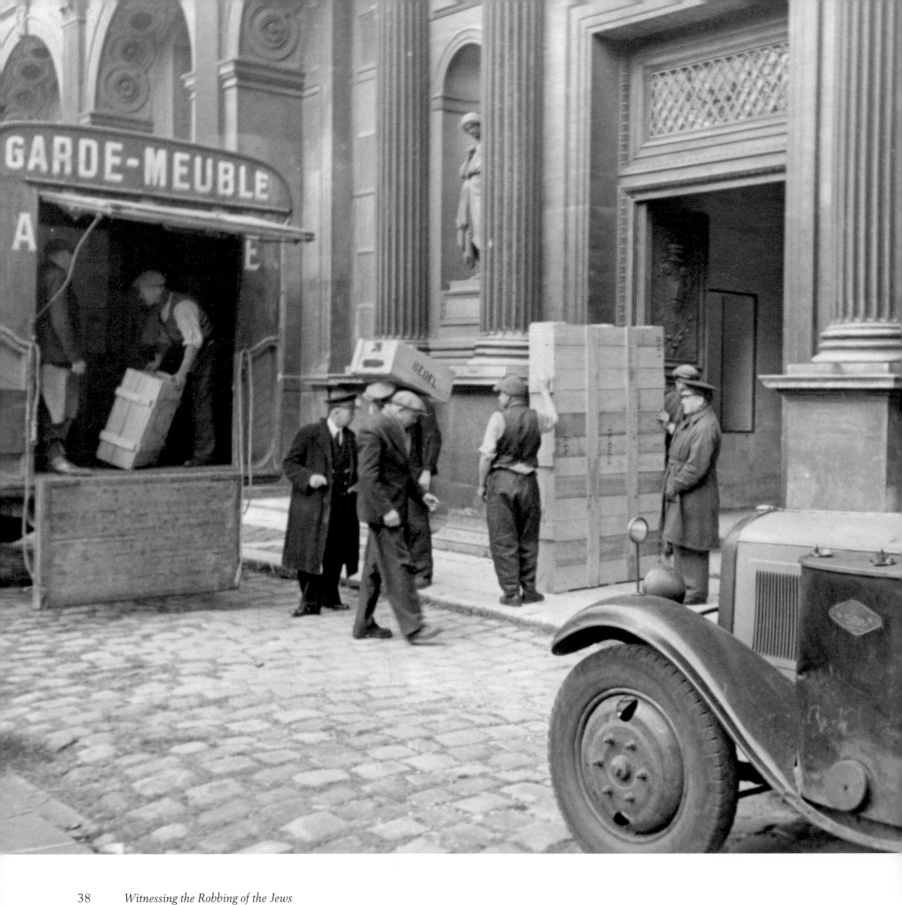

Witnessing the Robbing of the Jews

B 323-311 N° 8

In the middle of the photograph is a crate stamped "BEDEL." This time, the name does not refer to the owner of its contents but rather to where the crate has come from: the furniture removals and storage firm Bedel, still a household name in France today. When the Germans arrived in Paris, several collectors had already placed their property in the hands of storage firms for safekeeping, or so they thought. The E.R.R. wasted no time in going to these firms in order to get their hands on the artworks they coveted. In her diary from this time, Rose Valland noted the arrival at the Louvre in September 1942 of more than 150 paintings, 20 rugs, and around 60 pieces of furniture all taken from Bedel's storage depots, where Maurice de Rothschild had left them at the beginning of the war.[7] It is likely that the crate visible in this photograph belongs to this collection. From 1943 onward, the Dienststelle Westen would in turn go to these storage companies to seize the furniture and other possessions left there by their Jewish owners, this time far less famous and well off than the Rothschild family. At this point, COEDGM, of which Bedel was an important member, was ordered to send the Germans "a list of all property that is Jewish or presumed to be Jewish being kept by storage firms in the Paris region."[8]

This photograph was reproduced on the cover of Martin Dean's book *Robbing the Jews: The Confiscation of Jewish Property in the Holocaust, 1933–1945* (2008). It was given the caption "Confiscated property being loaded onto a truck of the furniture protection service, 'Garde-Meuble' in Paris, 1943 or 1944." Given that, with the exception of one picture showing the backs of some paintings (see no. 31), none of the property shown in this album is artistic in nature, the viewer (even when a historian[9]) is led to think that the objects inside these closed crates all belong to the same category—furniture kept in a "Garde-Meuble." They do not. As a result of his purely illustrative, decontextualized use of the picture, Martin Dean has no way of discovering that this photograph was taken in the courtyard of the Louvre and relates to the looting of artworks.

Once again, the eye of the album's creators forcefully guides that of the viewer, who thus becomes aware of what the images it contains represent. Aside from its inaccuracy and its lack of concern regarding the photograph's date—see photograph no. 20—and where it was taken, this caption also skirts around the question of the status of this "furniture protection service, 'Garde-Meuble.'" Several other photographs elsewhere in the album leave no doubt in this respect. Just how should we look at these removal firms whose names sometimes feature in close-up in these images?

7. AMN, R 32.1, note from Rose Valland to Jacques Jaujard, 14 April 1944. My attention was drawn to this point by Guillaume Fonkenell.

8. Federal Archives of Koblenz, B 323-259, 459, letter from COEDGM to the Dienststelle Westen, 11 October 1943.

9. Or an archivist, as will be explained later.

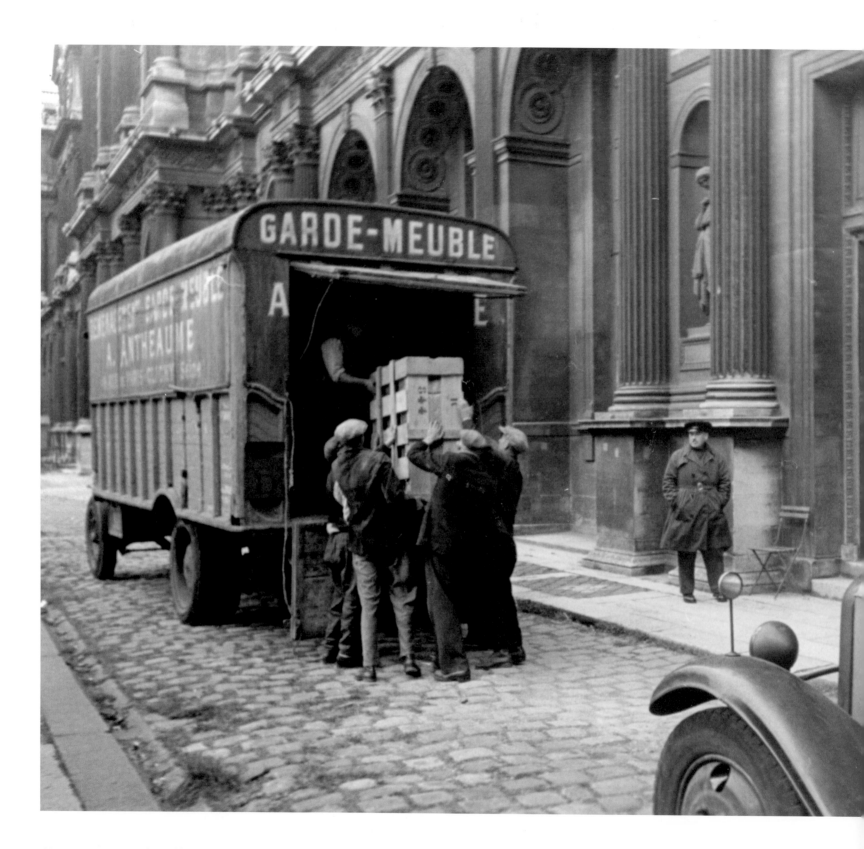

Witnessing the Robbing of the Jews

B 323-311 N° 9

In this picture, crate "R 844," containing piece no. 844 from the Henri de Rothschild collection, is being loaded onto a lorry, still in the Cour Carrée. The E.R.R. inventory indicates that piece no. 844 was a statue of a saint a little under one meter in height, and that it was the work of a Dutch artist. After the war, it would be found by the Munich Collecting Point team and eventually reunited with its owner in October 1947. Along with the entirety of the plunder assembled by the E.R.R.—but not, significantly, the banal items taken by the Dieststelle Westen—this piece was photographed. The picture in question is today kept in the collection of the Federal Archives in Koblenz.[10]

For their transport needs, both the E.R.R. and the Dienststelle Westen relied on French removal companies. In this photograph, it is the firm called "A. Antheaume," the name of which, like that of the "Maison Bailly" in photograph no. 6, is clearly visible in this image. In all probability, the civilians shown in this photograph, apart from the staff of the Louvre who are recognizable from their clothes, are French employees of the removal firms mobilized for this job.

Massively exceeding the scale of the E.R.R.'s activities, the transport requirements of Operation Furniture quickly became colossal. At the beginning, the Germans asked for three lorries per day from COEDGM's Department for Jewish Requisitions and Removals. This figure quickly rose to eighty vehicles per day. A number of companies based in Paris and the Paris region would thus send at least one lorry per day to be used by the Dienststelle Westen. In this respect, there is nothing special about the firms whose names appear on this image and elsewhere in the album, other than the fact that their names have been fixed on a photographic negative.

10. See B323/280 and the official E.R.R. database, http://www.errproject.org/jeudepaume/card_view.php? CardId=17967.

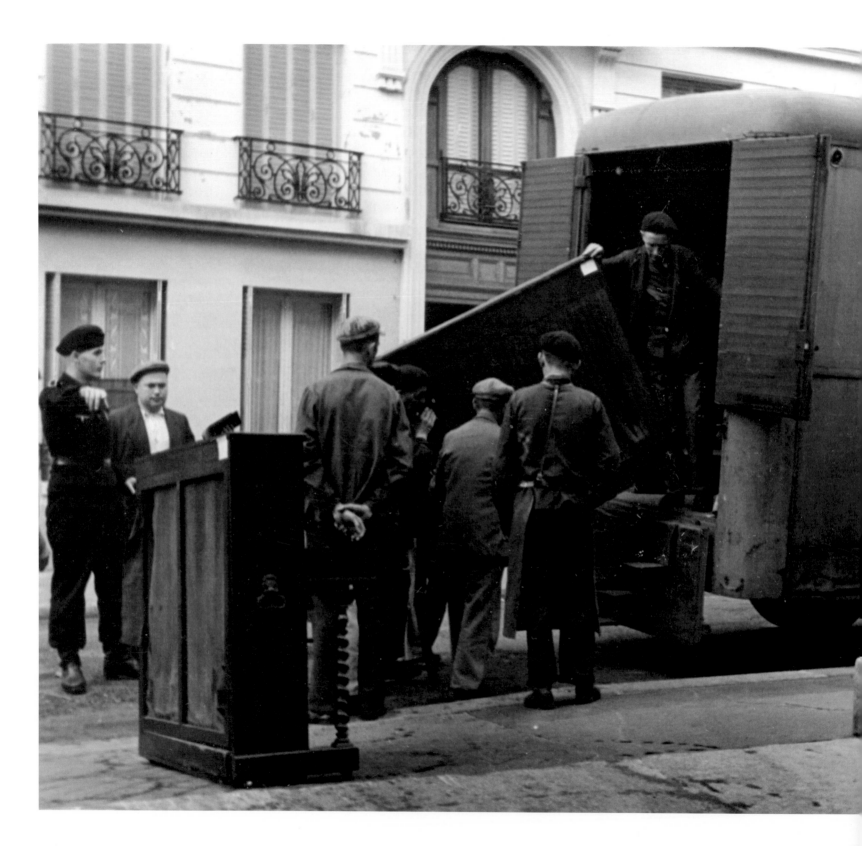

B 323-311 N° 10

Another image from the chapter in the album devoted to the loading of lorries. However, the site, the type of goods being loaded, and the German administrative branch in charge of the operation are all different from those in the previous picture.

Here, French civilians are working under the supervision of a sergeant (*Unterfeldwebel*) belonging to a Panzer unit, who is visible on the left of the image.[11] It is perhaps surprising that a soldier whose job would normally be to operate armored vehicles on the battlefield should be overseeing the loading of pianos onto a lorry. Whatever the explanation for this, it is certainly the case that, in the course of its visits to apartments that had been "abandoned" by Jews, the Dienststelle Westen acquired a large number of pianos. From October 1942 onward, it stored them in the basement of the Musée National d'Art Moderne, on the quai de Tokyo.[12] The loot was brought in via the back entrance at 2 rue de la Manutention, where this picture was taken.

Today, the Commission pour l'Indemnisation des Victimes de Spoliations created following the Mattéoli Mission has its offices directly opposite, at 1 rue de la Manutention. Set up in 1999, this organization has the job of dealing on an equitable basis with the requests it receives from Jews who were the direct victims of looting and from their descendants.[13]

11. For the identification of this and all the other uniforms in these photographs, I am indebted to Jordan Gaspin, official historian of the Musée de l'Armée, for his invaluable assistance.

12. AMN, L2 MNAM 1934–1945, dossier "Protestation contre le dépôt de mobilier installé par les Allemands dans les sous-sols du musée d'Art moderne," letters from J. Jaujard to Dr. Mobius, 27 and 31 October 1942. The French government had decided to build a national museum of modern art in 1934. In 1937, the "Palais des Musées d'Art Moderne" first opened its doors during the International Exhibition of that year. Although the buildings hosted an exhibition in 1942, having been due to open in 1939, the museum was only officially declared open in 1947.

13. For an account of its creation and work, see Laloum, "La restitution des biens spoliés."

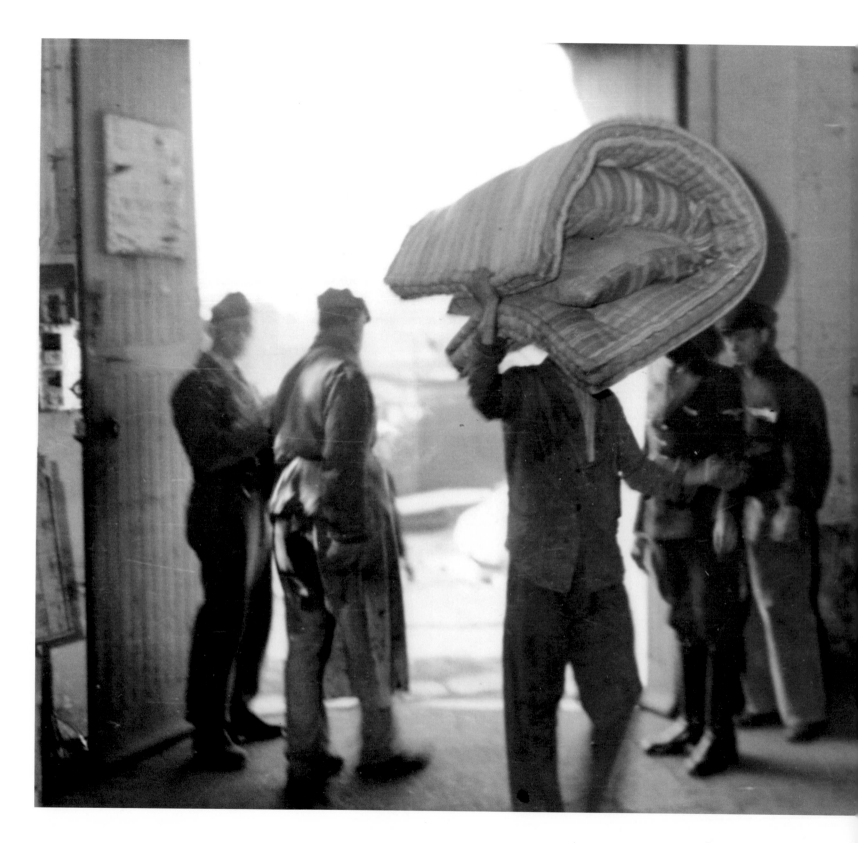

Witnessing the Robbing of the Jews

B 323-311 N° 11

This image opens what could be termed the third chapter of the album, which deals with the loading of trains. This implicit chapter contains nine photographs.

It is difficult to establish with any certainty where this picture was taken. However, two clues do allow us at least to formulate a hypothesis. In the background, an expanse of water and a barge are visible. To the right of the central figure carrying a mattress on his head, a German uniform can be made out. It is worn by a member of a second-line support unit of the German army specializing in rail operations, either the Reichsbahndirektion Köln or the Wehrmachtverkehrsdirektion Paris.[14] This picture was thus probably taken at the entrance to the Dienststelle Westen's depot at Aubervilliers. The site possessed the twin advantages of being situated next to the canal basin while also allowing trains to be loaded in situ, as it was directly connected to the rail network. The existence of such a depot is attested to by the numerous requisition orders sent out to removal firms who would go back and forth between this site and the three camps in Paris.

14. Davis, *Badges and Insignia of the Third Reich*.

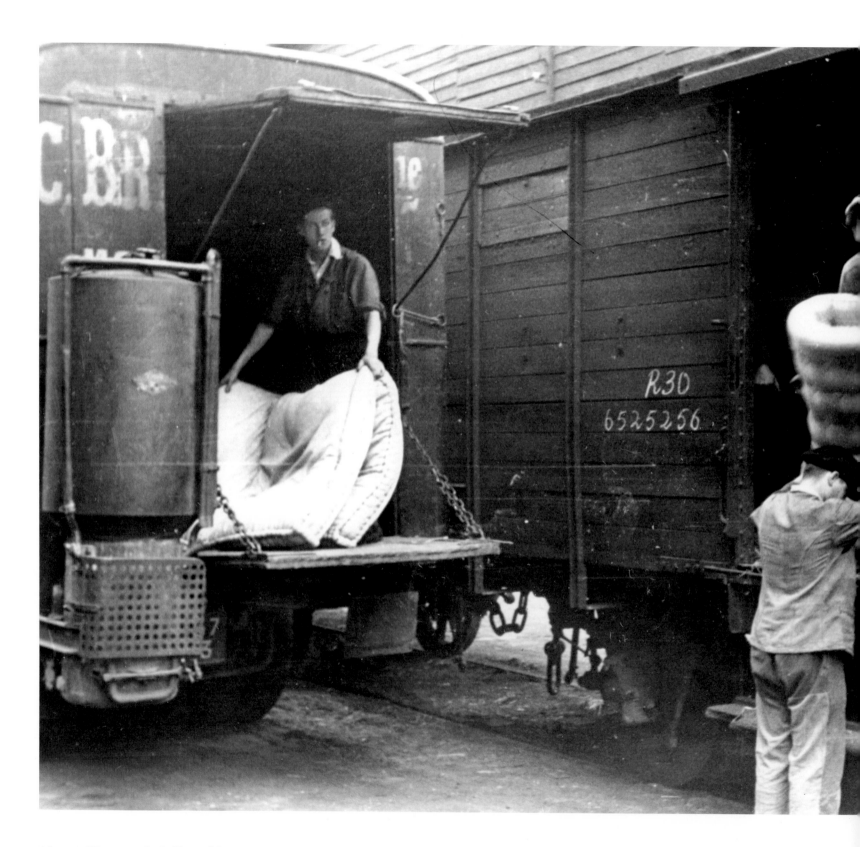

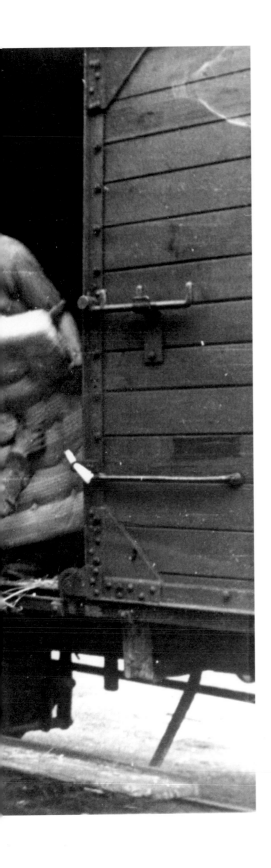

B 323-311 N° 12

More mattresses. As the subsequent pictures in the album reveal even more starkly, when the teams sent by the Dienststelle Westen emptied an apartment, they would seize the entirety of its contents, regardless of value. In this case, the mattresses are, it is true, being loaded onto a train. The system of thematic classification employed by the staff of the Munich Central Collecting Point who compiled this album means that one is tempted spontaneously to link this photograph to the preceding picture and assume that both scenes relate to the same action. However, while the action in both pictures may well have occurred on the same site at Aubervilliers, the mattresses have not come from the depot itself. They are being unloaded directly from a removal lorry. The workers would appear to be employees of a firm belonging to COEDGM.

This said, it is not possible to establish for certain where this photograph was taken.

B 323-311 N° 13

The way in which the images are arranged within the album leads us, once more, to move from the implementation of Operation Furniture to the looting of artworks. Like the previous image, however, it too shows a train being loaded. It seems therefore that the teams of the Munich Central Collecting Point, despite being specialists in the restitution of artworks—a far greater priority for them than the more mundane and also much more difficult task of reuniting ordinary Jewish owners with their everyday possessions—were unaware that the crates seen in this image contained cultural goods. The reader does know this, however, having identified the lorry in this picture as being the same as the one in photograph no. 6. In addition to the name on the lorry, the trailer is recognizable, as is the size and position of the crate it carries. Crate "KRA 24" is inside this lorry. The action seen here is taking place at the warehouses of the Entrepôts et magasins généraux at Aubervilliers, which were routinely used in the loading of artworks onto trains, and just next to the Dienststelle Westen's depots shown in the two previous photographs.

The most striking element in this image is the queue of removal lorries. The question of France's complicity with German policy toward the Jews is paramount today, meaning that the way we look at this photograph now is noticeably different to how the staff of the Munich Central Collecting Point, and people at the time more generally, must have seen it. Our reading is thus concerned above all with the motivations of the actors present in the image.

After the war, an inquiry was carried out by the Comité de confiscation des profits illicites de la Seine (Committee for the confiscation of illicit profits in the Seine region). This rather low-key investigation sought to recover all the money made by French individuals who had grown rich by working for the occupiers and use it for the common good. It resulted in the imposition of a fine of 303,543 francs on the director of the Department for Jewish Requisitions and Removals, not because he had been found personally guilty but rather because the payments in question had been going through his company's accounts.[15] COEDGM received a 3 percent cut of all compensation payments made during these German requisitions, nominally to cover handling costs.

More importantly, though, when work for private clients began to dry up entirely in 1942, German requisitions seemed to offer a commercial opportunity for these businesses. The following extract from a letter sent on June 6, 1943, by a removal company to the head of the department coordinating work with the Germans in COEDGM is revealing in this respect: "Having lost a whole month's work, I am writing to ask whether you would be able to add me to your work rotas wherever possible so that my men can have a little work."[16]

In addition to the fine imposed by the committee for the confiscation of illicit profits, a criminal prosecution was also launched in 1944 by the court of justice of the Seine region, along with an

15. AP, ruling of 15 February 1946, Perotin / 3314/ 71/1/3, box 56, file 913–914.

16. AP, Perotin / 3314/ 71/1/3, box 56, file 913–914.

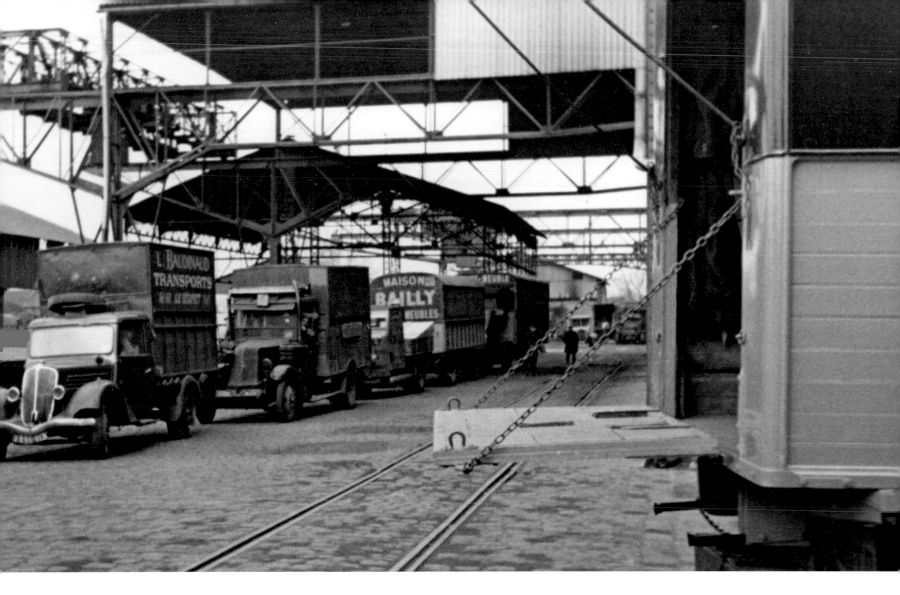

inquiry by the region's civil court, against the management of CO-EDGM. The charges related, respectively, to the crimes of conspiring with the enemy and of *indignité nationale* (national indignity).[17] In both cases, the proceedings resulted in an acquittal. The actions of COEDGM were judged not to have constituted conspiring with the enemy. As for the charge of national indignity, it was ruled that the collaboration of the committee and of removal firms more generally had been obtained under duress. The requisition orders sent to these companies did after all bear the warning that "failure to carry out this order is punishable by death."

There is, then, a risk that this image could be read anachronistically. Yet this risk should itself be put in context. For in 1948, during the then-ongoing trial, the judge did in fact raise many of the questions that we are likely to ask today on seeing this image. He expressed his indignation and disbelief to the president of COEDGM standing before him in the dock: "Was your first duty not to demand, when faced with such a plan of looting, that a daily report be given by the drivers, listing the dates of the removals and the addresses of the emptied apartments, for future reference?"[18]

17. Rousso, "Une justice impossible"; and Simonin, *Le déshonneur dans la République*.

18. Archives Nationales (hereafter cited as AN), 12 November 1948, transcript of interview, Z/6/292, file no. 8712, case brought by the civil courts of the Seine region.

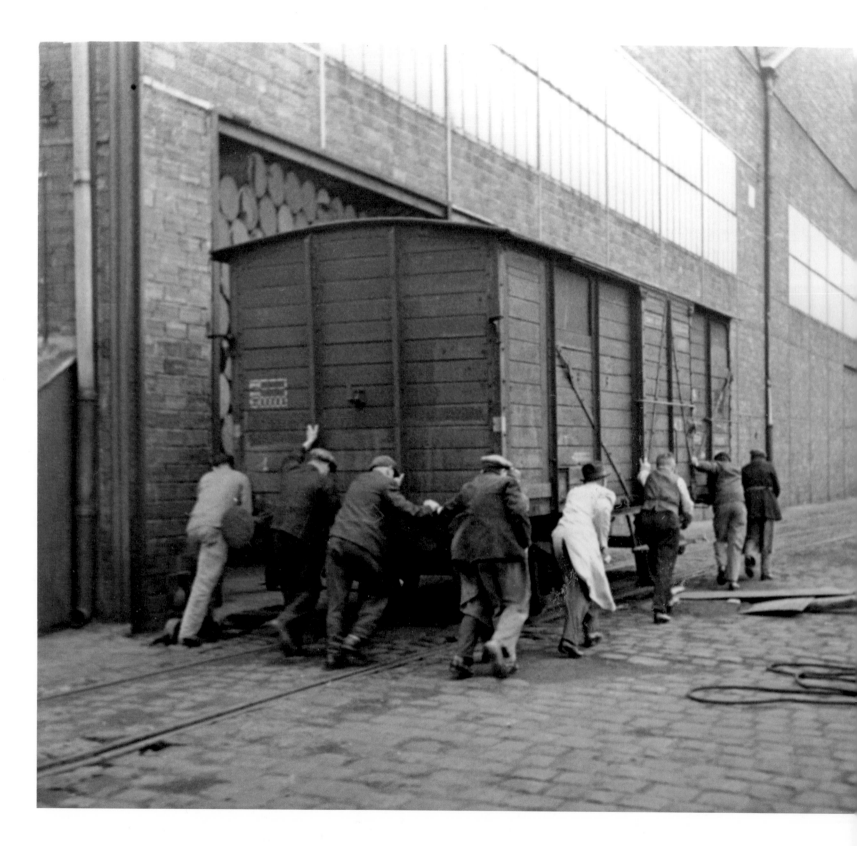

Witnessing the Robbing of the Jews

B 323-311 N° 14

This photograph was taken on the same site as the last picture. The railway freight wagons would be moved to allow the cargo from the arriving lorries to be loaded onto them. Between April 1941 and July 1944, 138 wagons filled with artworks were sent to Germany by the E.R.R.[19]

Rose Valland's job at the Jeu de Paume meant that she was able to give an account of the loading of at least one of these trains. On August 1, 1944, a number of fully laden lorries left the Tuileries gardens. Their contents filled five freight wagons that were locked and sealed at the Gare du Nord on August 2. However, the train also comprised another forty-six wagons that were earmarked for loading as part of Operation Furniture. The Germans had trouble getting this convoy under way. The train ended up being shunted endlessly around the Parisian suburbs. On August 12, the "museum train stands in the sidings next to the gasometer at Aubervilliers station."[20] The same sidings are shown in this photograph.

19. Le Masne de Chermont and Sigal-Klagsbald, *A qui appartenaient*, 10.

20. Valland, *Le Front de l'Art*, 184–185. Rose Valland will visit the train with James R. Rorimer (see Rorimer, *Survival*; and Edsel, *The Monuments Men*).

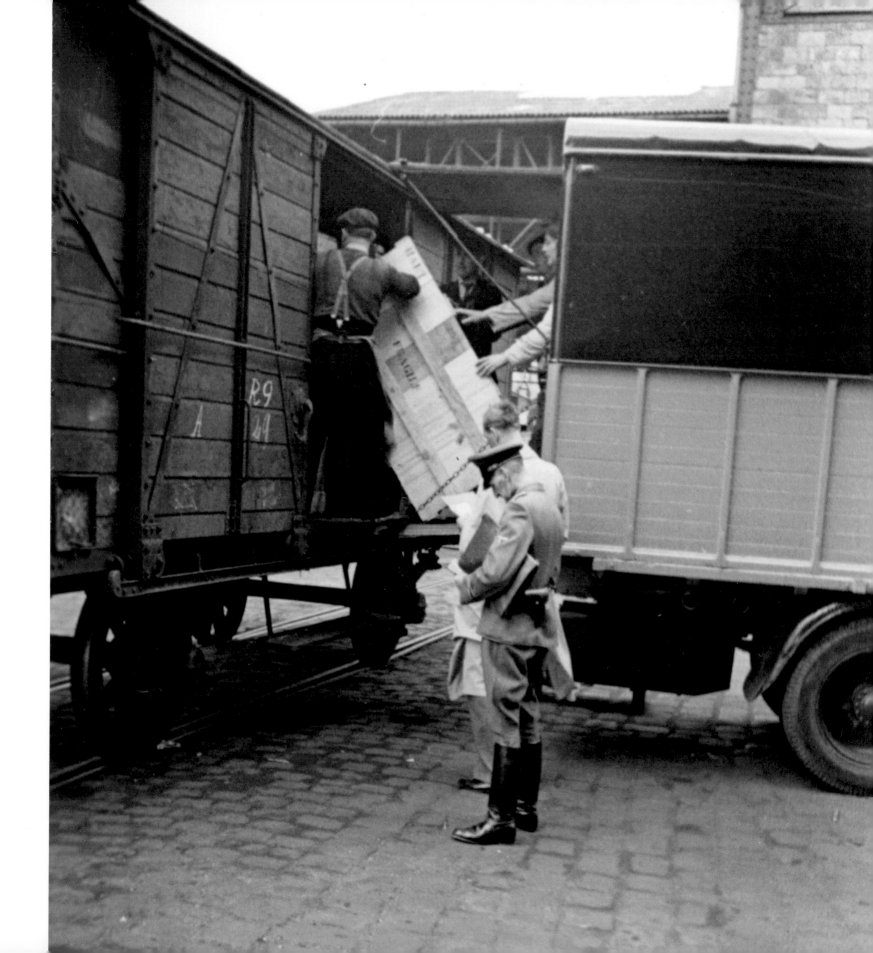

B 323-311 N° 15

The reader recognizes the uncovered lorry in the foreground from photograph no. 13. In the intervening time, a wagon, or perhaps an entire train, has been moved into position to be loaded. Photographs nos. 13–16 thus belong together. They were all taken on the same day and in the same place. Not only that, the presence of the lorry belonging to the Maison Bailly that was first seen in image no. 6 indicates that these four scenes were taken as part of the same series as images nos. 6–9. The whole sequence could be entitled "crates leaving the E.R.R. repository in the Louvre on their way to the Aubervilliers site, in order to be loaded onto a train bound for Germany."

Once again, the isolated use of these images as historical illustrations has given rise to erroneous captioning. In this case, it is not a historian (as we have seen with Martin Dean's book) but rather the German Federal Archives themselves who have labeled these pictures wrongly. In their online "photo gallery" on the looting of the Jews in Paris, this photograph is reproduced with the following caption: "Crate of items looted during Möbel-Aktion being loaded directly onto a rail car under German supervision."[21] The reader now knows that it shows nothing of the sort. What are actually being loaded onto these trains are artworks previously stored in the Louvre by the E.R.R.

21. http://www.errproject.org/jeudepaume/photo/.

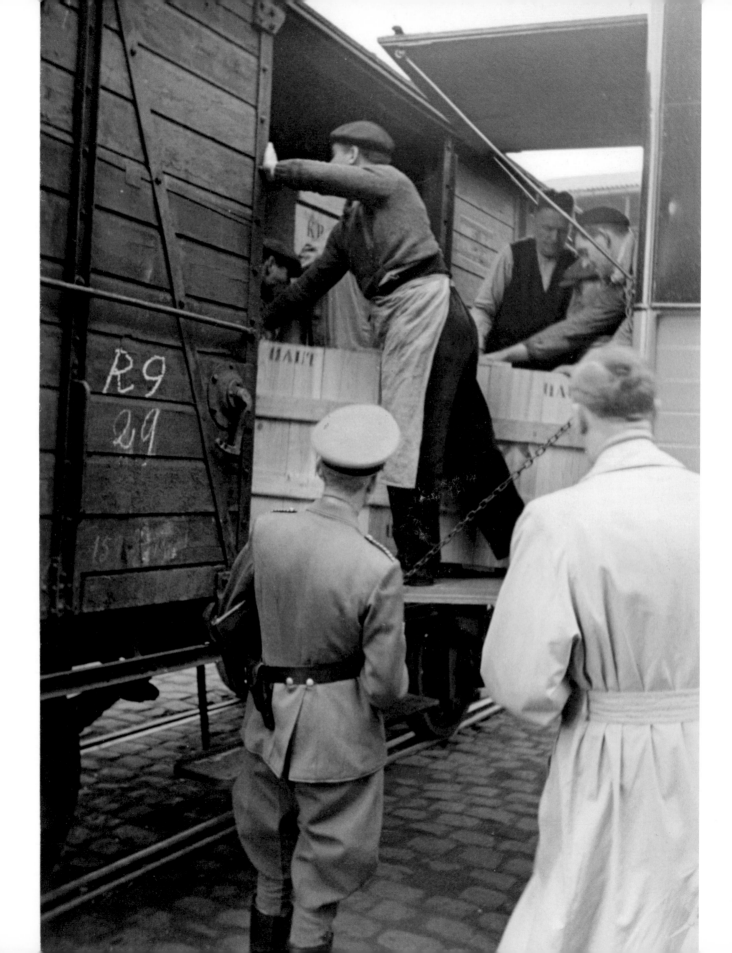

B 323-311 N° 16

Last photograph from the same series.

Magnification of the image reveals that at least one crate from the Kraemer collection has been loaded onto the wagon. The stamp "KR..." is visible between the arms of the civilian wearing an apron.

In the foreground, a German soldier overseeing the loading is seen from the back. The distinctive insignia on his uniform show that he belongs to the same unit as the man seen earlier in the Dienststelle Westen's depot on the same site at Aubervilliers, most likely the Wehrmachtverkehrs-direktion Paris. Generally speaking, the shipping of artistic loot back to Germany was overseen by the Luftwaffe, the German air force. Indeed its head, Hermann Goering, was one of the chief beneficiaries of the looting. In November 1941, as a mark of gratitude, an exhibition entitled Kunst der Front (Art from the Frontline) featuring paintings produced by members of the Luftwaffe was held inside the Jeu de Paume, right next to the looted old masters.

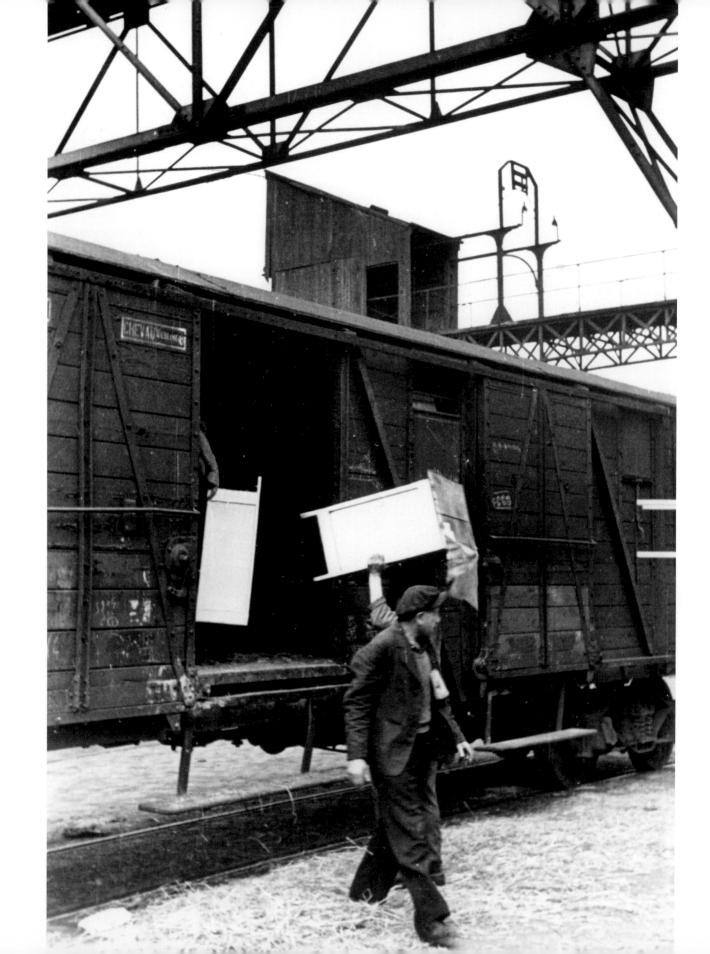

B 323-311 N° 17

In this case, the train is being loaded in the context of Operation Furniture. Low-value items of furniture are going to be sent to Germany. The metal structures in the foreground and farther back would seem to indicate that, as in the previous photograph, the action shown here is taking place by the canal alongside the Aubervilliers warehouse, on the site belonging to the Entrepôts et magasins généraux.

Unlike in image no. 16, however, the furniture here is not being moved by employees of removal firms but rather by Jewish detainees from the satellite camps of Drancy within Paris, for the figure in the foreground is wearing a white armband displaying his camp number. Unfortunately, it is illegible here. Internees were occasionally sent to work on detachments outside their camp—at Aubervilliers, as seen here, or at the Musée National d'Art Moderne, as in photograph no. 72. The presence of detainees indicates that this photograph was taken between July 1943 and August 1944. It thus constitutes the first visible evidence within the album of the existence of places of internment with a dedicated role in the looting process.

Between 200 and 300 wagons per week were sent to Germany in the context of Operation Furniture.

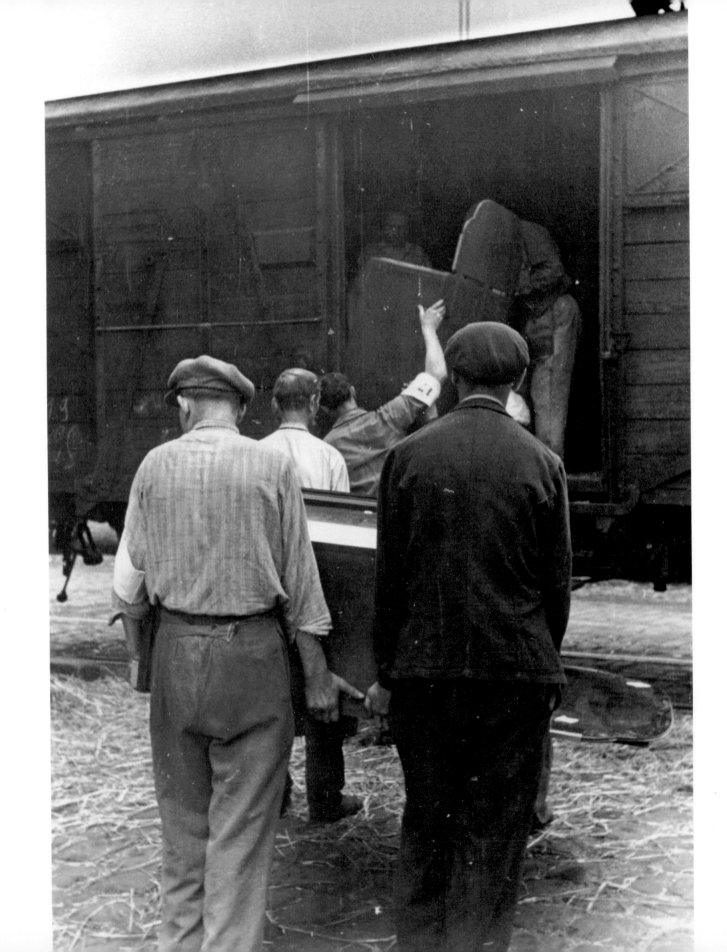

B 323-311 N° 18

This time, a camp number is visible. While registers of the internees held in the Operation Furniture camps may have been kept, they were destroyed at the end of the war along with the rest of the Dienststelle Westen's archives. In 2002, thanks to indirect sources consulted while researching the original French edition of *Nazi Labour Camps in Paris,* it was possible to draw up a list, although by definition an incomplete one, of these internees.[22] The number "17," seen here, was given to Jean Gradis. He was born on December 14, 1900, in the 16th arrondissement of Paris. At the time of his arrest he was working as a farmer in the Department of Indre-et-Loire, near Tours. Having been arrested by the Tours gendarmerie, he was interned in Drancy for the first time in April 1943. By virtue of being married to a non-Jew, he appears to have benefited from his status as the "spouse of an Aryan" and was released. He was rearrested the following October. The register of confiscated belongings at Drancy shows that he had 800 francs on his person. He was quickly transferred to Paris and held in Lévitan. It was from the latter camp that he was sent out on a work detail on the day shown here.

The straw visible inside the wagon and on the ground is an abiding feature of Operation Furniture. Several former internees that I have met have spoken of this straw that they had to pack between objects in crates and between pieces of furniture to protect them while being loaded. In March 1943, the internees of Austerlitz camp secretly produced a small satirical magazine with the evocative title *Camp-Camp.*[23] A copy is preserved today in the Yad Vashem Archives in Jerusalem. It includes a humorous "Glossary" where the following entry can be read: "*Stroh* ['straw' in German] is a material of vegetable origin with a lovely bright yellow colour. It is found in bales or artistically arranged in warehouses, on the doorways of wagons, on the rails, between skin and shirt and, very occasionally, inside wagons."[24]

A requisition order for a removal lorry dated April 18, 1942, shows how, in this way, straw truly formed the raw material of the looting process: "By order of the occupation authorities, removal firm X will deliver at 7:30 AM on 21 April 1942 a motor vehicle for removals with a floor area of between 1 and 25 m² (covered van or towed trailer or flat-bed with frame) to 54 avenue d'Iéna with six men plus the driver, 10 crates (or stowage baskets) and 100 kilos of straw."[25]

22. The archives of the l'Union générale des Israélites de France (UGIF) have proved the most useful on this subject. Created in 1941, this organization replaced the various existing Jewish associations, which were henceforth proscribed (see Laffitte, *Un engrenage fatal*). When the Parisian camps opened in July 1943, the UGIF was tasked with providing them with logistical support. This administrative activity included producing daily menus, laundry coupons, and other lists of supplies, all of which may be consulted in the Centre de documentation juive contemporaine (hereafter cited as CDJC). The archives of the CDJC also hold two lists giving the names of internees at various dates under the shelfmarks UGIF 92, 1679 à 1681, "Liste Austerlitz, Lévitan, Bassano," undated (probably January 1944); and CCCLXXVI-4, "Liste Dienststelle Westen," 29 October 1943.

23. The title is based on a pun in French, as a *cancan* is a rumor or piece of gossip shared within a small group of insiders—a perfect description of the content of this magazine written in a camp (-camp).

24. Yad Vashem Archives, journal "Camp Camp"; and CDJC, UGIF, 93, 10.

25. AN, Z/6/292, dossier no. 8712, case brought by the civil courts of the Seine region. According to the terms under which I was allowed to view these documents, I have replaced the name of the company with an "X."

B 323-311 N° 19

Here, the Gare du Nord has been photographed from one of the windows of the postal sorting office building belonging to the SNCF, giving a view both of the platforms and of the rue de Maubeuge.[26] Unlike in the previous images, while trains can be seen here, there is no evidence of loading. As was the case with the first five views of the capital, the person who took, or at any rate kept, this picture apparently simply wanted to have a souvenir of a particular part of Paris, having perhaps worked there.

This photograph is also evidence of the probable existence of an office used by the E.R.R. and/or the Dienststelle Westen. While I have not yet been able to find documents confirming this hypothesis in the SNCF archives, it is nonetheless the case that the Gare du Nord was the departure point from which many of the trains laden with belongings stolen from Jews left for Germany between 1940 and 1944, whether the goods in question were precious artworks or simply everyday objects with little value. The register kept by the staff of the Louvre, for instance, indicates that crates were regularly moved by the E.R.R. from the sequestration to the Gare du Nord.[27] Requisition orders sent out by the Dienststelle Westen concerning the transportation of goods and furniture taken from apartments "abandoned" by Jews also routinely refer to the station as the destination for the lorries in question. Each vehicle would make between two and three round-trips daily between the Parisian depots involved in Operation Furniture and this station.[28]

26. Archives of the SNCF, Photographic Documentation, Paris Gare du Nord, Sorting Office, platform D. Some of these buildings have been replaced by the building at 112 Maubeuge used as a medical center and hostel. I was able to reconstitute the point of view from which this photograph was taken, having been given access to the building by André Krol, a former railway worker and member of Histoire et vies, a local history association in the 10th arrondissement of Paris.

27. For example, the transportation on 7 July 1941 of 243 crates, mainly belonging to the Rothschild collection. See "Notes sur les collections séquestrées," 17 July 1941, AMN, R2 C 2.

28. AN, Z/6/292, dossier no. 8712, case brought by the civil courts of the Seine region.

B 323-311 N° 20

This image opens a fourth implicit chapter within the album, which is devoted to images of crates, beginning with closed crates (in transit, then stationary), before showing open ones. It contains sixteen pictures.

With this image, we are back at the Louvre. This time, the photographer is not standing in the courtyard but rather inside the repository itself. The patterned floor and the details of the plaster mouldings allow this room to be identified with absolute precision.[29] The action is taking place in the main room of the repository, today "salle A" of the west wing of the pavillon Sully. For the first time, civilian personnel belonging to the E.R.R. are visible. In total, the administrative staff working for Rosenberg in Paris numbered around sixty.[30] From October 1942 onward, Dr. Walter Borchers, the former curator of Stettin's art museum,[31] was placed at the head of a team of experts. The young woman drawing up a list of works leaving the site is his assistant Ursula Heinz, who can be identified thanks to a photograph held in the Archives des Musées nationaux.

Containing a bas-relief, crate no. 852 from the Rothschild collection is being moved. The register kept by the museum's staff indicates that, like the previously encountered crates "KRA 24" and "R 844," this crate left the sequestration on March 31, 1943, for Aubervilliers station, in order to be loaded onto a train heading for the castle of Neuschwanstein in Bavaria, one of the E.R.R.'s main art depots in Germany.[32] In total, thirty-three crates from the Rothschild collection and eighty-one from the Kraemer collection were transferred on the day in question.

Along with the next image, then, this photograph was taken on the same day as the eight others showing the activities of E.R.R. that we have already seen (nos. 6–9 and 13–16), taken in the Louvre courtyard and the sidings at Aubervilliers, respectively. Together, these images make up a coherent piece of photographic reportage that clearly shows the E.R.R. at work. They have only become separated within the album because of the taxonomic concerns of the staff of the Munich Central Collecting Point.

This picture was reproduced by Cécile Desprairies in her guide to *Paris dans la Collaboration*.[33] It is captioned as follows: "propaganda document produced by the department for the protection of works of art (Kunstschutz) in 1942." It is thus used, quite correctly, to illustrate the occupation of the Louvre by the Germans and the use of the museum in the looting of works of art. However, the author not only attributes a specific function to the photograph that is, as we shall see, somewhat debatable, but she also gives a date (1942) that is clearly incorrect.

29. I would like to thank Dimitri Salmon for his invaluable assistance in the process of identifying these rooms.

30. Polack and Dagen, *Les carnets de Rose Valland.*

31. Now in Poland, before the war Stettin was a German city.

32. AMN, R 32.1, "NOTE concernant les mouvements du séquestre du musée du Louvre" ("NOTE concerning movements in the Louvre sequestration"). On the functioning of the sequestration see R32.2, subfile no. 4, "Note sur les collections séquestrées" ("Note on the sequestered collections"), dated 20 February 1941.

33. Desprairies, *Paris dans la Collaboration* (2009). The shelfmark was given incorrectly as B 323-311 no. 21.

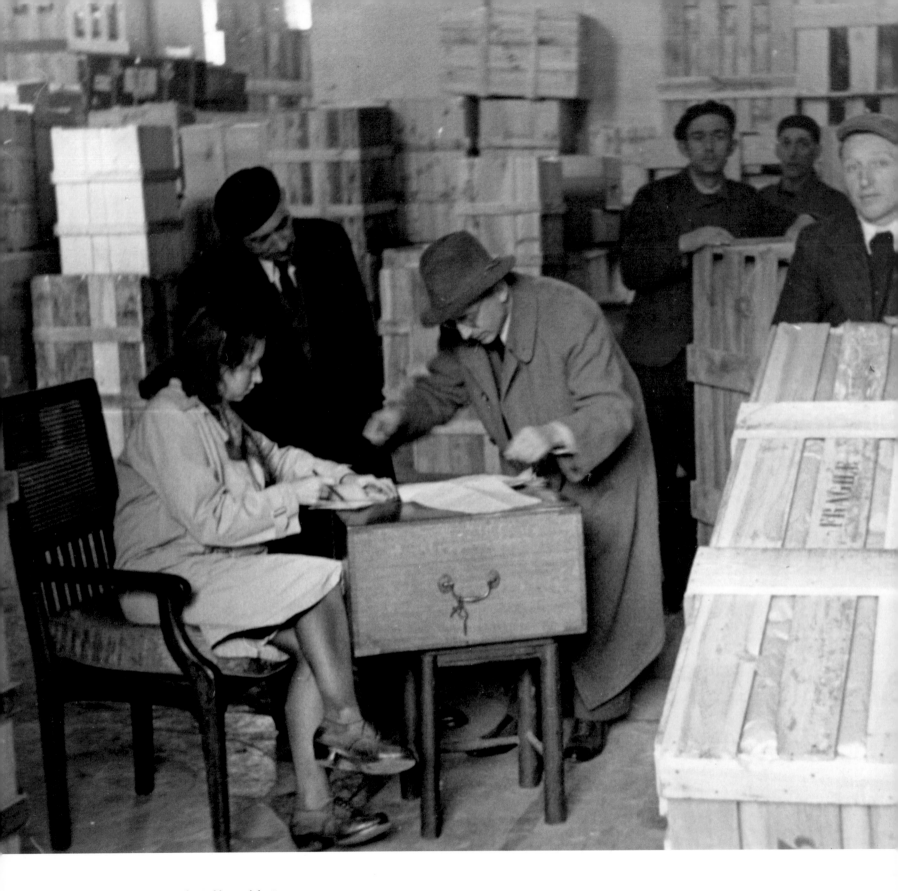

B 323-311 N° 21

Ursula Heinz continues her work. In this picture, the man accompanying her has raised his head, and his features would seem to correspond to those of Borchers. Dr. Helga Eggemann, who after the war would bring the photographs now in this album to the attention of the restitution teams of the Munich Collection Point, also worked under Borchers's command. The German staff of the E.R.R. spent most of their time drawing up and modifying inventories. When works arrived at the Jeu de Paume, lists were drawn up "with the name of the artist, the title of the work or its description, dimensions and a number placing it in order on the list. Works' owners were designated by their initials (Ka for Kann, R for Rothschild, PR for Paul Rosenberg).... Once they had been processed, the objects were sent on to the Louvre to be prepared for shipping."[34]

This photograph has already been reproduced in Götz Aly's *Hitler's Beneficiaries,* alongside five other images from the album. The possessions shown in all six images are referred to collectively as having been "sorted through by Jewish forced laborers in Paris, then collected and prepared for transport to German cities bombed by the Allies."[35] Yet the crates marked "KRA" and "R" were never intended for the population of the Reich, and no Jewish detainees were ever involved in handling the E.R.R.'s loot. Nor, more specifically, were any internees ever sent from the Parisian satellite camps of Drancy to work in the German repository in the Louvre. Like Götz Aly in 2006, then, the creators of the album in 1948 do not seem to have realized the exact nature of the contents of the crates visible in this and the previous photograph. They are simply placed in a single category that could be referred to as "crates visible in a photograph taken indoors."

Tellingly, the Koblenz archives in which the album is held have chosen to put both this image and the previous one online to illustrate the looting in Paris. In both cases, the caption provided situates this "processing of looted cultural property in one of the M-Aktion camps (either Austerlitz or Bassano)."[36] It would seem, then, that these images are so at odds with the idea of the careful display of artistic plunder that still dominates the traditional vision of the E.R.R. in the Jeu de Paume that it is hard for the archivists in question to imagine that this type of image, in which art is photographed like any other object, could have been produced in the Louvre.

My aim here is not to point out errors or shortcomings in the work of colleagues but more fundamentally to point out the limits placed on the role of images in our contemporary evocations of the past. In some ways, then, our desire to see, and to show, seems to prevent us from looking and understanding.

34. Le Masne de Chermont and Sigal-Klagsbald, *A qui appartenaient,* 9–10.

35. Aly, *Hitler's Beneficiaries,* 121. Indeed, as will be seen later, the five other pictures relate to Operation Furniture, even if nothing enables one to say that they were taken in September 1943.

36. For image no. 21, an additional caption reads, "In foreground, a worker moves crate R 852 containing items from the Rothschild family." http://www.errproject.org/jeudepaume/photo/.

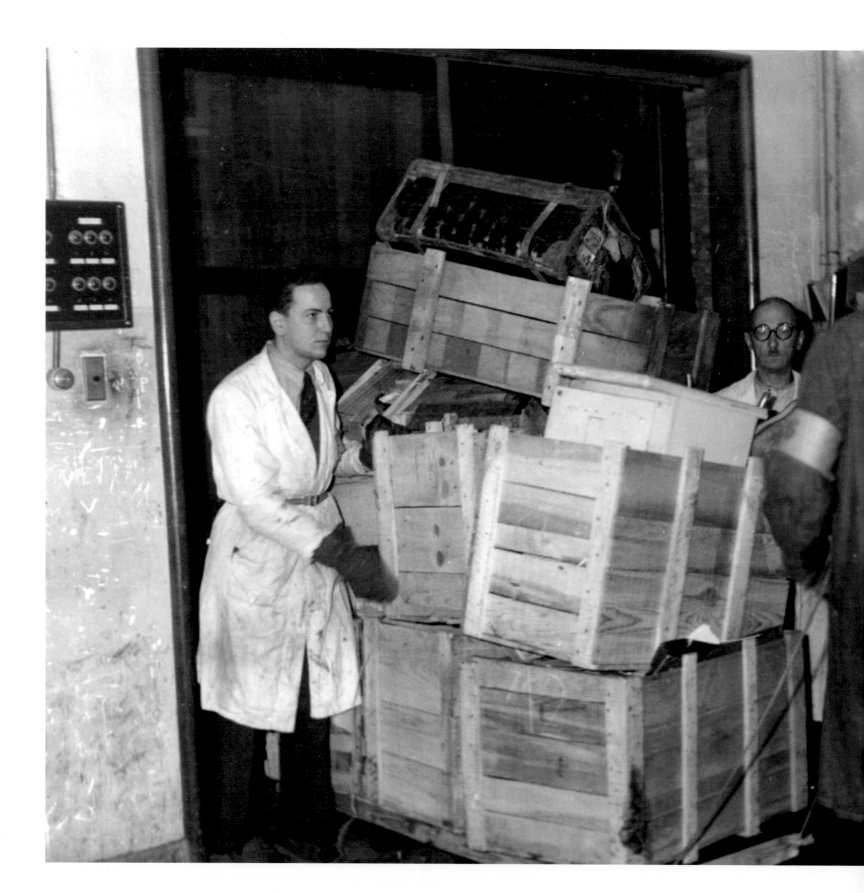

B 323-311 N° 22

This photograph again shows crates being handled. However, unlike the preceding images, this one was indeed taken inside one of the Operation Furniture camps, namely Lévitan, at 85–87 rue du Faubourg-Saint-Martin in the 10th arrondissement of Paris. The capacious goods lift makes it possible to identify this location with absolute certainty, for the main reason this building was chosen by the Germans was that it contained equipment essential for Operation Furniture. Where better than a furniture store to organize and handle the looting of apartments? Here, open crates are shown straight after being unloaded from removal lorries. After this, they would be distributed over the four floors of the building to be sorted. Their contents would be split up and the objects then grouped together by type and placed in new crates that, once full, were sealed and ready to be sent to Germany.

The men visible in this image are internees. An armband bearing a camp number can be seen in the foreground. The internee on the left is wearing a tie. It is quite possible that he had been told to look presentable for the purposes of this photograph. However, the fact that he is shown wearing a tie, along with the relatively smart clothing and hairstyles of the internees seen in most of the other images from Lévitan, is indicative of the highly unusual character of these places of imprisonment. When they arrived at Lévitan on July 18, 1943, the detainees discovered that there were no washing facilities. In spite of these unhygienic conditions, the packages they received from their non-Jewish relatives—who also washed their clothes outside the camp—supplemented by items taken surreptitiously from crates, meant that internees were able to dress decently and improve their day-to-day existence. Some detainees that I have met have even recounted a memorable dinner, eaten from porcelain dishes, that they managed to organize.

To the right of the image, the shutters are closed. The leadership of the Dienststelle Westen was keen to maintain the utmost secrecy.

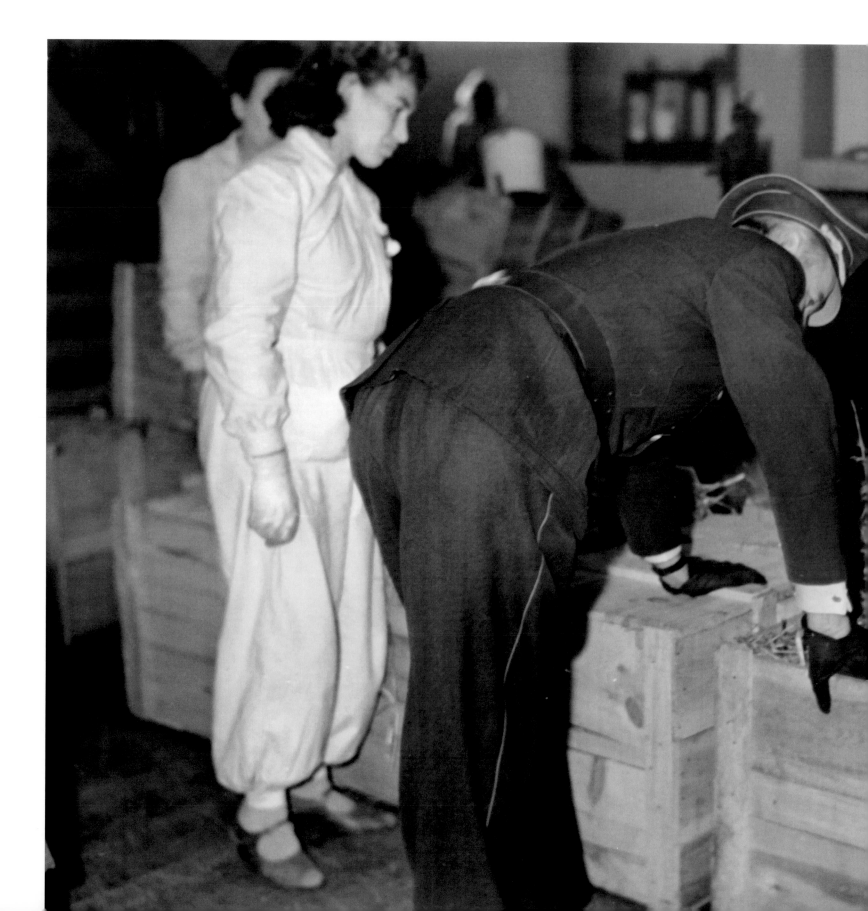

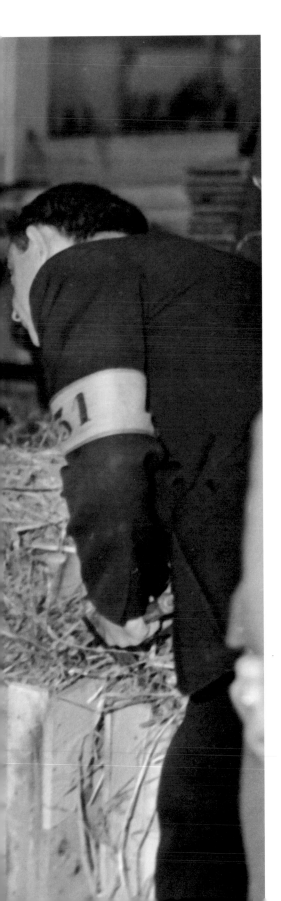

B 323-311 N° 23

The stairs shown in the background are part of the Lévitan building's central staircase. In the foreground, seen from the back, is Colonel Kurt von Behr, head of the Dienststelle Westen and the chief architect of Operation Furniture. He would make regular visits to the various depots, including here on the rue du Faubourg-Saint-Martin. The number of soldiers permanently stationed within the Parisian camps was relatively small. Although the buildings were surrounded by troops from the Vlasov Army, the number of German personnel inside them was kept to a minimum. The threat of deportation was the best way of enforcing discipline without using too much manpower.

Generally speaking, as was the case in Drancy, the day-to-day responsibilities of running the camps and maintaining discipline were given to selected Jewish internees. The posture of the detainee wearing the armband marked "31" suggests that he may have been given this role. He appears to be accompanying Kurt von Behr on his inspection. Roger Hartmann was the first camp chief at Lévitan. Having been unable to prevent two escapes, however, he was deported to Auschwitz on November 20, 1943, on convoy no. 62. It is not known who replaced him.

Camp no. 31 belonged to André Hanau. At the time of his arrest, he was living in Troyes. He arrived in Drancy on December 9, 1943, with 21 francs on his person. He was transferred to Lévitan four days later. This allows us to give a preliminary date for this photograph of between December 1943 and August 1944.

On the left of the image, an internee is wearing a work overall on which one can just make out a yellow star. While uniforms of this kind were issued to internees, they were not systematically worn. It was, however, compulsory to wear them on these visit days, as Gilberte Jacob, a former internee of Austerlitz, a camp not shown in any of the images in the album, would describe in her account given after the war: "when a visit from the colonel was announced, we had to quickly go and put on our work uniform."[37]

37. Dépôt Central de la justice militaire, file "Utikal et autres," Gilberte Jacob's testimony, consulted by Jean-Marc Dreyfus.

B 323-311 N° 24

This photograph opens a subsection within the fourth chapter of the album. It still shows crates, but these are no longer being moved. Instead, they are shown grouped and stacked according to the type of objects they contain. To the right of the first pillar, a sign reading "kichen utensils" is visible. It indicates that all the crates in this immense pile contain this category of objects. These crates are thus ready for shipment to Germany, where their contents will be distributed among the civilian population.

The architectural details visible here suggest that this photo was taken in the basement of the Musée d'Art Moderne de la ville de Paris (Paris Municipal Museum of Modern Art), which was directly connected to the basement of the Musée National d'Art Moderne next door on the avenue de Tokyo, where the stolen pianos were kept. Indeed, in September 1943, the management of the municipal museum informed the electricity company of the increased energy consumption resulting from this new use for the building.[38] Yvon Bizardel, the Municipal Museum of Modern Art's chief curator, related this episode in his *Souvenirs*. His account reads like a description of this very photograph: "They used the municipal museum to store heavy crates, whereas the national museum was reserved for furniture. Positioned according to a detailed plan and in order of size, the crates formed regular cubes in between which access corridors were left clear. At the entrance to each corridor, a sign was suspended from the ceiling bearing an enormous letter: A, B, C, etc. Cutting across these corridors at right-angles to form a chessboard-pattern were narrower passageways clearly marked with numbers: 1, 2, 3, 4, etc. On the labels pinned to each crate could be read: "Lace curtains . . . Lined curtains . . . Pillows . . . Sheets . . ."[39]. In the foreground, attached to the pillar, is a small sign with an arrow pointing in the direction of the "Büro" of the Germans in charge of this depot.

38. Letter of 14 September 1943 from the French Inspector General of Fine Arts, document supplied by François Michaud, curator of the museum.

39. Bizardel, *Sous l'occupation*, 148.

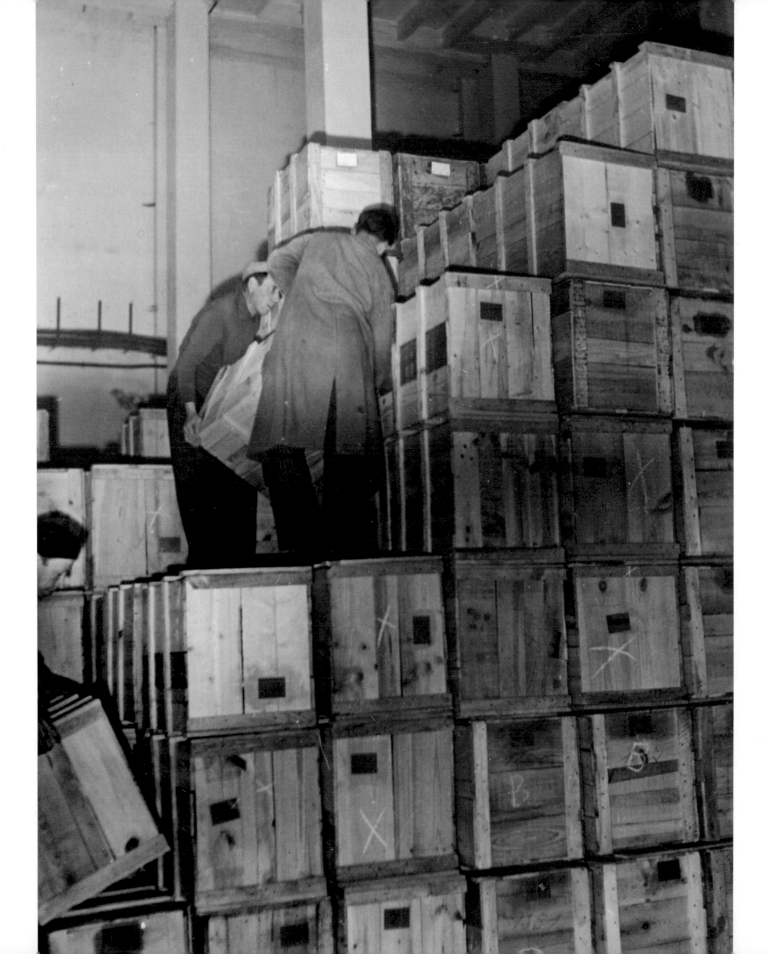

B 323-311 N° 25

Crates being stacked on the premises of the Musée d'Art Moderne de la ville de Paris. Invoices sent out by the Department for Jewish Requisitions and Removals of COEDGM show that the depot on the avenue de Tokyo was indeed one of the main sites to which lorries were dispatched. For the months of February and March 1943 alone, the bill for transporting items just from this one site came to no less than 75,225,760 francs.[40]

40. AN, Z/6/292, dossier no. 8712, case brought by the civil courts of the Seine region, invoice check, 5 April 1943.

B 323-311 N° 26

Back in the Louvre. When it was first opened in October 1940, the sequestration only consisted of three rooms, but this figure would later rise to six. The vaulted ceilings visible in the background show that this photograph was taken in the sixth room, looking back into the fifth. These are now rooms 10 and 11 of the west wing of the pavillon Sully.

Witnessing the Robbing of the Jews

B 323-311 N° 27

The pattern on the floor indicates that this photograph shows the same room as that seen in the previous image but from a different angle. On several occasions between 1940 and 1944, Jacques Jaujard would attempt to reclaim the rooms belonging to the Department of Oriental Antiquities.[41] With the increasing scale of the looting, however, he was faced with constant requests for ever-greater amounts of space.[42] He would find it hard enough to limit the number of rooms in German hands to six.[43]

41. AMN, R2B 18, "Demande de libération des cinq salles du Rez de Chaussée de la Cour carrée" ("Request that five rooms on the ground floor of the Cour Carrée be made available").

42. AMN, R2 C, correspondence between the directorate of the Musées nationaux and the Kunstschutz, letter dated 22 November 1940.

43. The building used by the Commissariat Général aux Questions Juives, 1 place des Petits Pères in Paris, also housed many artworks taken from Jewish collections. Some were still there at the time of the Liberation. See AMN, R 20.2.3, fonds Bouchot Sauppique, Information Bulletin no. 11, from the Department of Studies in Culture to the general directorate of study and research, 15 March 1945.

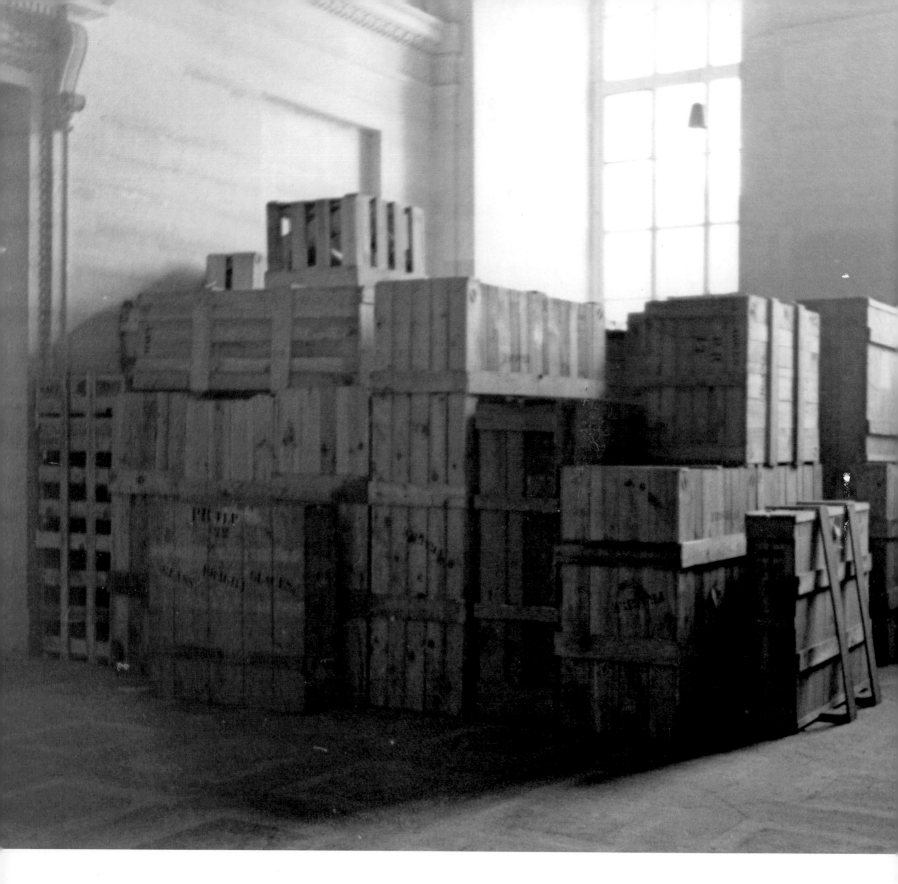

Witnessing the Robbing of the Jews

B 323-311 N° 28

The room shown here is one of the original three used for the repository. Again, the pattern on the floor and the plaster mouldings on the walls allow it to be positively identified. The stamp "PR 14" on the small crate on the right designates this as piece no. 14 of Paul Rosenberg's collection. This consisted of "mirrors." Elsewhere in the image, crates "PR 12" and "PR 22," containing "frames" and "table mirrors," respectively, are visible. This photograph shows a relatively cluttered space. By October 26, 1940, just twenty days after being opened, the Louvre repository would already contain 105 crates and 370 paintings, pieces of furniture, and other assorted objects.[44]

Given the patchy nature of what registers still exist, as well as the countless underhand deals involving these objects—which were used both to feed the Parisian art market and enrich the personal collections of Nazi grandees—it is difficult to determine the exact number of pieces of furniture, paintings, and sculptures that passed through the Louvre repository. It is, however, possible to establish an approximate figure for the plunder amassed by the E.R.R. Between April 1941 and July 1944, this organization would send 4,174 crates to Germany, equating to a total of about 22,000 individual pieces.[45]

44. AMN, R 20.2.3, fonds Bouchot-Saupique, note dated 21 February 1941, directorate of the Musées nationaux.

45. Le Masne de Chermont and Sigal-Klagsbald, *A qui appartenaient*, 10.

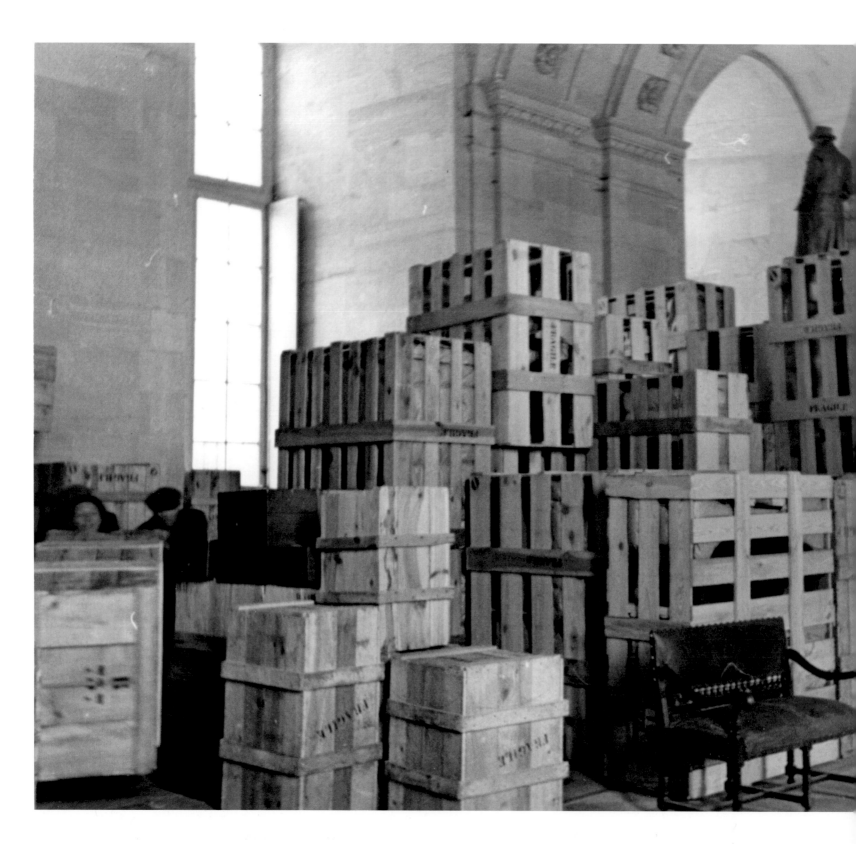

Witnessing the Robbing of the Jews

B 323-311 N° 29

Back in the main room of the sequestration. Here, on the left of the image, it is the turn of crate "R 737" to be moved. The register kept by the employees of the Louvre mentions that this, like the crates seen in photo no. 20, would also leave the repository on March 31, 1943. This document also states that, prior to this large-scale departure, "at the beginning of March, the rooms making up the sequestration were full of crates piled up on top of each other."[46] These photographs are visible proof of this.

46. AMN, R 32.1, "NOTE concernant les mouvements du séquestre du musée du Louvre."

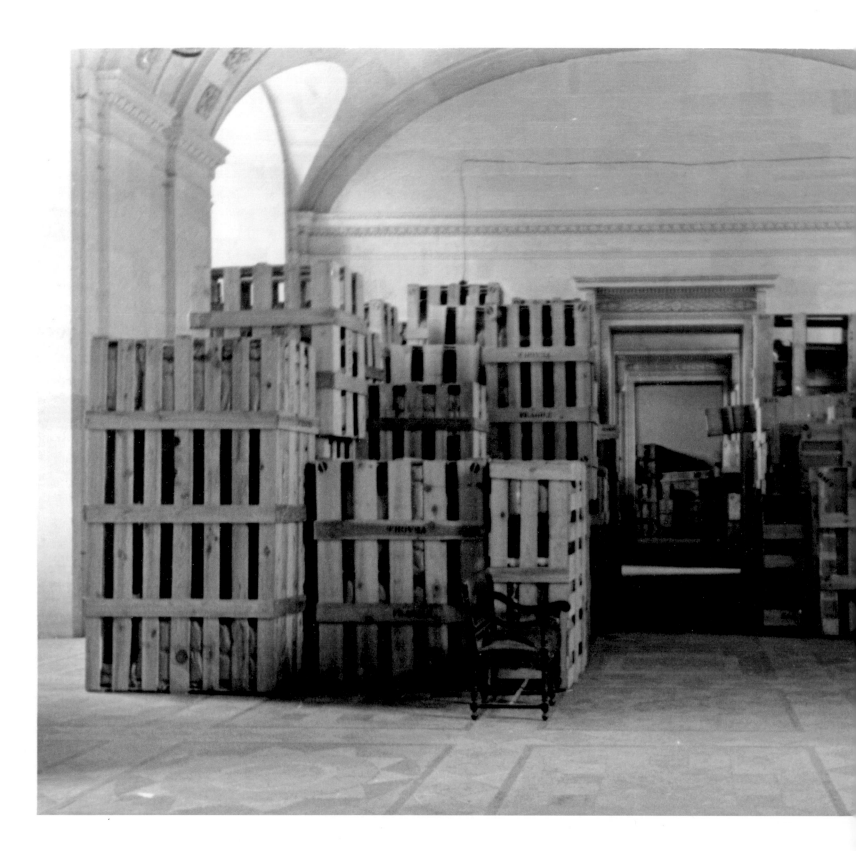

Witnessing the Robbing of the Jews

B 323-311 N° 30

The same room in the E.R.R.'s repository in the Louvre, seen from a different angle. From this position, we can see down through the series of rooms the repository comprised. Photographs nos. 26–31 thus allow us to reconstitute the layout of the sequestration.

When the capital was liberated, these rooms were piled high with objects. In August 1944, the leadership of the E.R.R. had decided to transfer the collections being held in the Jeu de Paume to the Louvre. In the end, they had to leave the contents of the repository behind when they withdrew from Paris. Sixty crates from the Rothschild collection were still there in January 1946.[47] These six rooms belonging to the Department of Oriental Antiquities would not be reopened to the public until June 27, 1947.[48]

47. AMN, B2 Administration, letter from the head of security staff to the director of the museum dated 12 January 1946.

48. AMN, B1 Antiquités orientales, "Organisation: 1881–1958."

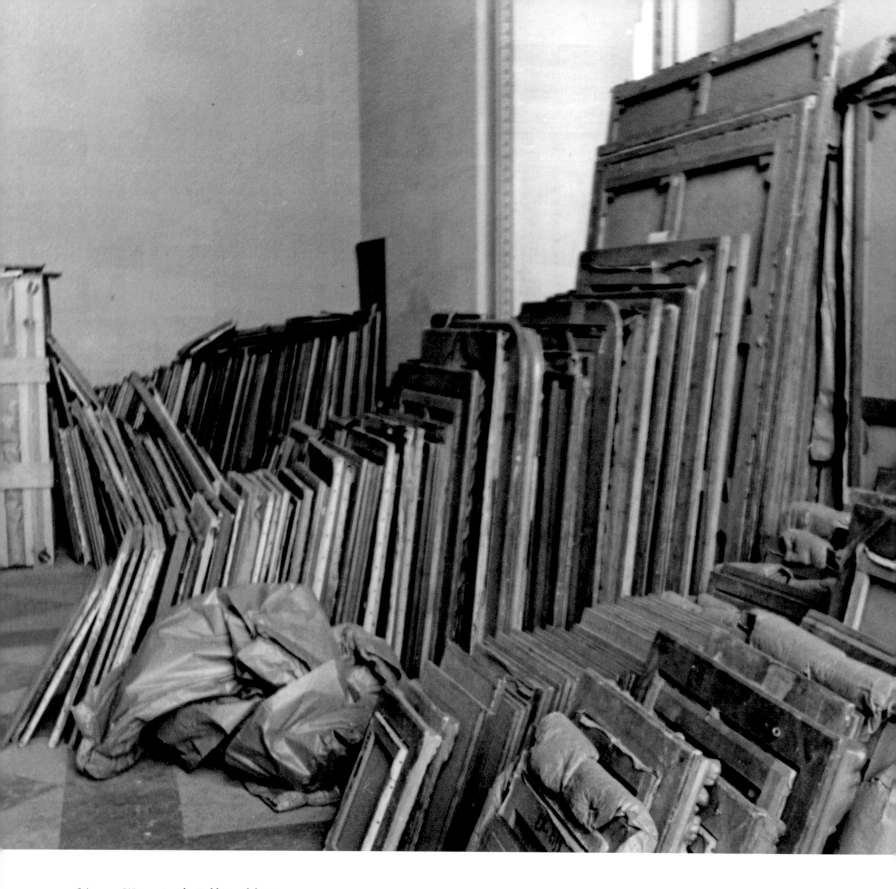

B 323-311 N° 31

The checkered marble floor marks this out as the small room situated to the left of the Louvre sequestration's main room. About 170 paintings are visible in this image. Some are still in their frames, while others, perhaps in order to facilitate their transportation, have had theirs removed. The fact that only the backs of the paintings have been photographed may seem somewhat surprising to the viewer.

This image needs to be viewed alongside the many other pictures taken between 1940 and 1944 by the official photographers of the E.R.R. who had the job of photographing these paintings from the front in order to establish, quite literally, a catalog of the plunder. Readers wishing to see the front of some of the paintings looted by the Nazis should refer to Hector Feliciano's book *The Lost Museum* (1998) or the catalog accompanying the exhibition À qui appartenaient ces tableaux? (Who did these paintings belong to?) (2008).

Inventory numbers are clearly written on the wooden stretchers. These numbers were assigned by the art historians who processed these collections on their arrival at the Jeu de Paume and presumably allowed the painting in question to be identified. However, it has not been possible to find any record of them in the archives of the E.R.R.

It would also seem that a fair number of paintings were not placed on this inventory. What were these? On June 15, 1944, Rose Valland noted in her diary: "Fifty-seven modern paintings with no inventory marks have been brought back from the Louvre depot [to the Jeu de Paume]. These are works of high quality including Braques, Picassos etc. . . . Borchers is astounded that these paintings have not been recorded on the inventory and wants to have them packed up as they are, without labelling them. Are these some of the 67 paintings reported as missing from the Louvre sequestration? Quite possibly . . . But why weren't they recorded as they should have have been before being transported to the Louvre?"[49]

49. Polack and Dagen, *Les carnets de Rose Valland*.

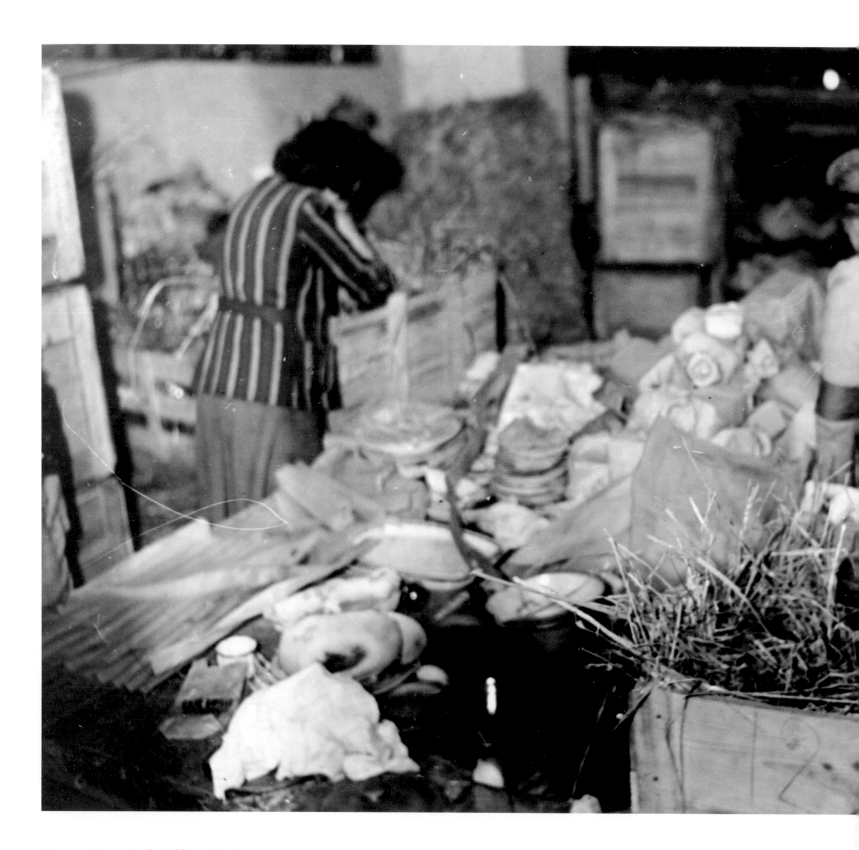

B 323-311 N° 32

This image opens the final section of what the reader takes to be the album's fourth chapter. The crates are still the subject of the photograph but now they are open and workers are busy sorting their contents.

The workers visible in this image are Jewish internees on secondment from Drancy camp to the Lévitan store in Paris. The reader's eye is drawn to the numbered armband on the woman's arm to the right. Here, as is often the case in the album, these women are photographed from behind or with their heads lowered.

Straw is visible in the foreground; once again we see how it constituted the raw material of looting insofar as it allowed the crates to be packed.

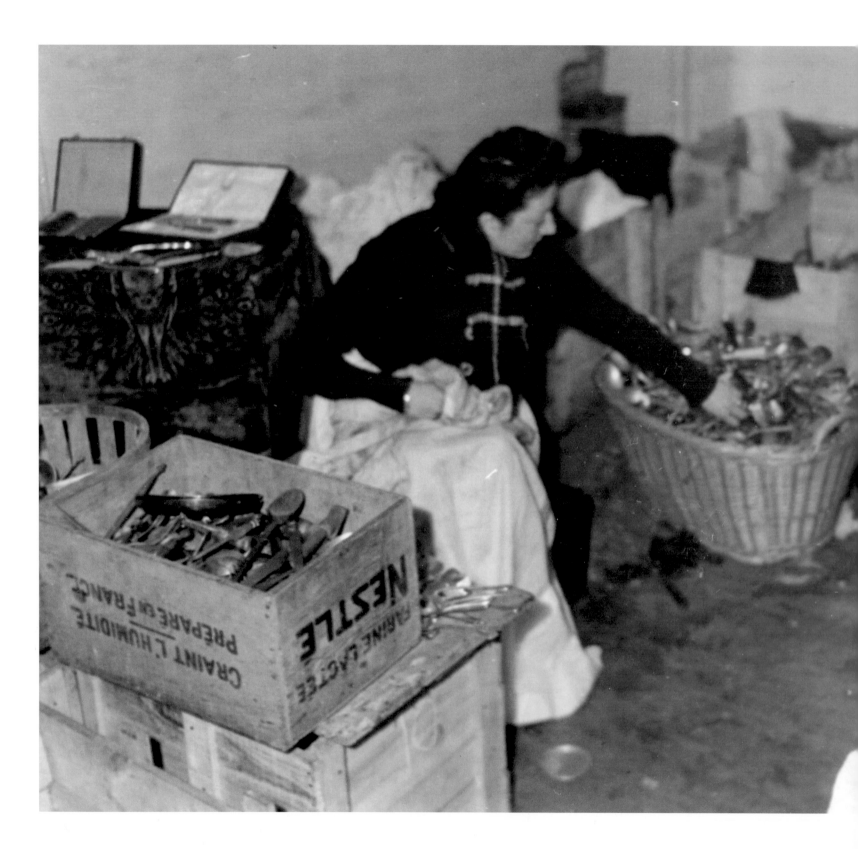

Witnessing the Robbing of the Jews

B 323-311 N° 33

Women sorting cutlery in Lévitan camp. These detainees cannot be identified. As elsewhere, the people appear secondary here.

For my part, however, I am immediately reminded of Odette Dassonville, a former Lévitan internee whom I met in 2002. She told me how for a long time she was assigned to the "cutlery department" of 85–87 rue du Faubourg-Saint-Martin. Her days were spent polishing forks, knives, and spoons.

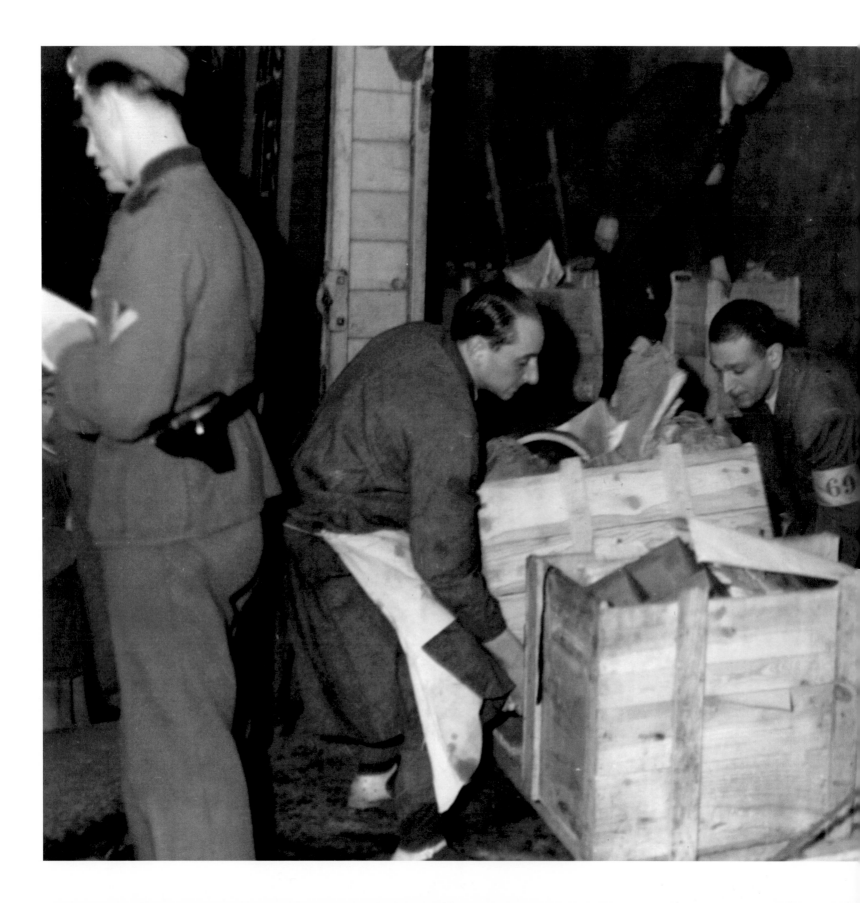

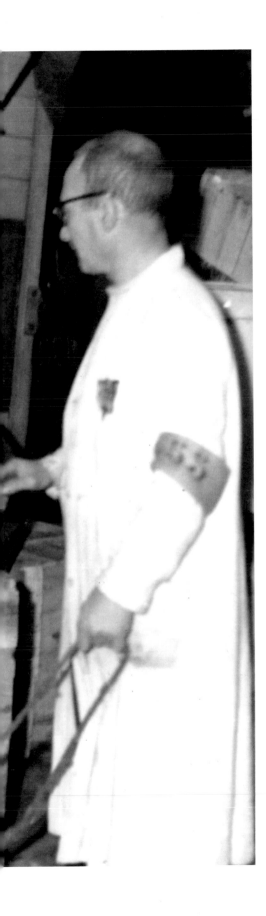

B 323-311 N° 34

This scene would have taken place thousands of times between July 1943 and August 1944. A removal lorry unloads its contents to be sorted and packaged at one of the Operation Furniture camps. On the left is a soldier of the Wehrmacht. The few individuals assigned to the Dienststelle Westen were indeed members of the regular German army. The soldier is holding a piece of paper, most likely an inventory like those drawn up for every Jewish apartment that was emptied. When the Dienststelle Westen learned that a property was vacant, in most cases through the *préfecture* or the Commissariat général aux questions juives, a team was sent to the location. They would draw up a summary inventory, then requisition a removal firm to take possession of what was listed.

This official operation, however, did not prevent corruption. In his recent autobiography, the painter Gérard Garouste explains how his father, a furniture dealer, "filled his stores" thanks to the trafficking of "Jewish apartments."[50] The case file of the action taken by the civil courts of the Seine region against COEDGM's management concludes that "Jewish removal jobs were sought after by the firms because they had developed the habit, along with the Germans who monitored their work, of selling off some of the furniture in question and sharing the profits."[51]

Here, crates are again the subject of the photograph, but, unlike in the previous image, we are able to identify one of the men and thus determine the location. Three of the men wear numbered armbands. These are detainees, as too, in all likelihood, is the man with the apron whose left arm is hidden. The regulation yellow star is clearly visible here.

It has not been possible to trace the wearer of the number "53." However, the number "69" was assigned successively to two inmates of the Parisian camps: Madeleine Rentz and Jacques Gali-papa. It is the latter who appears in this photograph. He had only one assignment in the capital: Lévitan camp, where this picture was taken. Born in 1883 in Constantinople, in 1940 he was living at 4 rue de Palestine in the 19th arrondissement. The father of two children, he was married to a non-Jew, which allowed him to be transferred to Paris. He arrived at Drancy on June 18, 1943, one month before the opening of the camp at Lévitan. Consequently, his presence in the photograph does not allow us to determine the date.

50. Garouste and Perrignon, *L'intranquille*, 21.

51. AN, Z/6/292, dossier no. 8712, case brought by the civil courts of the Seine region.

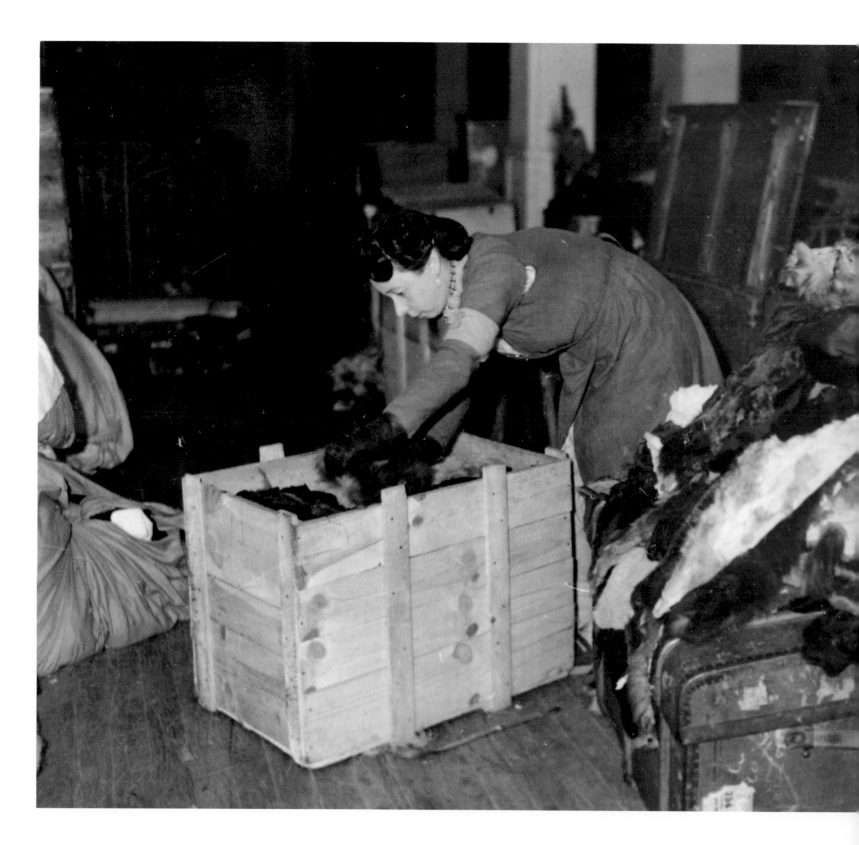

B 323-311 N° 35

The wrought-iron balcony visible to the right of the image allows us to identify this as showing the furniture store Lévitan. Although the building's interior has been completely redesigned today, several of the shop's catalogs show pictures of the building and its various floors as they appeared in 1939. This distinctive ironwork can be seen in these images.

An internee places furs in a crate. Most photographs taken inside Lévitan depict women. In these places of internment, the division of labor was gendered. The task of sorting crates and cleaning went to women, while men were responsible for loading and handling furniture. This organization of their work explains why a large proportion of women, mostly wives of Jewish prisoners of war, were held at Lévitan, which mainly dealt with housewares, whereas furniture was usually handled at 43 quai de la Gare, at Austerlitz.

It is important to note the care that these women have taken over their appearance, with their hairstyles and delicate earrings.

Of course, because of their special status, some inmates of the Parisian camps could benefit from resources, including clothing, that were not available to those who remained interned at Drancy. It is also conceivable that the camp authorities and von Behr's staff requested that the detainees make a good impression for these photographs.

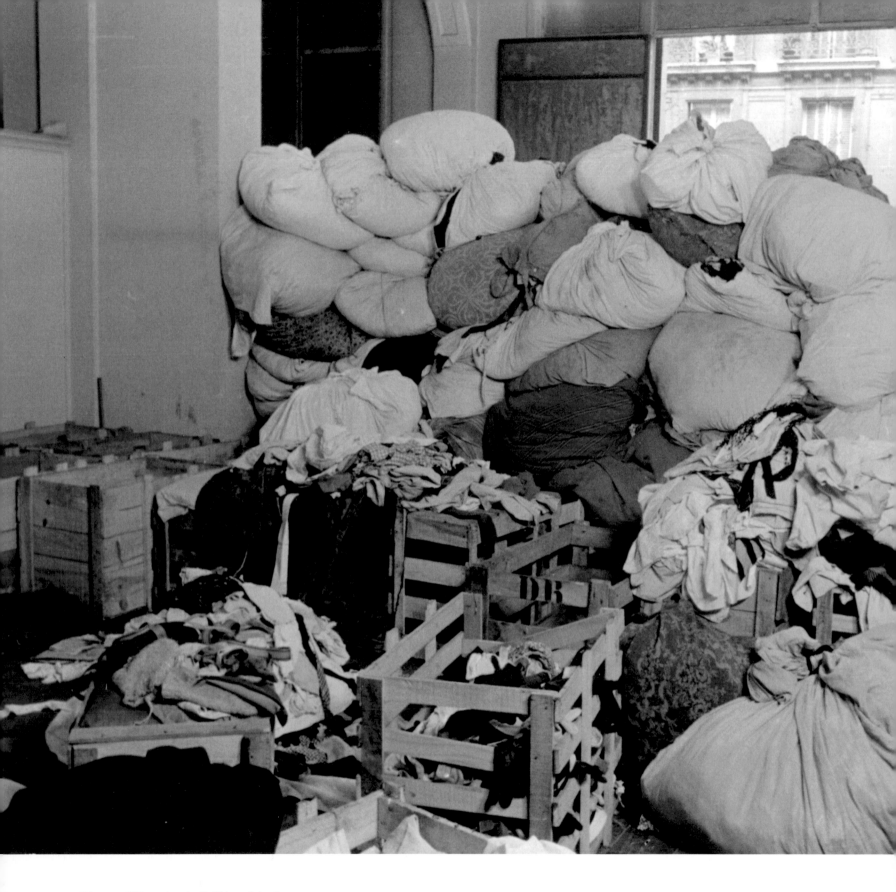

B 323-311 N° 36

This image opens the substantial fifth implicit chapter of the album, consisting of sixteen photographs all devoted to textiles.

The windows are covered with wood and the shutters of the building across the street are closed by order of the Germans. In 2006, while preparing for the exhibition Retour sur les lieux, Michèle Cohen and I passed before this open window several times. One day we were accompanied by Patrick Eveno, a historian and local resident who is also interested in the building's history. He drew our attention to the bullet holes that are visible on the wall directly opposite. A neighbor must have opened his or her windows between July 1943 and August 1944, an act that was strictly forbidden.

In 2003, after posting advertisements around the neighborhood, I met with two women who had lived near the building between 1943 and 1944. They told me that they were aware that Jews had been held there. Located on the upper floors, their apartments gave them a view of the building's terrace where prisoners walked once a day, sometimes wearing their yellow stars. However, these neighbors told me that they never saw what kind of work was actually done behind these walls.

Why then is the window wide open in this picture? This was most likely at the request of the photographer or photographers, as the daylight would have made shooting easier. In this respect, this picture differs from the preceding shots in terms of brightness. It is also possible that the daylight coming through the window may have lit the following two pictures, which show more pronounced contrast than the others. All three pictures certainly depict the same space.

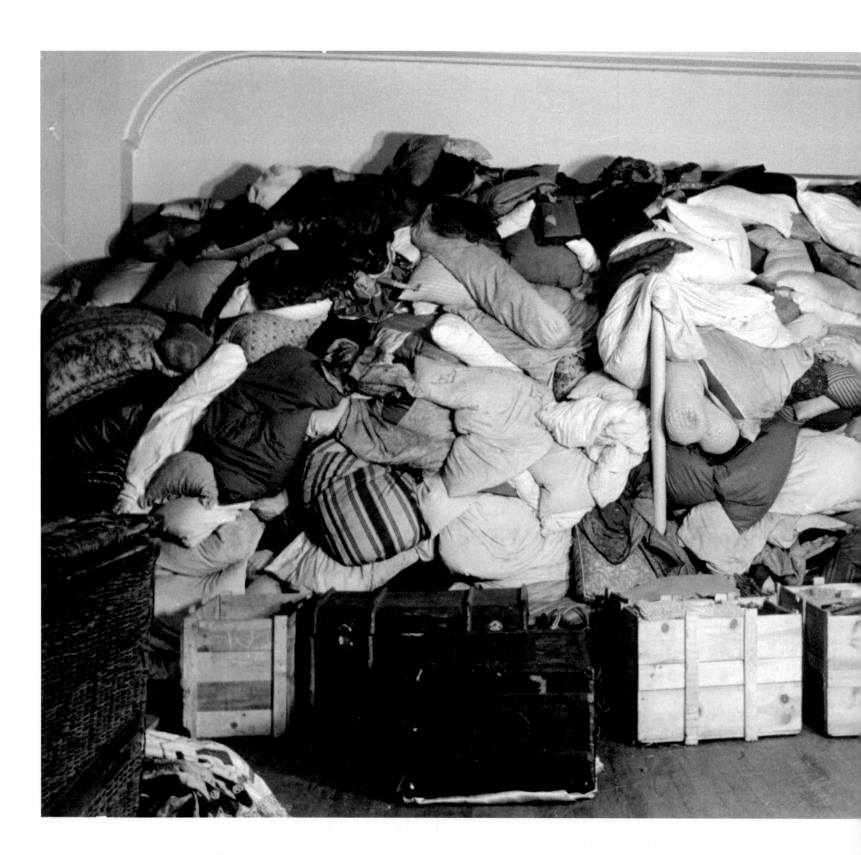

Witnessing the Robbing of the Jews

B 323-311 N° 37

One cannot help but wonder what the photographer's personal view of this photo might have been at the time.

 Due to the contorted shapes created by the eiderdowns, the manner in which they are thrown on top of each other carries painful echoes of the discovery of the concentration camps and the piles of bodies that, through the numerous photographs taken of them, continue to haunt the imagination today.

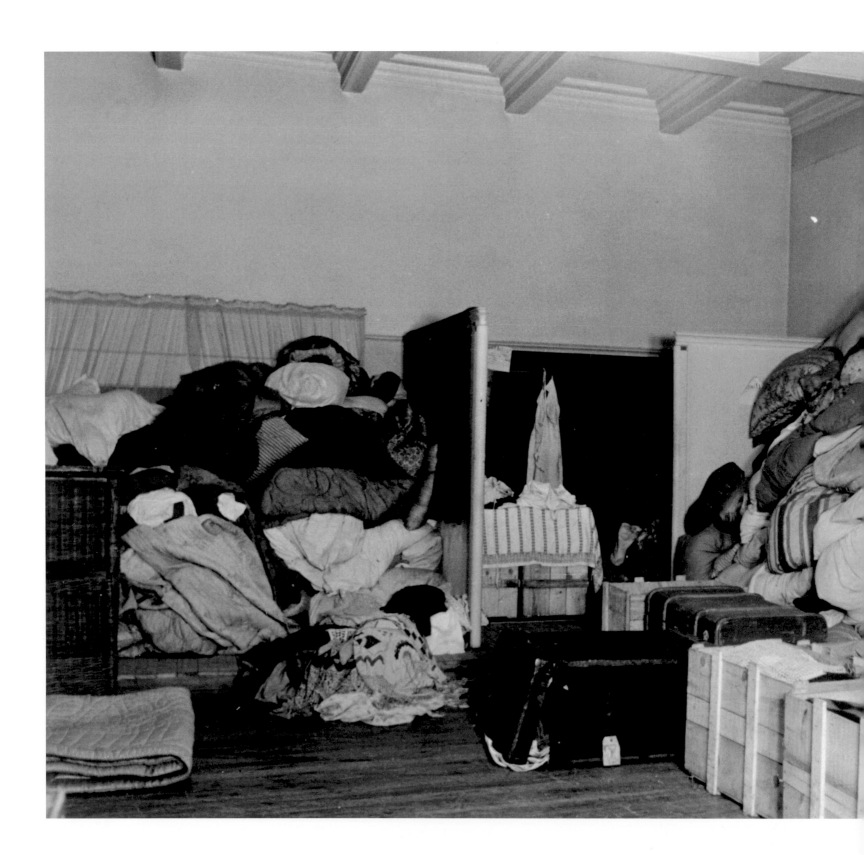

B 323-311 N° 38

More textiles, still at Lévitan.

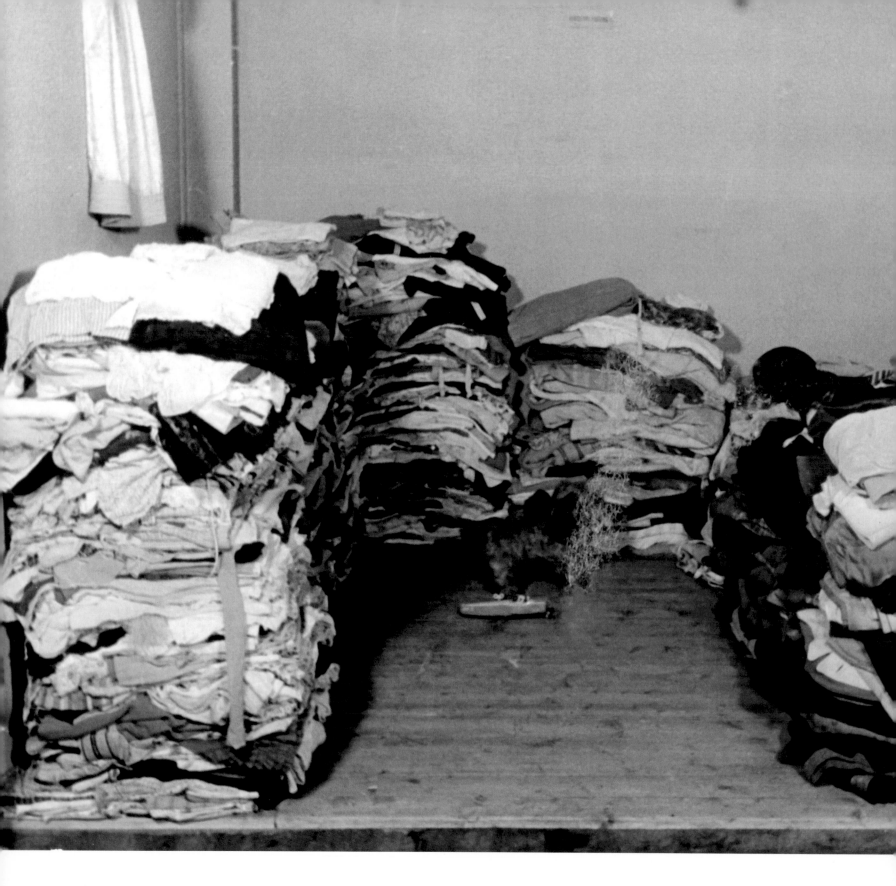

B 323-311 N° 39

Although this photograph also shows fabric items, it is quite different from the previous picture. Here, the textiles are carefully presented. They are placed in one of the display units that the Lévitan store itself would have used, before the war, to show its own merchandise. A label affixed to the wall, illegible here, identifies each of these spaces. This is the first image showing the themed stalls that detainees had to set up for von Behr's visits, visible in several shots at various points in the album.

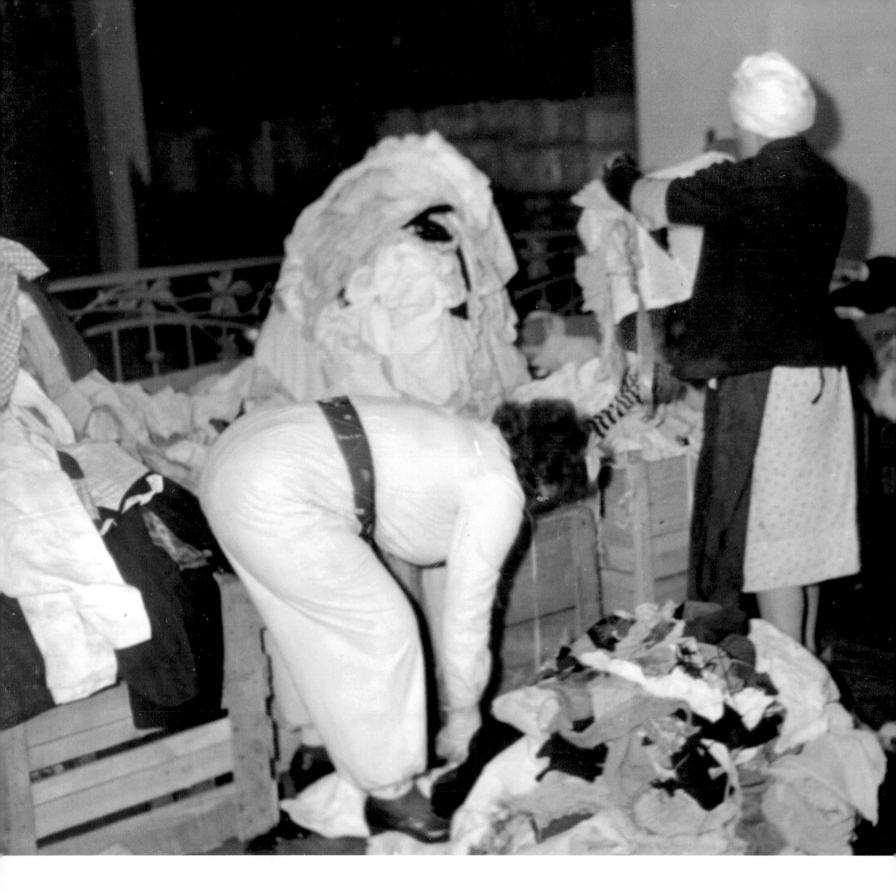

B 323-311 N° 40

Still at Lévitan. The reader will recognize the ironwork in the background.

With heaps of loose clothing and the detainees shown from behind, it seems that the photographer is only interested in the work being done. The Munich Central Collecting Point's staff evidently saw this image as going with the previous one, as it shows the same type of objects. While this is true, this picture seems to represent a quite different perspective on the part of the German photographer.

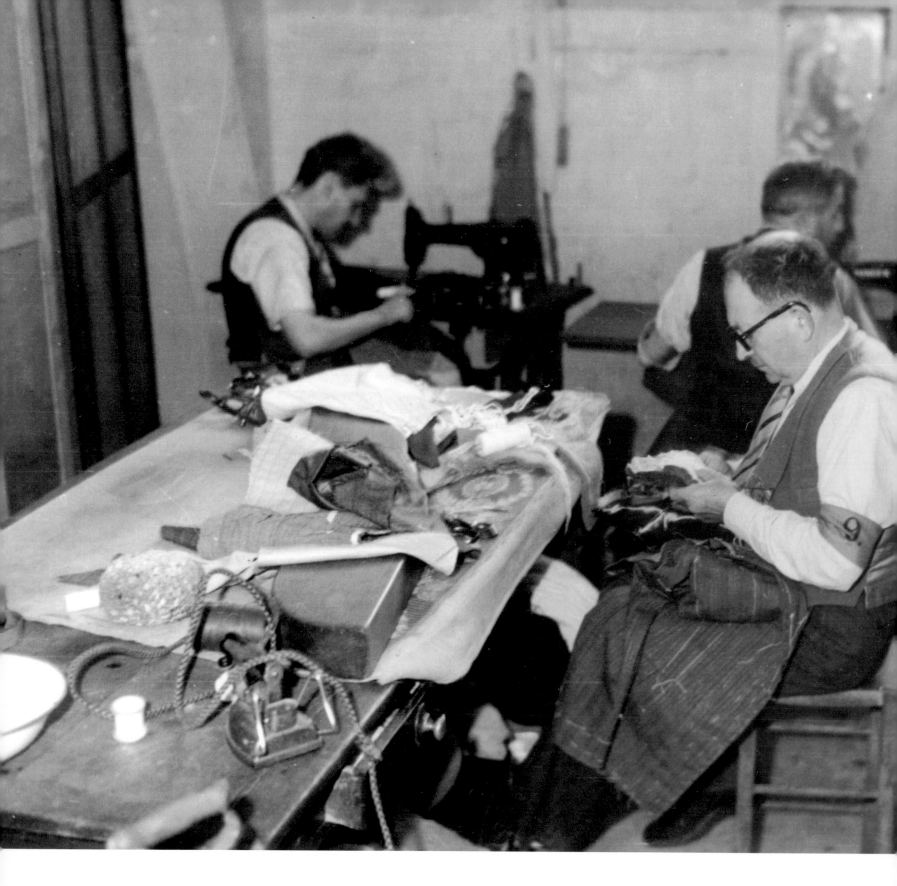

B 323-311 N° 41

Along with the work of sorting, several detainees were forced to put their specialized skills to use. A sewing workshop was first established in Lévitan camp and later in Bassano in March 1944. In the latter camp, clothing was produced in a manner reminiscent of the big fashion houses. This department was made up of twenty-one internees: a "head tailor" and two "head seamstresses" with twelve seamstresses, three tailors, and three ladies' tailors under their command.

The number "9" visible on the armband of the man sitting in the foreground allows us to locate this image. The number belonged to Joachim Monetta. His entry papers at Drancy indicate that he was a tailor by trade and his wife was "Aryan." He was transferred to Lévitan in the first group of internees, on July 18, 1943, where he remained until August 12, 1944, when he was sent back to Drancy before finally being released on the August 18. It is therefore the Lévitan sewing workshop that is shown here. It seems that his particular job ended when the Bassano camp opened in March 1944. Therefore, this photograph was probably taken between July 1943 and March 1944.

Although Joachim Monetta does appear to be making a suit, the reader will note that the jacket hanging in the background is not a product of the workshop but belongs to one of the three prisoners. A yellow star is sewn onto it.

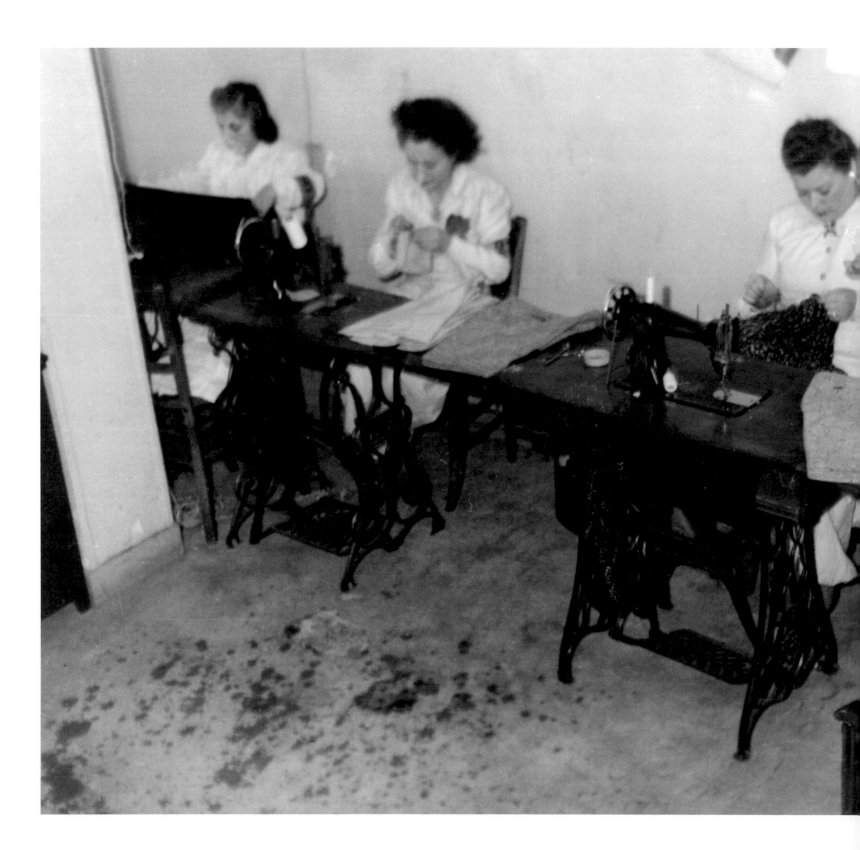

B 323-311 N° 42

On seeing this picture, I immediately thought of Erna Herzberg, whom I met at her home in 2002. A former internee at Lévitan, then Bassano, before being deported from Drancy to Auschwitz by convoy no. 76 on June 30, 1944, she was assigned to Lévitan because of her experience as the head seamstress in a Parisian fashion house, even though she did not possess the racial or marital status normally required for such transfers to the capital.

During our interview, she told me that she was asked to set up and run a sewing workshop upon her arrival at rue du Faubourg-Saint-Martin. With her subordinates, she was supposed to make "little skirts for little German girls."

Only a handful of these skirts were ever made. These were carefully put to one side, and every time von Behr came visiting accompanied by dignitaries they would be brought out to illustrate the general's boasts of sending off "a big crate of little skirts and trousers for the children of the Reich every fortnight." In reality, Erna Herzberg handled the personal orders of von Behr and other Nazi leaders, as well as their wives, girlfriends, and mistresses. She continued to do so after being transferred to Bassano, where she became deputy-chief seamstress.

It is thus the official face of this workshop in the basement of the Lévitan building that the photograph depicts. The staged quality of this photo can also be seen in the internees' wearing of the regulation one-piece suit with yellow star.

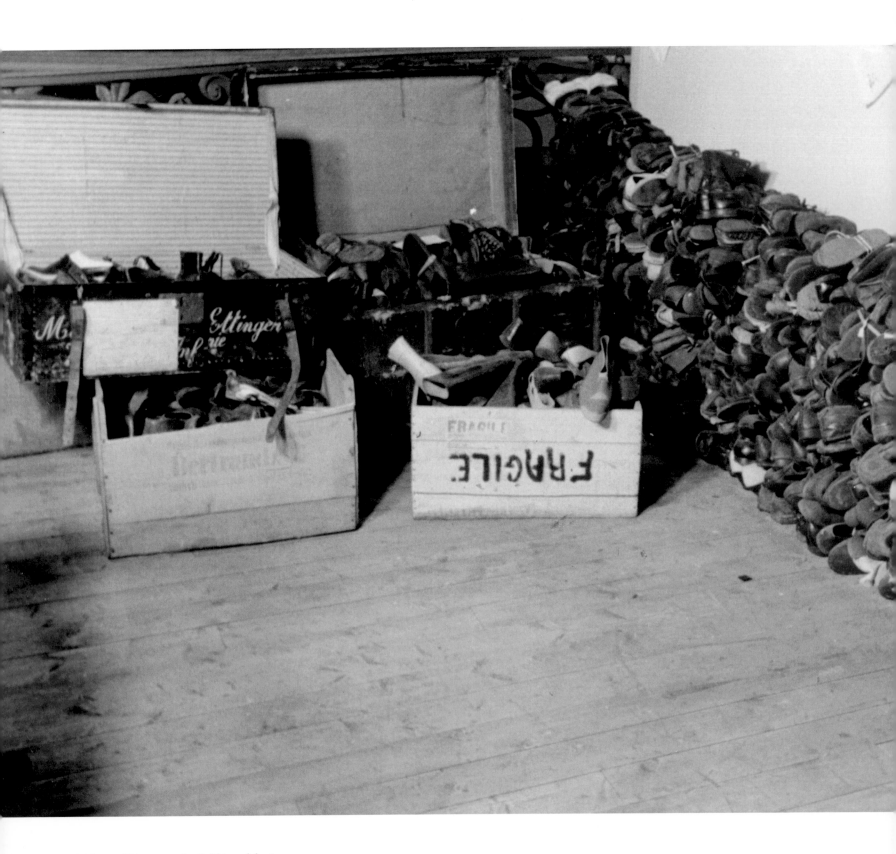

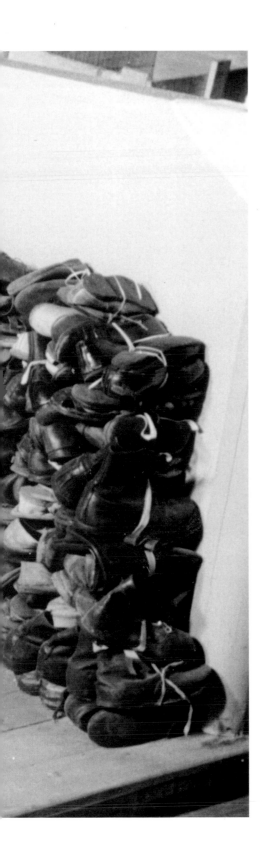

B 323-311 N° 43

This photograph was in all likelihood also taken at Lévitan. Many of the goods seized from apartments were restored before being sent to Germany. Here, the Dienststelle Westen sought to draw upon the expertise of the internees just as they did in the case of fabrication.

A letter dated December 19, 1943, from the camp's chief internee to his contact at the UGIF, shows the existence of a shoe repair workshop working at full stretch, since he requests the following supplies: "2 kg of 8 mm cobblers' nails, 2 kg of 10 mm, 2 kg of 12 mm, 100 men's steel toe pieces, 100 women's steel toe pieces, 100 men's steel heel pieces, 100 women's steel heel pieces. All with fixing-pins. A bottle of special glue for glueing on the pieces. *Bouchou* glue if possible."[52]

Today, these piles of shoes cannot fail to evoke those produced by the "Canada" commando, who sorted the personal objects of deported Jews in the Auschwitz extermination camp; the work of the artist Christian Boltanski also comes to mind.

52. CDJC, UGIF 18-842.

VORHANGE
BEStd. 134 KIStEN
am 20 - 9 - 1943

B 323-311 N° 44

"Curtains. 134 crates."

This photograph is a close-up of a slate attached to one of the stacks of crates in photographs nos. 24 and 25. In photograph no. 24, a similar slate is also legible. The latter refers to "kitchenware" and bears the same date, September 20, 1943, which corresponds to the departure of a convoy for Germany. This photograph was thus taken in the basement of the Musée d'Art Moderne. This photo helps us to date no. 24 to September 1943 as well, but above all it tells us that a train for Operation Furniture left Paris for Germany on September 20. This said, the reader will by now have understood that the date of September 1943 can in no way be taken to apply to all the images in the album.

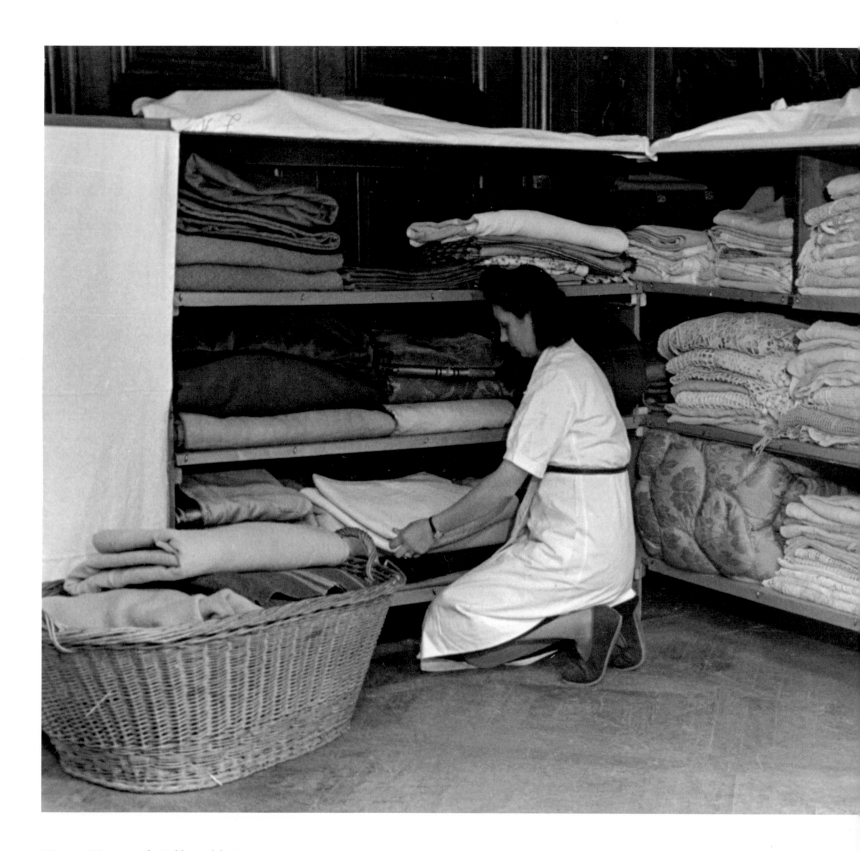

B 323-311 N° 45

Although this image belongs to the same chapter of the album, it shows textiles held on a different site. The wall panelling allows us to identify with certainty where the photograph was taken, for in 2006 the decorative woodwork was still in place. This photograph is the first in the album to show the interior of 2 rue Bassano in the 16th arrondissement of Paris.

The cloth and high-quality fabrics are carefully folded. When valuable items in good condition were found in the crates that arrived at Lévitan in bulk, they were set aside, sometimes to be chosen by von Behr himself during his visits, before being taken to Bassano. Here, the top brass of Operation Furniture would drop in and take what they wanted, either for their personal use or in order to ingratiate themselves with dignitaries of the regime by offering them quality goods.

It is impossible to know whether the woman visible in this photograph is a Jewish inmate or a regular employee, either French or German. Before being used as an internment camp, the building was used as a repository for precious objects. Many archive documents testify to its being used in this way from August 1943 onward. During this period, civilian employees handled the loot, but from March 1944, this work would be done by internees of Drancy. Dated May 8, 1944, an organizational schema for Bassano found in the archives of the UGIF states that Eda Lopert became "attendant of the linen depot." She was an internee in Paris because of her status as the wife of prisoner of war. Like most of the women in the same situation, she was deported in July 1944. After leaving Bassano for Drancy, she went to Bergen-Belsen on convoy no. 80.

Another room at 2 rue Bassano. Again, the mirrors and gilded woodwork seen behind the linen shelf still exist today.

B 323-311 N° 47

The same room at 2 rue Bassano.

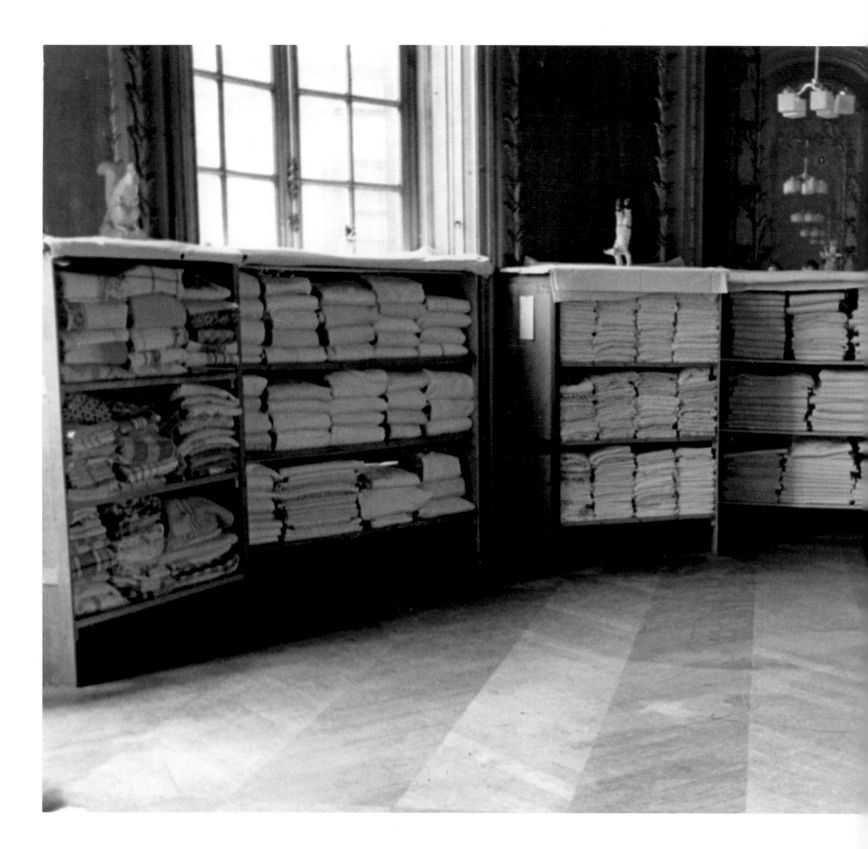

B 323-311 N° 48

Another view of the main room of the linen depot at 2 rue Bassano.

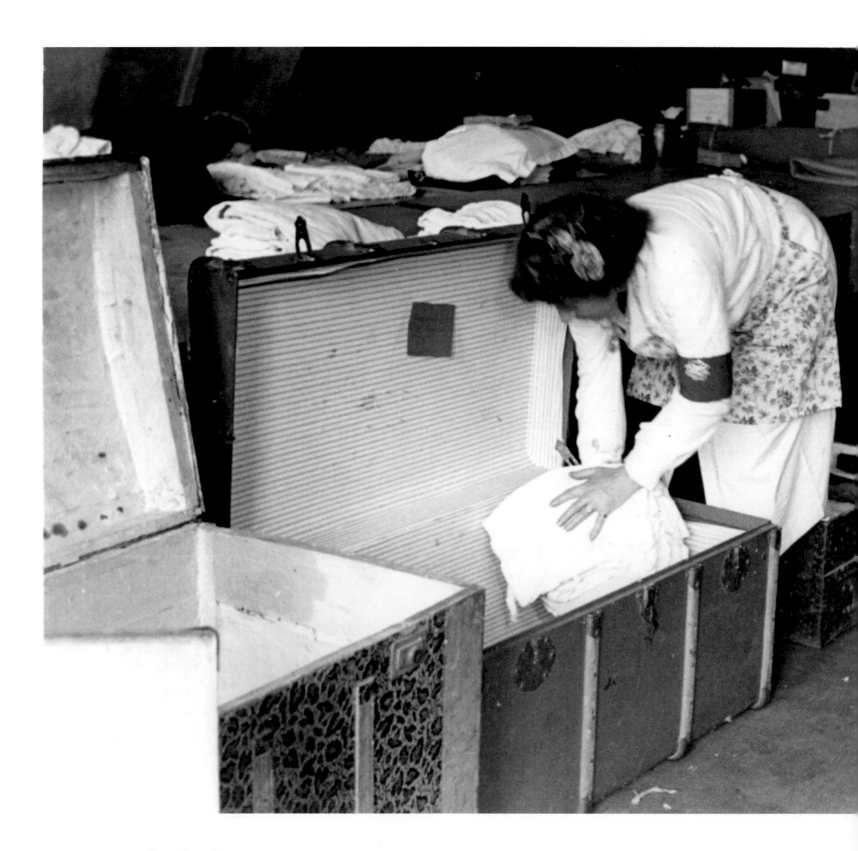

Witnessing the Robbing of the Jews

B 323-311 N° 49

The change of decor and the woman's armband both suggest that this time, the photograph was taken at Lévitan. However, this is impossible to say with any certainty.

This image closes the "Textiles" chapter of the album.

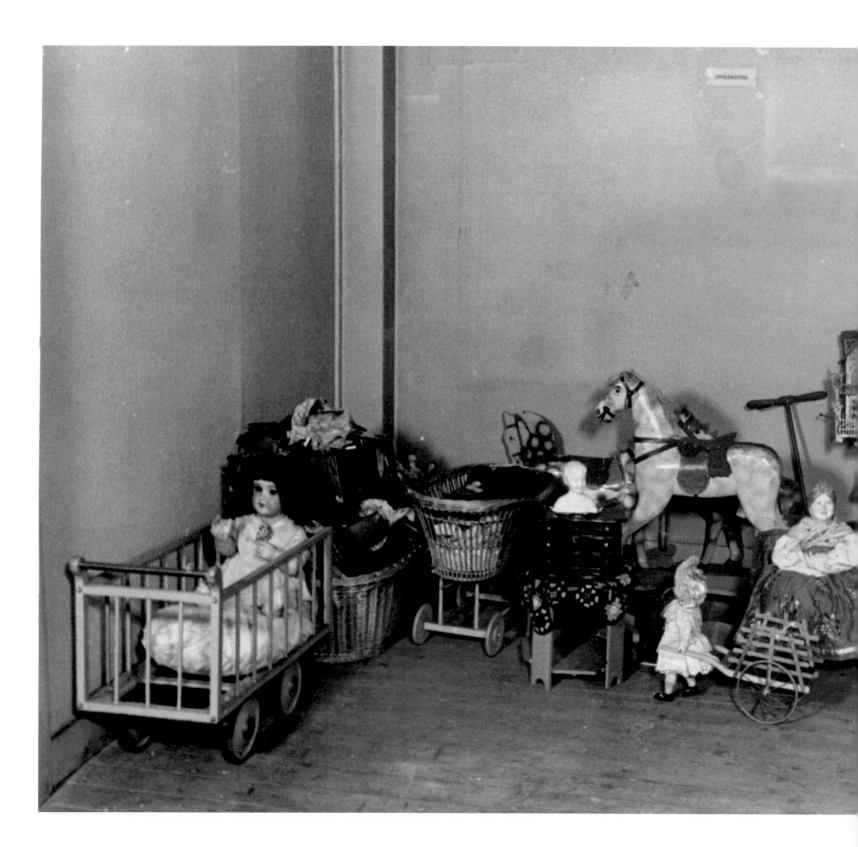

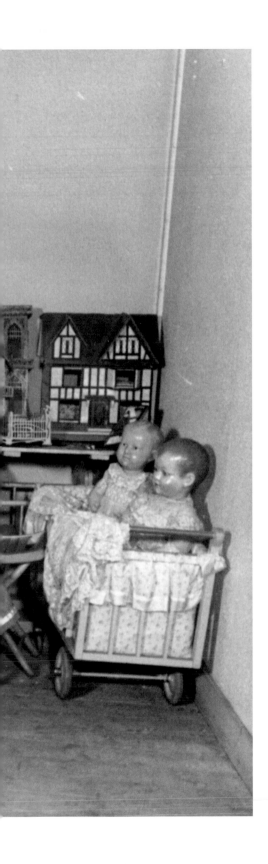

B 323-311 N° 50

This photograph is part of a series that shows thematic stands displaying objects, of which image no. 39 is the first in the album. It opens the brief sixth chapter entitled "Toys," as the label attached to the wall in this picture announces.

This image is of course poignant. When one looks at it today, we see the Jewish children—hidden, deported, or already exterminated—in these dolls and cradles. It is probably this evocative power that prompted Götz Aly to put this picture on the first page of his album of images.

For my part, this picture immediately brought to mind Hélène Grunwald and Samuel Pintel, whom I met in 2002 and 2003. Both were Jewish children during the war, and their experiences were virtually identical. In 1944, their fathers were prisoners of war and their mothers were interned at Lévitan before being deported to Bergen-Belsen in July. The children themselves were hidden to escape arrest. At these Parisian satellites of Drancy, visits were allowed and with relatively little formality. So, this little girl and boy went to visit their respective mothers, despite the fact that there was, of course, some risk involved. Their mothers then discreetly gave them a keepsake. A doll for one, a set of dominoes for the other, toys that the Germans had taken from other Jewish children who were themselves hidden or had already been deported.

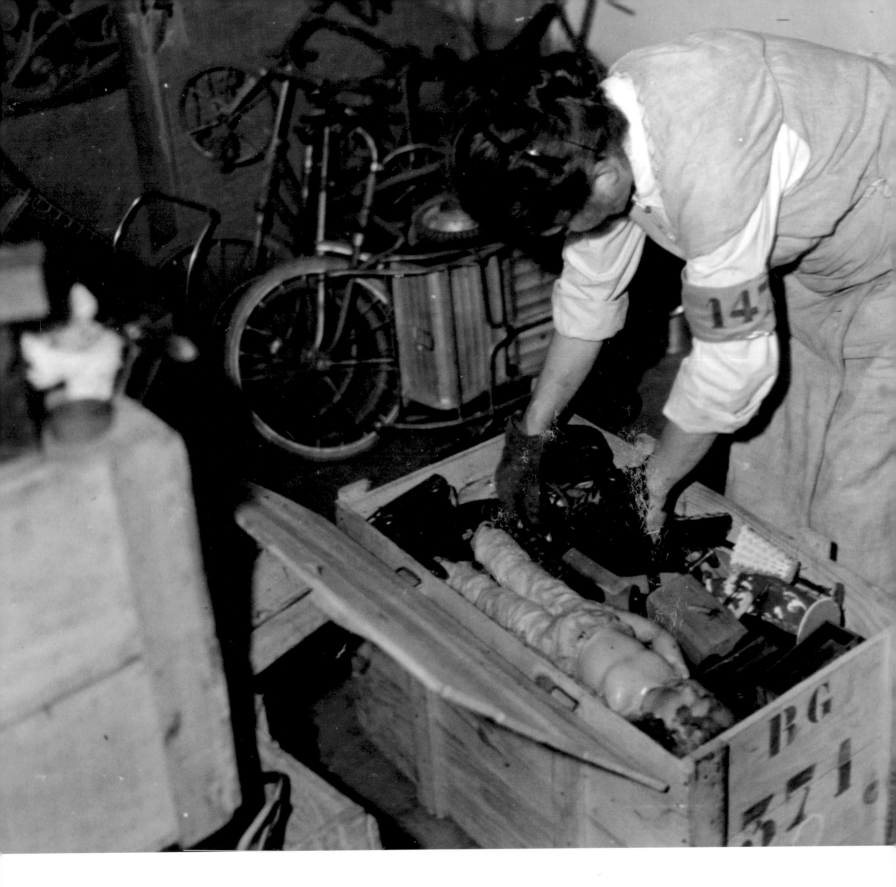

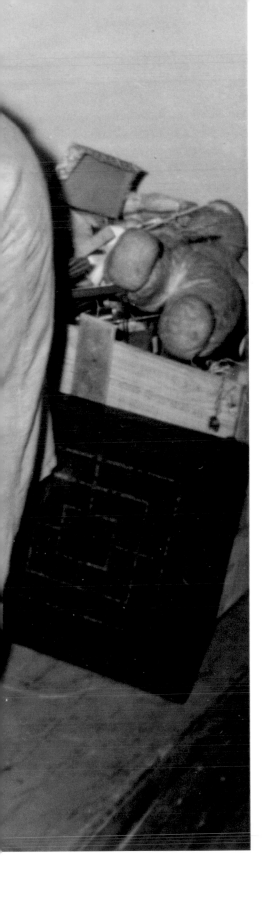

B 323-311 N° 51

Another image of toys. But here the photograph shows the work being done and not the loot. We are not able to identify the person wearing the armband numbered "147" here. Laundry lists kept in the archives of the UGIF clearly indicate that this number was assigned to Jules Botwinick, a male inmate of Austerlitz, who is visibly not the person seen in this photograph. Numbers were, however, assigned in parallel in the various satellite camps, so since there was already a number "147" at Austerlitz, this woman cannot have been held there at the same time. This shot was thus taken at Lévitan, as confirmed by the ironwork visible in the background.

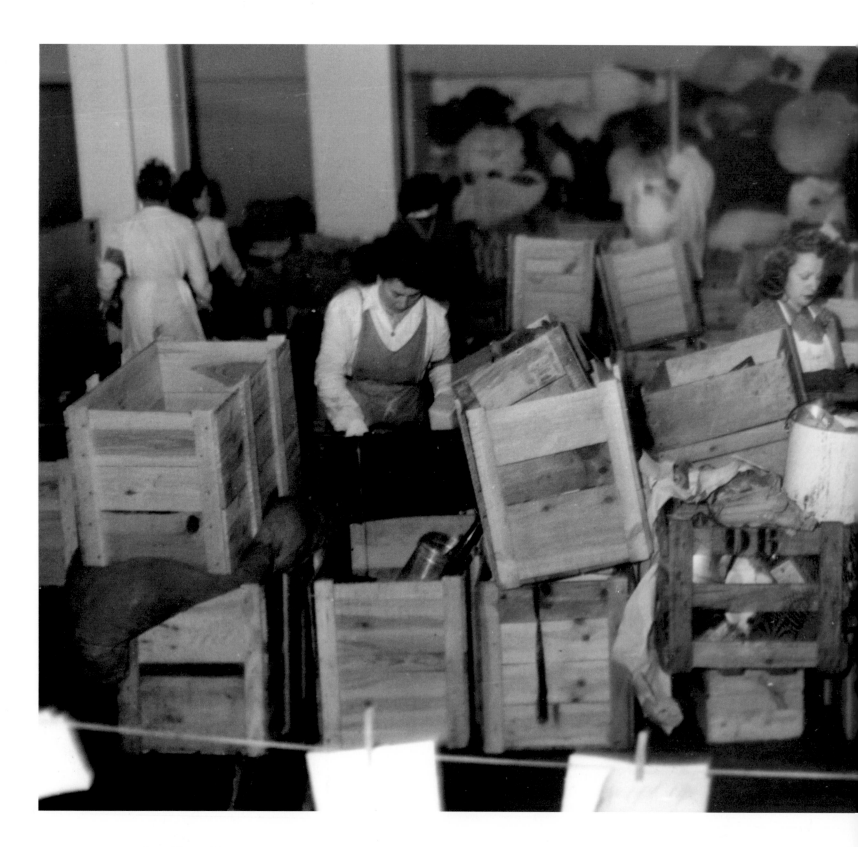

B 323-311 N° 52

Area used for sorting crates at Lévitan.

On first seeing this image, I was again immediately reminded of Odette Dassonville, a former internee at 85–87 rue du Faubourg-Saint-Martin. "The lorries arrived without stopping, in an endless stream. It seemed as though if we did not sort quickly enough, we would be overwhelmed by objects. They would swallow us up."[53]

In a letter to his wife in February 1944, Simon Sarfati, an internee at Austerlitz, describes the inmates' daily existence as "something like life in a barracks." "The work is very tiring. We are carrying crates around non-stop. I'll briefly describe the daily timetable: wake up at six, work from eight until 1:30 PM; lunch then back to work at 3 PM until 7:30 PM."[54]

After the war, one of the former chief internees at Lévitan estimated that 2,400 crates were delivered daily.[55]

53. Interview with Odette Dassonville, 4 November 2002, Orly, France.

54. Private archives kept by Jacqueline Ribot, Simon Sarfati's daughter.

55. Dépôt central de la justice militaire, Le Blanc, Indre, "Dossier Utikal et autres," Georges Kohn's deposition of 6 September 1944, consulted by Jean-Marc Dreyfus.

Witnessing the Robbing of the Jews

B 323-311 N° 53

An internee, pictured as is often the case with her head down, puts together a six-piece tool kit. The photograph was evidently taken in Lévitan, as one of the partitions separating the display compartments inside the furniture store is visible in the foreground to the left. Work in the satellite camps was organized by thematic departments. The former inmates that I interviewed all used the recurrent metaphor of "Galeries Lafayette," an ironic reference to the well-known Parisian department store. At the end of the war, one of the rare historical accounts of this time in the capital was published by Muriel Schatzmann, a former internee, who wryly described her experiences under the title "Galeries Austerlitz 43 quai de la Gare Paris."

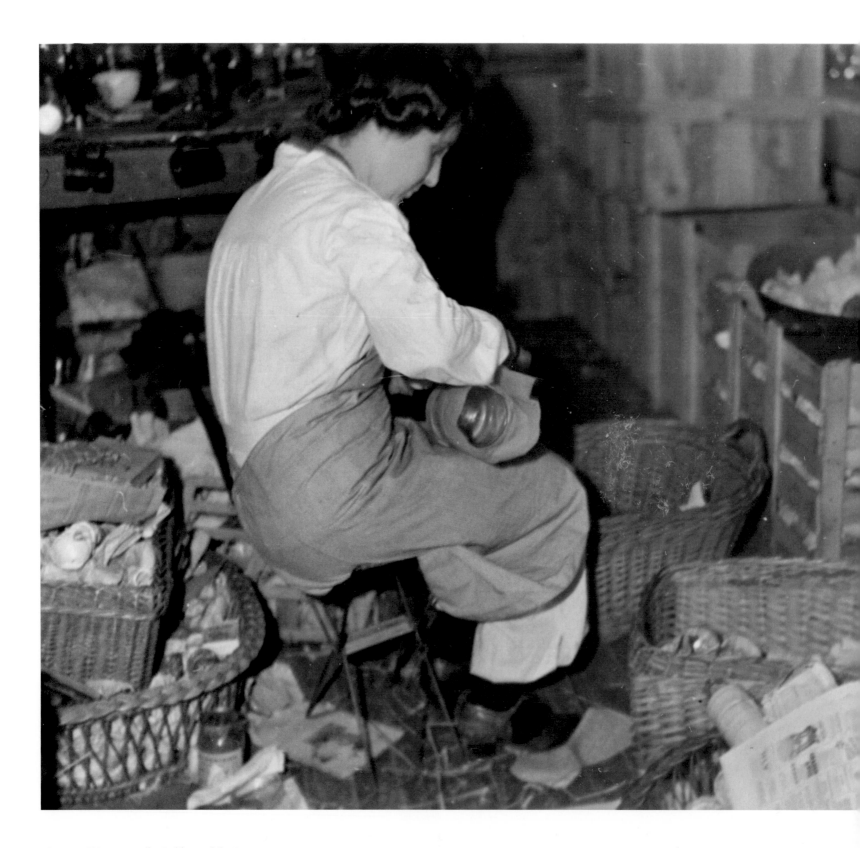

B 323-311 N° 54

This photograph, showing glasses being packed for shipping, opens what may be considered to constitute the eighth chapter of the album. A suitable title for it would be "Kitchenware," and it consists of twelve images.

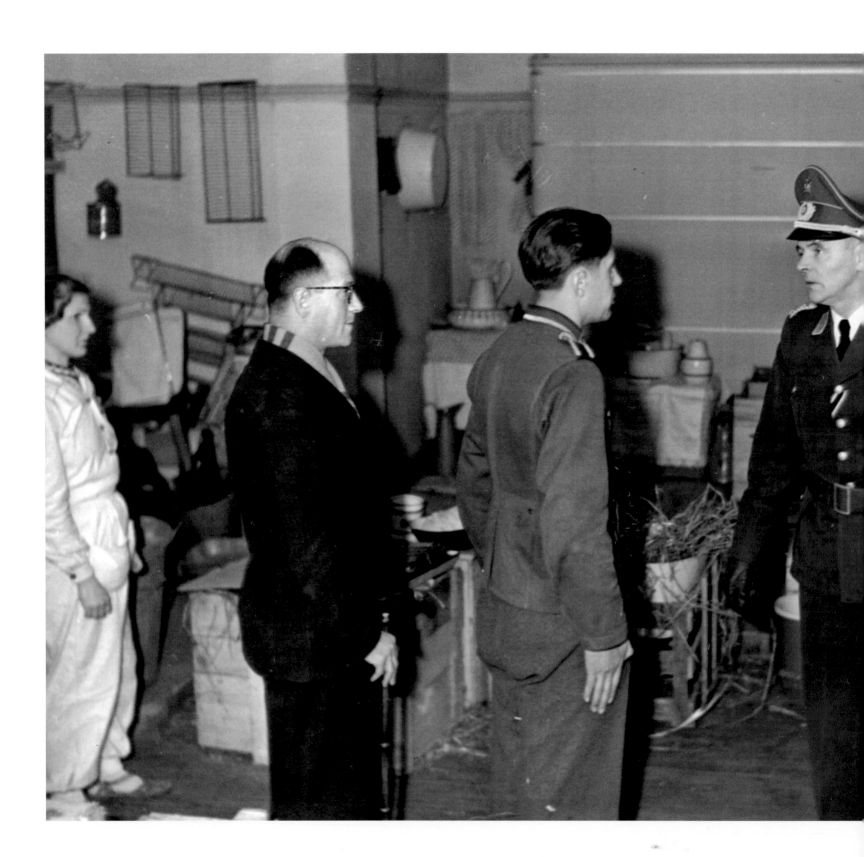

B 323-311 N° 55

Most of the photographs showing von Behr's visit are grouped together in this chapter. For the compilers of this album, it was not the people—even though there were German officers present—but rather the objects on display that governed their classification of these images, in this case the basins and draining boards seen here. For my part, though, the first thing that I thought was, this is one of von Behr's visits. In interviews with former internees, they all spoke of these regular inspections during which the colonel went "shopping" and threatened sanctions for misdemeanors.

Colonel Kurt von Behr is seen here from the front. His uniform proclaims his identity. The cross that can be seen on his chest as well as the one on his cap indicate that he claimed to belong to the German Red Cross.[56] Founded in 1929 as a volunteer medical service, in 1938 it underwent a change in status to become one of the many auxiliary and paramilitary services of the German army. His shoulder pads are the insignia of his rank: *Oberstfeldführer* (colonel). The corps to which von Behr belonged and the incongruous status of all personnel assigned to Operation Furniture attest to the peculiar nature of this looting; for while it was directed from the highest level, it was obviously not in keeping with the official codes and practices of the regular German army.

This is not all the uniform tells us, however. On his chest, just beneath the cross, von Behr wears a decoration for bravery obtained during the First World War, in which he indeed fought and was taken prisoner. Kept in captivity for three years, he had the opportunity to learn French, which partly explains his assignment to Paris, where his position allowed him to foster his megalomania. He continually presented members of Parisian high society, whether French or German, with gifts taken from the plunder of Operation Furniture. Whenever he had visitors to "his" camps, von Behr was proud to show off the members of the aristocracy among "his" staff. These were, it was true, relatively numerous, consisting for the most part of women from Jewish high society who had married into noble families. Years later, in her English memoirs, Colette Dampierre, a former internee of Lévitan, would in turn ironically bestow upon Baron Kurt von Behr the title of "His Royal Highness."[57] Von Behr maintained his airs to the end. In 1945, in hiding in Banz Castle in Germany, he committed suicide wearing his full uniform after having first opened a bottle of champagne, vintage 1918.

In the foreground, from right to left, are a Wehrmacht soldier and behind him a man who was perhaps the chief internee of the camp at the time of the photograph or possibly, as indicated by his scarf and his cane, a representative of UGIF who had come out for the occasion;[58] on the far left is a female inmate in the regulation one-piece suit, on which we can just make out the yellow star. Von Behr demanded that the internees always stood facing him during his visits.

56. Angolia, *In the Service of the Reich.*

57. Private archives of Christian de Montbrison, who kindly allowed me to consult them.

58. Possibly Kurt Schendel, chief of service 14 of the UGIF and in charge of the logistics of the camp; see his report from September 1944 on his activities, CDJC, CCXXI-26.

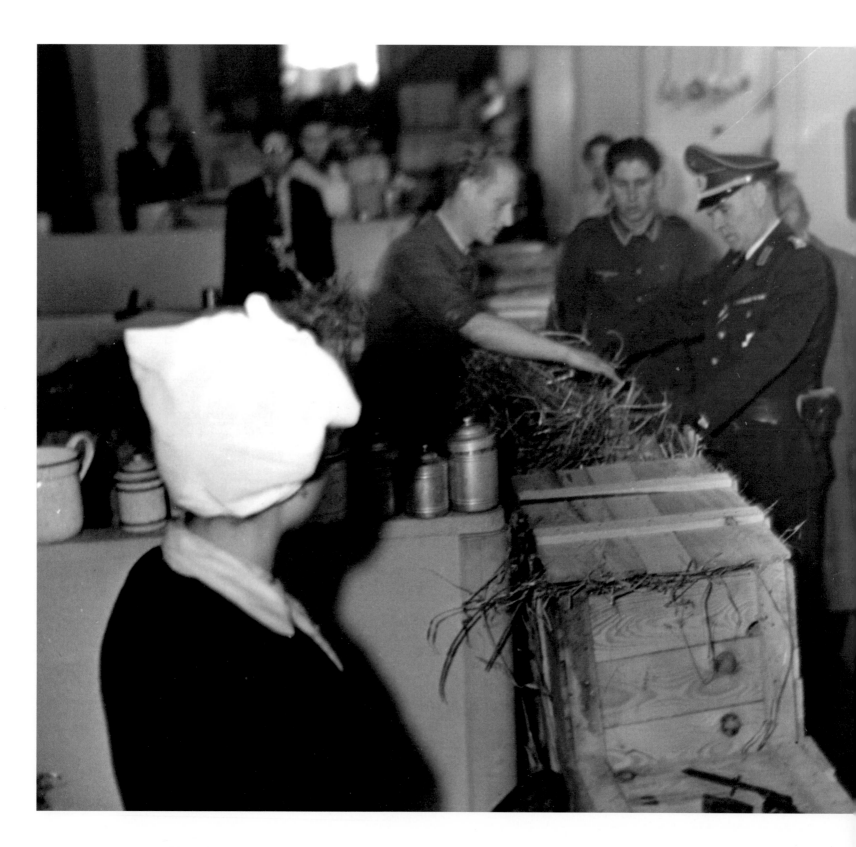

Witnessing the Robbing of the Jews

B 323-311 N° 56

"If we came across something good, we displayed it prominently and then Rosenberg and others would come and choose a cutlery set, or something like that. And when they came, everything had to be spotless; the floor had to be cleaned and the windows too. And everyone at attention!"[59] This picture seems to illustrate these remarks by Odette Dassonville.

A poem entitled "Visits," apparently written for the camp newspaper at Austerlitz, was published as part of a collection after the war.[60] Although it was inspired by that camp, and not by Lévitan, it could still serve as a caption for this photo. Its author, Paul Drori, gives voice to the internees, puppets living on borrowed time amid these objects on display:

So they dance
So they dance/
To the tune
To the tune/
Reich's on the march
Glass eye and all
Baron Colonel von Starch
Sounds the roll-call./
For the greater good
There we all stood
In tears, pain, the noise
Of the whip cracked
And the shelves stacked.
With toys./
So they dance
So they dance/
To the tune
To the tune/
Side by side

Queen and slave
Jackboot strides
In their veins
There we stood
In the mud
Must always face
The lord of the race./
So they dance
So they dance/
To the tune
To the tune/
We are displayed
We explode
In silence.
The marionettes
Keep their lips firmly set
On the toy racks
As the whip cracks.

59. Interview with Odette Dassonville, 4 November 2002, Orly, France.

60. Drori, *Matricule 5586*, "Visits."

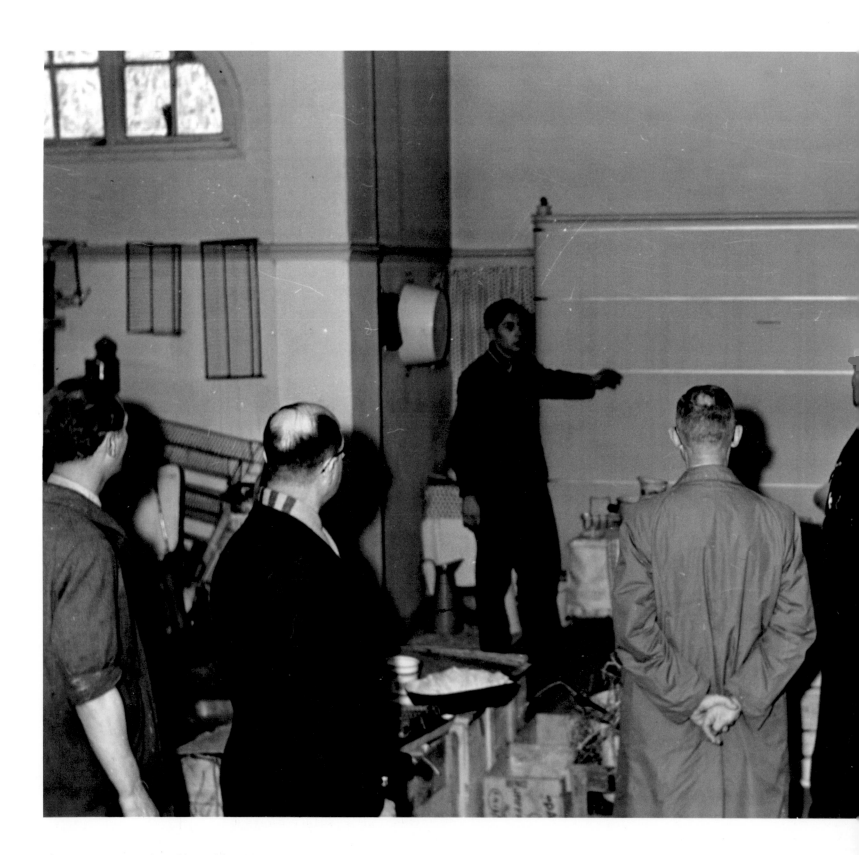

Witnessing the Robbing of the Jews

The visit continues. This exchange seems preposterous amid the basins and other second-hand items.

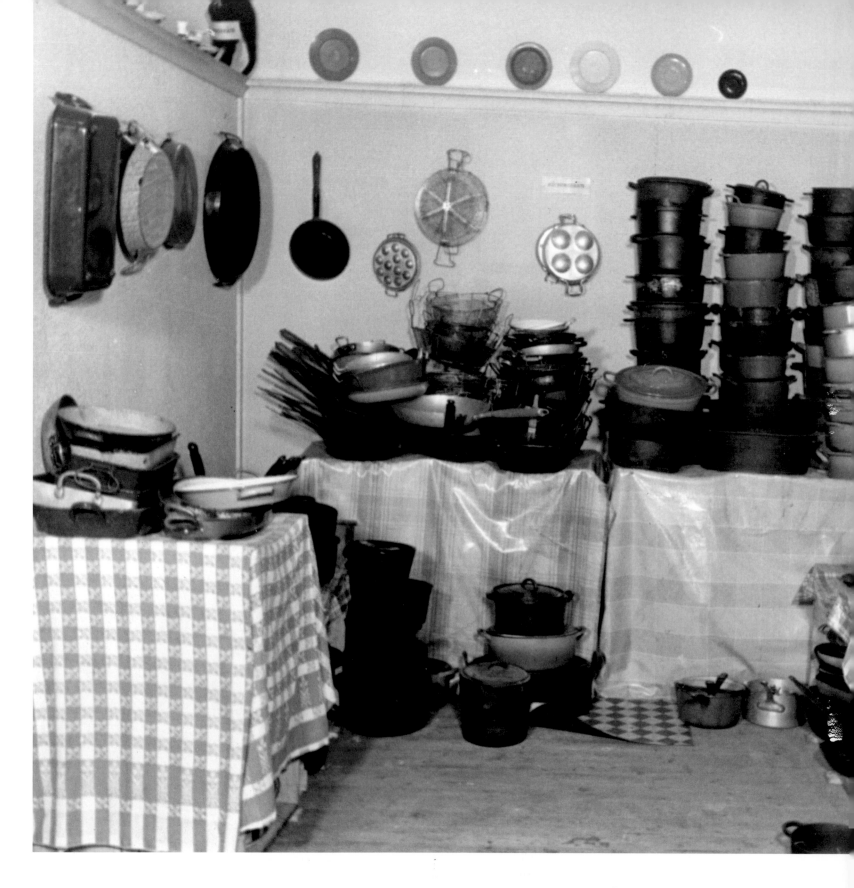

B 323-311 N° 58

This stand of cookware is the same one visible on the right in photograph no. 56, behind von Behr. The reader will recognize the rectangular roasting pan and two round baking dishes hanging on the left-hand wall above the checked tablecloth covered with gratin dishes. This would suggest that the photographs of stands in the album were probably all taken during the visit of the head of the Dienststelle Westen.

B 323-311 N° 59

More kitchenware. In better condition, it is stored at 2 rue Bassano. Behind the shelves, we can again see the golden rosettes that decorate one of the reception halls on the ground floor of the mansion.

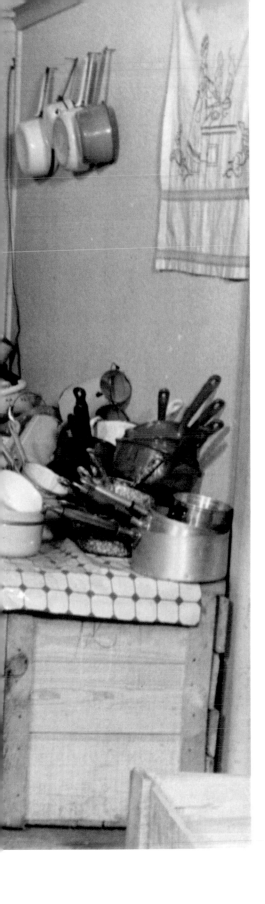

B 323-311 N° 60

Back in Lévitan. This time, it is not baking dishes but everyday pans and kettles that are displayed here in another stand set up for von Behr's visit.

Another scene from Lévitan. Cake molds, draining boards, and baking trays.

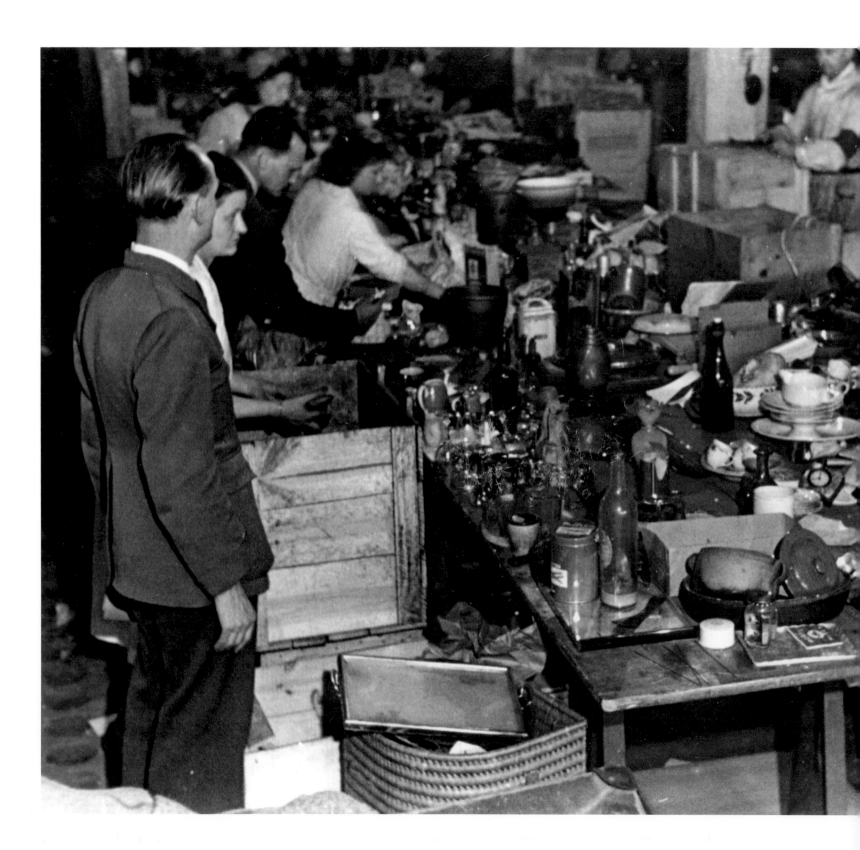

Witnessing the Robbing of the Jews

B 323-311 N° 62

Sorting in the "crockery" department at Lévitan. This photograph offers a different perspective from the previous images, as here the activity rather than the goods themselves forms the focus of the shot. As elsewhere in the album, however, the inmates are made to appear incidental, shown from behind or with their heads down.

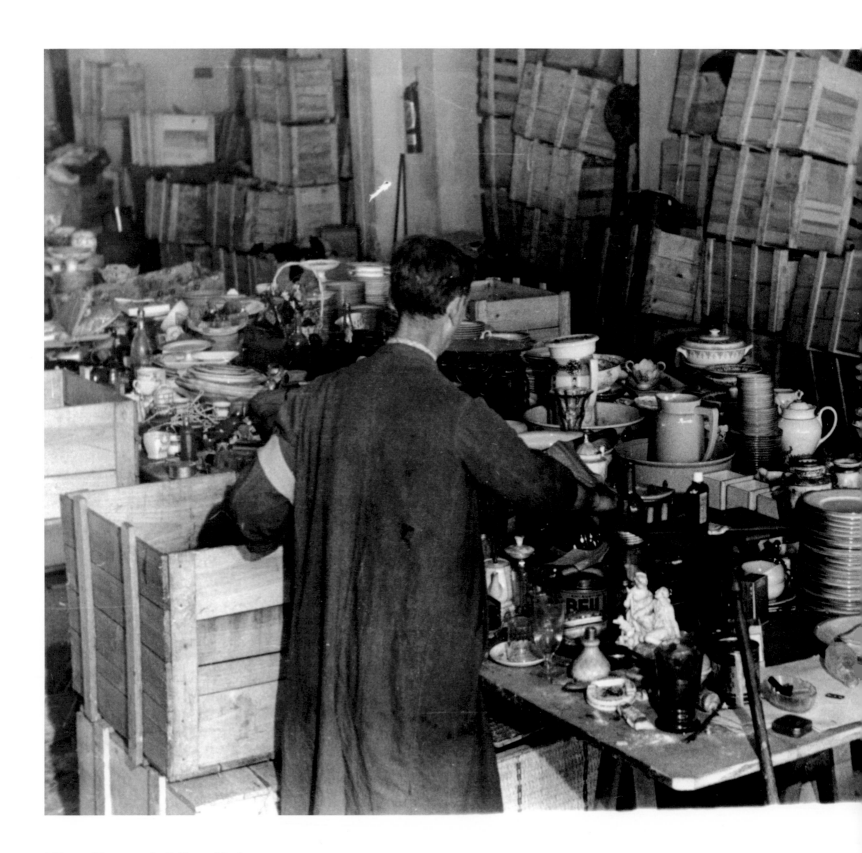

B 323-311 N° 63

Same place, same subject, same viewpoint. The size of the pile of crates in the background is staggering. Here, one begins to get an idea of the sheer quantity of goods that the internees had to deal with. Yet these images are still incapable of expressing what the inmates of these camps must have felt while performing their work on a daily basis.

I remember Odette Dassonville telling me that she had once recognized some possessions belonging to members of her own family in one of the crates. "And when these drawings came before me, I said, 'These belong to my aunt and uncle!' There were some drawings my cousin had made. So I took one of the drawings. . . . And I kept it on me at all times to protect it and I managed to keep it intact."[61] In these camps, belongings became goods.

61. Interview with Odette Dassonville, 4 November 2002, Orly, France.

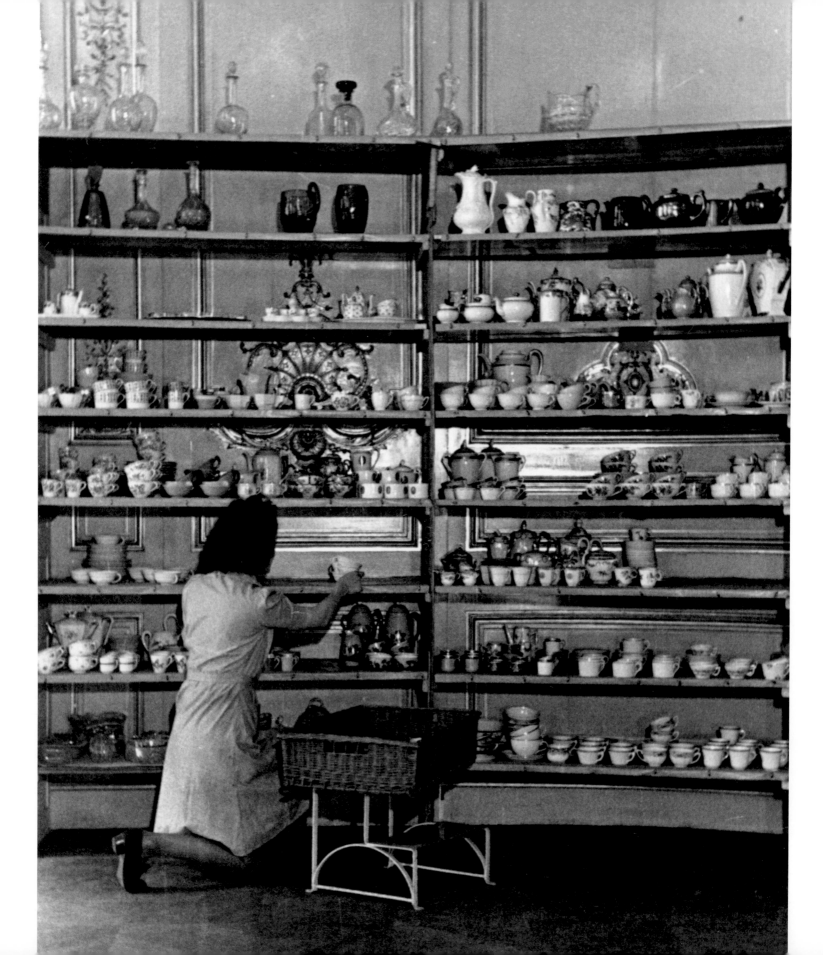

B 323-311 N° 64

The same "Kitchenware" chapter of the album and the same subsection featuring crockery. But not the same place. This picture was taken inside 2 rue Bassano. The room is the same as in photograph no. 59. The reader can recognize the golden rosette woodwork behind the shelves.

The woman seen from behind is the same one seen in image no. 45. It is still impossible to identify her with any certainty; she may have been a civilian employee or a Jewish internee. It has been established that high-quality porcelain was collected on this site before it was used as in internment camp. There is also a reference in the camp's organizational schema, found in the archives of the UGIF, to a "porcelain and crockery depot" being placed under the responsibility of Tilec Protsenko and his assistant Germaine Héloin on May 8, 1944. The latter internee had been sent to Paris as the "spouse of an Aryan." On March 29, 1943, Henri Héloin, her husband, wrote once more to Marshall Pétain to request the release of his wife, arrested in Rouen on January 15 of that year. He argued that his wife, born Katzka, had converted to Catholicism in 1937.[62]

However, since the same person appears in the photograph of the porcelain depot and linen depot—posts that would in theory have been assigned to two separate internees—one could draw the conclusion that this person is not an inmate. It is also conceivable, however, that Germaine Héloin or her colleague in the linen department, Eda Lopert, was placed before the camera on these two occasions for purely aesthetic reasons.

62. CDJC, CII-89.

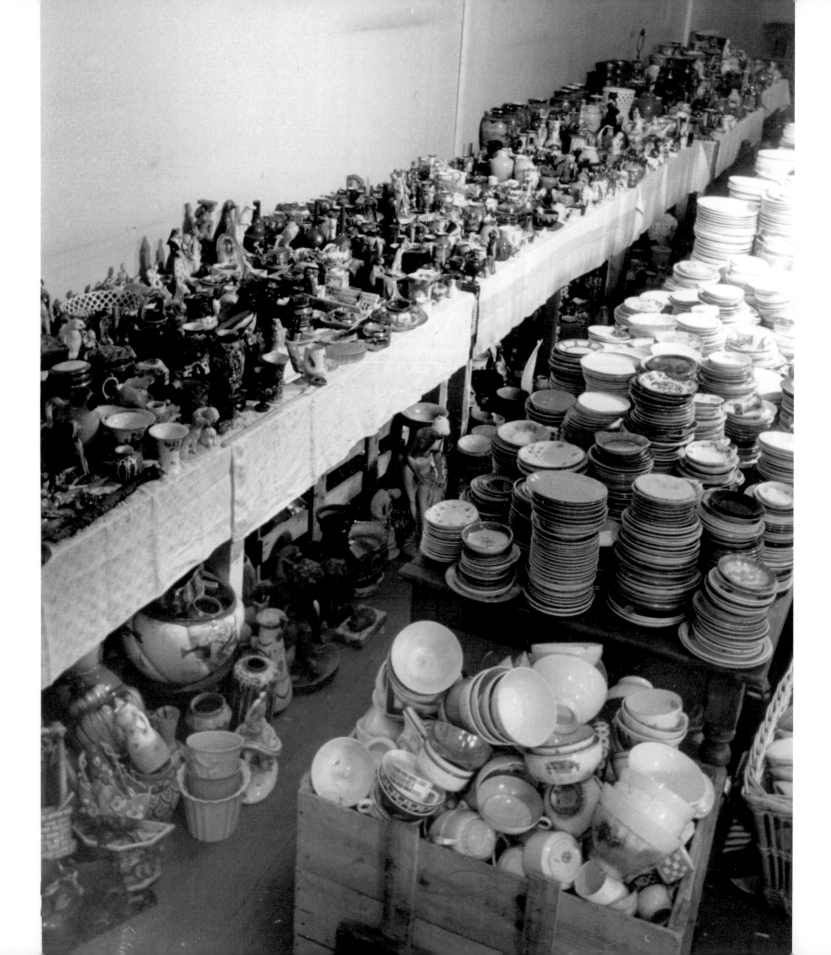

B 323-311 N° 65

Back to Lévitan. More crockery. The perspective chosen emphasizes the sheer quantity of the plunder. The "Kitchenware" chapter of the album ends with this shot.

B 323-311 N° 66

One of two shots in the album's "Lighting" chapter.

This photograph opens the selection of six images from the album reproduced by Götz Aly in his book. And what could be more evocative of the utterly exhaustive nature of the looting of Jewish apartments?[63]

It is precisely because this picture speaks for itself, and with such force, that it is useful to describe it briefly: an internee (we can just make out the armband on her left arm) at Lévitan (note the ironwork), testing the working condition of lightbulbs. But this photograph stands apart from the rest in the album (along with image no. 68). Like the other photos, it shows the work performed at Lévitan. However, unlike them, the internee here does not blend in with her surroundings. She seems to smile. What should one think of this smile? Was it requested or did it arise, in the midst of this setting of internment, from an admiring comment from the photographer?

63. In addition to oral testimonies, records of restitution claims made by Jewish families after the war show how apartments were stripped entirely, down to the lightbulbs (see Auslander, "Coming Home?" and Fogg, "Everything had ended").

B 323-311 N° 67

A stand of lamps arranged for von Behr's visit. For those who put the album together, it made sense to put two photographs that show "light" side by side, despite their manifest differences.

B 323-311 N° 68

One of the two images constituting the "Wireless Sets" chapter within the album.

The reader will by now be aware that the furniture and objects seized by Operation Furniture from apartments inhabited by Jews sometimes needed more than a simple cleaning to be brought back to good condition. Restoration workshops were thus created.

Here we see a workshop for the repair of electrical appliances and radios. This kind of workshop had already existed at Lévitan before being transferred to Bassano, where it was expanded. The organizational schema of this camp in the 16th arrondissement, dated May 8, 1944, mentions the presence of an "electrical and wireless workshop" with a "foreman," an "assistant," and a team consisting of an "electrician and a wireless technician." These positions were occupied, respectively, by inmates named Moïse Segal, Mathilde Atlan, Isaac Schragin, and Isaac Kleinmann. The internee visible in this image is perhaps one of the three men in question before his transfer to Bassano. The presence of the cupboards on the left suggests that this photograph was taken at Lévitan. The interior bears little resemblance to the home of the Cahen d'Anvers family that was pressed into use as Bassano camp.

B 323-311 N° 69

According to the by now familiar classificatory approach, a photograph showing radios being repaired is followed by one that shows the radio stand set up for von Behr's visit.

This image tells us something about the varying degrees of Jewish compliance with German orders. From August 13, 1941, a Nazi order dictated that radios belonging to Jews would be confiscated. The head of the German army's administration in France stated that it was forbidden for Jews to have radios in their possession. In Paris, they had until September 1, 1941, to hand over these devices to the *préfecture de police de la Seine* or to the police station in their arrondissement. It is clear that in February 1942, which marked the beginning of Operation Furniture, and even in July 1943, when Lévitan was created, there were many Jews who had not obeyed this order.

B 323-311 N° 70

This image is one of two that make up the curious "Clocks" chapter of the album.

A stand of high-quality clocks set up in honor of von Behr's visit to Lévitan. A watch-making workshop and a goldsmith's workshop existed at 85–87 rue du Faubourg-Saint-Martin and, later on, at 2 rue Bassano.

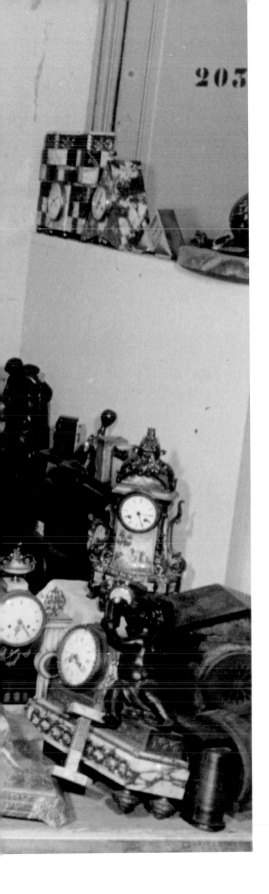

B 323-311 N° 71

Why a second shot of the clock stand? Perhaps the photographer had the impression that the identification label pinned to the wall, showing the category to which the objects belonged, was not in shot the first time?

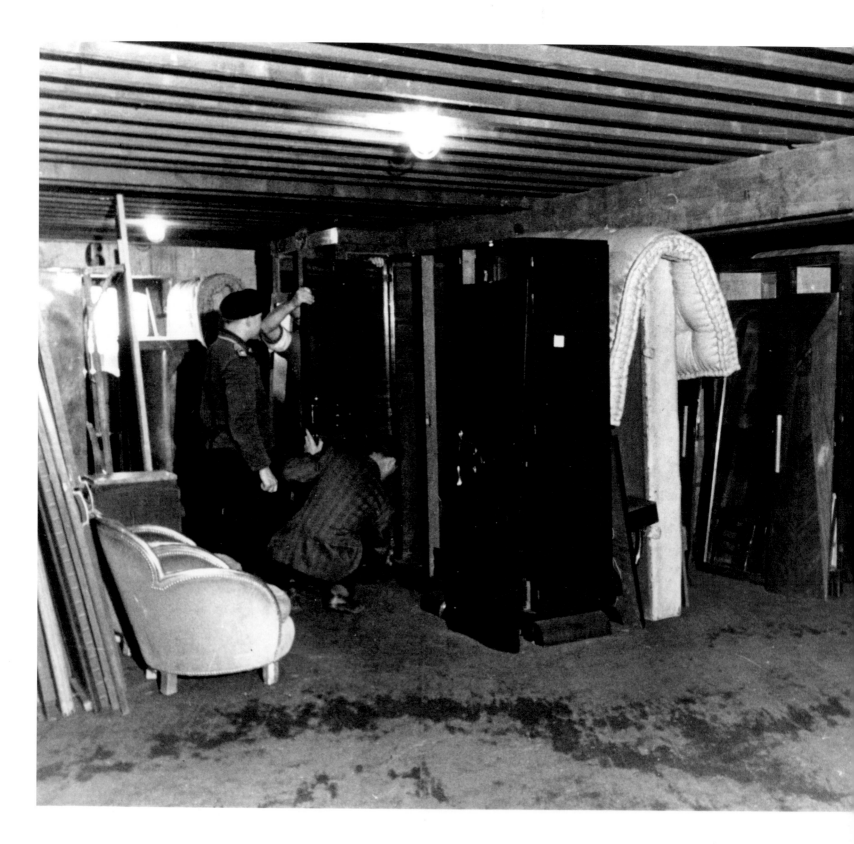

B 323-311 N° 72

This image opens a new chapter of the album, "Furniture," which contains twelve pictures.

Complete rooms (mattresses, bedsteads, wardrobes, etc.) are stored here. Under the supervision of a soldier, internees are taking a door off a wardrobe. The reader will notice that this time they wear armbands on their right arms. The German uniform is not identifiable. It may be a composite uniform similar to that worn by the Panzer units.

It is impossible to establish where this picture was taken. In an attic? At Austerlitz (which was requisitioned as a warehouse in February 1943 and was demolished in 1997)?[64] It could also be in a basement such as that shared by the two Musées d'Art Moderne on the quai de Tokyo, which has several levels and is partially lit. One can indeed see daylight streaming in from a window right in the background of the image.

On May 28, 1943, the curator of the Musée National d'Art Moderne complained to Jacques Jaujard, director of the Musées nationaux, in the following terms: "I wish to inform you that the basements of the MNAM which, according to a note received on 4 November 1942, were to be used only 'for a limited period' to store a certain number of pianos, have become the repository for a large amount of broken furniture, papers, crates, cabinets, boards, etc."[65]

64. AP, 2ETP/5/3/004.

65. AMN, L2 MNAM 1934–1945.

B 323-311 N° 73

The structure of the building (with a glass roof) and the existence of another level (note the stairway handrail to the right) make it difficult to identify this location.

The kitchen cabinets are in poor condition and of little value. They are similar to those carried by the inmates in photograph no. 17. Perhaps this picture was taken the same day to show the warehouse in which goods waiting to be loaded onto trains were stored.

B 323-311 N° 74

The "kitchen dresser department," as the internees called it. Nothing in this picture allows us to locate where it was taken.

Witnessing the Robbing of the Jews

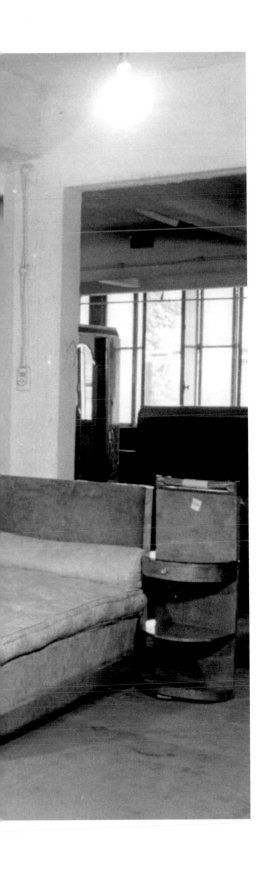

B 323-311 N° 75

Carefully displayed furniture replaces heaps of furniture here just as, in previous images, photos of crates in disorder and chaotic piles of objects sometimes give way to carefully presented goods in thematic stands. The "Furniture" chapter is likewise composed of several such varying viewpoints.

Here is a room that is perfectly dressed, right down to the bouquet of flowers. What could be more appropriate than the Lévitan furniture store—the large windows of which are recognizable in the background—to display furniture?

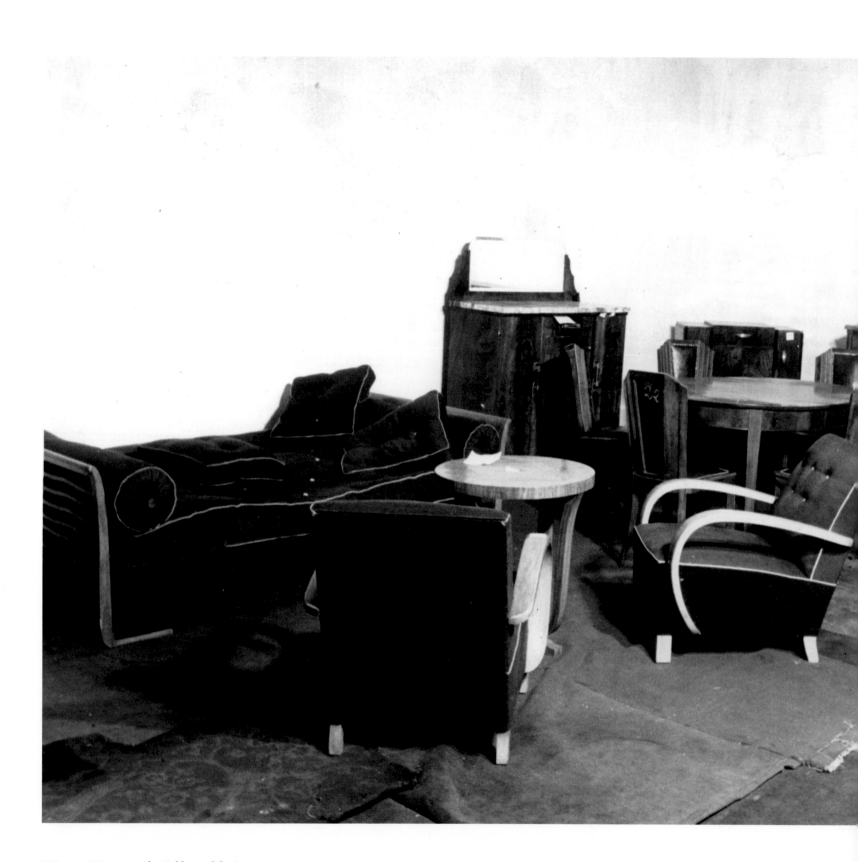

It is impossible to say where this photograph was taken. In his report dated July 21, 1944, von Behr announced that the workshops set up in the camps had up to that date restored thirty kitchen dressers, twenty-three dining tables, fifty-six dining chairs, forty-three wardrobes, sixty-five beds, ten dressing tables, thirty bedside tables, twelve bookcases, twenty-four writing desks, twenty-five armchairs, twenty-five kitchen cabinets, fifteen kitchen tables, thirty-five kitchen chairs, and one sofa, while four armchairs had been refitted with springs and reupholstered.[66] This may be the sort of activity that the photographer wanted to highlight here.

66. CDJC, XIII-47.

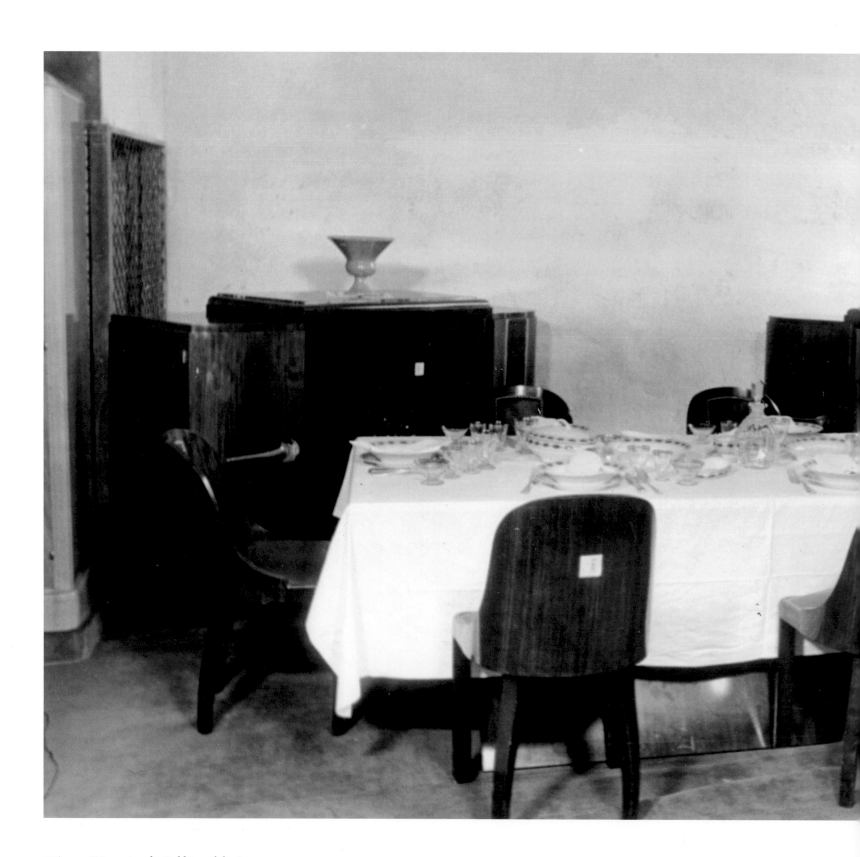

Witnessing the Robbing of the Jews

B 323-311 N° 77

Lévitan was particularly well suited for displaying furniture, not only because of its original function but also because of the large amount of decorative objects sorted on the site's various floors, which were at the photographer's disposal for the setting up of these shots of dining rooms.

Another, similarly presented tableau at Lévitan.

B 323-311 N° 79

The reader will recognize the distinctive ironwork found throughout the various floors of the Lévitan store. Today, everything is different at 85–87 rue du Faubourg-Saint-Martin. The main lobby seen here no longer exists, although many architectural features have been preserved, or rather restored, as the building was subsequently used as a car park and its interior completely destroyed.

However, Miranda Salt, head of public relations for BETC Euro RSCG agency, the current occupant, has a document that Rémi Babinet, one of the company's directors, found in a flea market: an old Lévitan catalog from the year 1939. A photograph comparable to this one is included there.

Witnessing the Robbing of the Jews

B 323-311 N° 80

On the E.R.R. database, today, this photograph is one of the eight made available by the German Federal Archives. It is labeled as "Furniture looted from Jewish apartments during Möbel-Aktion organized in living-room style, separated by partitions, in one of the main M-Aktion camps—perhaps Austerlitz."[67] However, it was in fact taken at Lévitan.

In the Lévitan catalog from 1939, close-up shots of this main lobby are also included. In this photo, the resemblance between the fine furniture seized by the Dienststelle Westen from apartments "abandoned" by their Jewish inhabitants and the modern, stylish furniture sold by Monsieur Lévitan before the war is particularly striking.

67. http://www.errproject.org/jeudepaume/photo/. The seven others are nos. 9, 15, 20, 21, 56, 62, and 64.

B 323-311 N° 81

Here, furniture is displayed in the partitioned compartments, in a similar way to the smaller items seen earlier.

B 323-311 N° 82

What was the original purpose of these photographs, which allow us to identify this furniture with such accuracy? Maybe there were others like this, as many as there are compartments visible in photograph no. 80? Altogether, they would have constituted a true catalog, not intended for sale as in 1939, nor for restitution as in this album, but simply as a selection tool for those who benefited from the looting of Jewish property.

B 323-311 N° 83

The architect who designed the interior of the BETC Euro RSCG agency has restored, albeit unintentionally, this organization of the interior space into compartments. Today, each has its own specific color, and the compartments are used as meeting spaces.

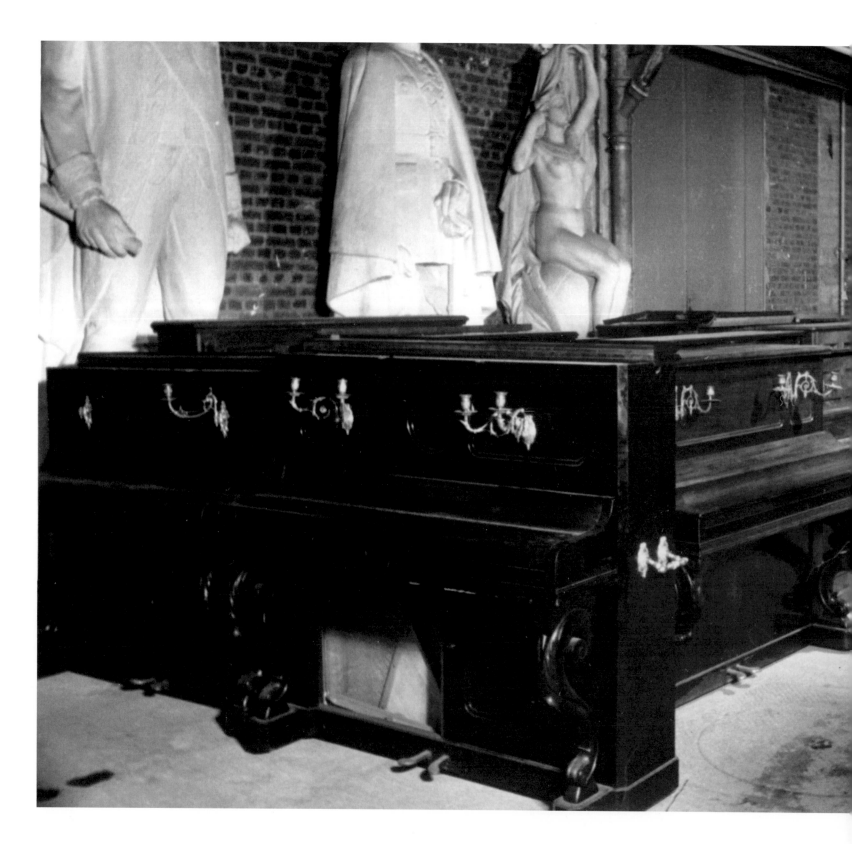

B 323-311 N° 84

The album ends with a brief chapter dedicated to pianos.

This photograph was taken in the basement of the Musée National d'Art Moderne. The loading of pianos as seen in image no. 10 would therefore have taken place via the exit from this space.

The sculptures that appear in this photograph are not part of the loot from Operation Furniture or even the artistic spoils amassed by the E.R.R. They belong to the collection of the Musée National d'Art Moderne. Initially, these sculptures were intended to prevent the museum from being taken over by the German authorities. In July 1942, three months before the space became occupied, the curator wrote to the Director of National Museums: "I would like to submit the following proposal for your consideration; it involves a partial reorganisation of the Musée d'Art Moderne, in order to avoid, if possible, its requisition by the occupation authorities." Since "the collection of sculptures has not been evacuated, or only to a minor extent,"[68] their exhibition was under consideration. But it would never happen. The sculptures became the silent witnesses of the requisition of the premises.

On January 25, 1943, the same curator finally told the secrétaire d'État aux Beaux-Arts that "it was decided that some of the rooms, which are currently unoccupied, will be used by [the Dienststelle Westen] to store furniture and pianos for a limited period. The sculptures that are in the corridors of the basements will not be affected."[69] They can be seen here.

68. AMN, L1 1931–19--.

69. AMN, L2 MNAM 1934–1945, letter dated 4 November 1942.

B 323-311 N° 85

Same location. Along with upright pianos, grand pianos were also seized by the Dienststelle Westen. After the Liberation, owners were sometimes able to retrieve these musical instruments. Unlike pans and other everyday objects, they often bore various distinguishing marks.[70] But because many of their owners were now dead, destitute, or simply unaware of their location, a large number of them remained in the hands of the state.

Pianos thus were held in the basements of the Musée National d'Art Moderne until 1948, despite the insistence of the management that they be evacuated. On January 13, 1948, the head of the Restitution Service for the Property of Victims of the Dispossession Laws and Related Measures penned one of many replies to the impatient letters of the Director of National Museums. "In reply to your aforementioned letter concerning pianos stored in the basements of the Musée d'Art Moderne, 2 rue de la Manutention, I would like to inform you that the Central State Auction Service (French Territorial Administration) made the last sale of pianos on 30 December 1947. There are currently eleven pianos still subject to dispute, and I am in talks with the French Territorial Administration about transporting them to the *dépôt domanial du Palmarium*."[71]

Today, in the basements of what is now known as the Palais de Tokyo, the green bins of the museum stand in the exact place occupied by the pianos visible in this photograph.

70. On the viewings of the dispossessed after the war, see AN, AJ 38 6409 and AJ 38 5941.

71. AMN, L2 MNAM 1946–1966, records from 13 January 1948, "dossier relatif aux pianos entreposés dans les sous-sols du musée d'Art moderne."

4

IMAGES AND TRACES OF THE PAST

The taxonomic eye exercised by the staff of the Munich Central Collecting Point who first brought these images together in an album continues, more than sixty years later, to exert a powerful hold over all those who consult this document, from archivists to historians. Götz Aly's book is a prime example of this. Six of these photographs were reproduced therein. Some of them have been discussed above on a case-by-case basis. Yet they also need to be examined as a whole. For they have been chosen from the various different chapters of the album, as if the intention had been to constitute a representative sample of its contents: "Lightbulbs, children's toys, bed and table linen, furniture and household effects of all varieties."[1] They are also all given the same date. Since the album is evidently perceived as a whole, and since September 20, 1943, is the only time reference to appear therein, "September 1943" is, quite logically, the date ascribed to all six of the pictures selected. Yet we know now that this is incorrect.

Owing to its classificatory power, the album has the even more marked effect of drawing a parallel between two distinct types of looting: that of the priceless property belonging to Jewish art lovers and that of the largely worthless contents of the ordinary apartments of the vast majority of Jews. As our analysis of the album has shown, photographs that, on the basis of their content, should be ascribed to one or the other of these operations are on several occasions placed together within the same chapter. We have seen this same homogenizing process at work in the description accompanying image no. 8 when it was used on the cover of Martin Dean's book, *Robbing the Jews: The Confiscation of Jewish Property in the Holocaust, 1933–1945* (2008). Similarly, Götz Aly places crates full of looted everyday belongings stacked in the basement of the Musée d'Art Moderne de la Ville de Paris side by side with—and also beneath the same caption as—others stored in the Louvre, which contain cultural goods. Even the Federal Archives themselves seem unable to accept that the activities of various different organizations based at different sites might feature in the album.[2] Having long maintained that all the images represented the work of the E.R.R., the archives now describe them as all showing sites connected with Operation Furniture.

If we are to treat the Koblenz album as a real historical source, we must first free ourselves of the structures imposed by its internal organization. A geographical and administrative reclassification of the pictures is made possible by considering each image as an independent document in its own right, thereby allowing us to gain at least a partial understanding of the contexts in which these pictures were taken, the gazes they represent, and the frameworks of action into which they fit. For these eighty-five photographs relate to various distinct looting operations and make up a number of identifiable series.

The first series comprises six views of the capital, if one includes the photograph of the Gare du Nord alongside the five other "postcards" that open the album.[3] Whatever the actual reasons for which they were taken, it is hard to see them as having been kept as anything other than souvenirs of time spent working in the city often considered as the playground of the Reich. For

1. Aly, *Hitler's Beneficiaries,* 121.

2. For more details, see images nos. 20 and 21 in particular.

3. Images nos. 5–19.

today's viewer, the aesthetic aspect of these images is disquieting.[4] There can be no doubt that it was intentionally sought by the photographer.

A second series of sixteen photographs, this time dispersed across the different chapters of the album, is quite distinct from the others.[5] It constitutes a piece of genuine photographic reportage shot on March 31, 1943. It shows crates containing cultural goods being taken from the Louvre to the site at Aubervilliers prior to their being loaded onto a train bound for Germany. These pictures are all marked on the back with an official stamp reading "Bildstelle ERR, Sonderstab Bildende Kunst, Berlin W9, Bellevuest. 3" that, through its reference to the address of the E.R.R. in Berlin from February 1943 onward, is further confirmation that they all come from the same official administrative source. Rosenberg's organization certainly had access to a team of professional photographers, whose job was usually to record confiscated artworks for its inventories. Rudolph Scholz was their main photographer in Paris, and he may well have been the author of this series. While his portraits of the other members of the E.R.R. were all taken indoors, a self-portrait held in the archives of France's national museums shows him at precisely the same location, beside the canal and the railway sidings on the Magasins Généraux site at Aubervilliers, seen in photographs nos. 13 and 14.[6]

The remaining sixty-three photographs all relate to the activities of the Dienststelle Westen. They are not marked with any official stamp. Given that the archives of Operation Furniture were destroyed at the end of the war, it is harder to assign dates to these pictures or place them in any particular order. Most were taken inside Lévitan camp. We can therefore say with some certainty that these photographs were, for the most part, taken after July 18, 1943.

The date of September 20, 1943, that appears on photograph no. 44 only refers to the three views of the basement of the Musée d'Art Moderne de la Ville de Paris, which all seem to have been taken on the same day, most likely in September but before the 20th.[7] However, the composite character of the album and the positive identification of a different date for the sixteen pictures forming the E.R.R. series mean that we cannot deduce anything from this time reference as far as the rest of the images are concerned, and to this day it remains impossible to assign a precise date to these.

The sixty remaining photographs can nonetheless be divided into four main categories. The pictures in each of the first two groups were probably taken together as a sequence. One set of thirteen photographs seems to have been taken at Lévitan during one of Kurt von Behr's visits.[8] While von Behr indeed appears in some images, other shots show the stands on which objects have been displayed for his inspection. The fact that the same figures are visible from one image to the next, along with other shared background details, indicates that these pictures were all

4. Kaplan, *Unwanted Beauty.*

5. Images nos. 6–9, 13–16, 20, 21, and 26–31.

6. Polack and Dagen, *Les carnets de Rose Valland*, 113.

7. Images nos. 24, 25, and 44.

8. Images nos. 23, 39, 50, 55–58, 60, 61, 67, and 69–71.

taken as part of a single photographic session. The same is true of the six photographs taken in the mansion on the rue Bassano.[9] Indeed, several of the latter feature the same young woman, who has a decidedly well-groomed appearance and is not wearing a camp number. It is therefore not unlikely that these pictures were all taken in a single session before the site was turned into a camp, giving us a date of between August 1943 and March 1944.

The rest of the photographs from Operation Furniture, however, were taken in a variety of locations and very probably on different dates and in varying circumstances. They can be split into two main categories. One group of twenty-three images shows individuals, for the most part Jewish detainees, at work on various tasks: unloading, sorting, repairing, manufacturing, and loading.[10] A second group, comprising eighteen pictures, shows only objects, some carefully presented, others simply left in heaps.[11]

The Koblenz album thus brings together a set of photographs that are quite disparate, not only as far as the dates on which they were taken and the administrative departments that commissioned them are concerned but also as regards what they show and the way they show it. In this respect, their arrangement in this form has given rise to an artifact that, first and foremost, reflects the vision of the people who originally compiled the album. Nevertheless, we do need to consider just what, besides their physical contiguity in a single album, these images might still have in common.

Given that the Nazi regime made large-scale use of photography in its propaganda campaigns, it has become something of a reflex action to classify any newly discovered German image as a propaganda picture.[12] The history of the analysis of the famous *Auschwitz Album* proves that such initial interpretations are by no means always correct.[13] The same can be said of the eighty-five photographs that make up the Koblenz album. For the looting it shows, whether of the collections of Jewish connoisseurs or of ordinary apartments, was always kept carefully under wraps by the authorities involved. Well aware of the covetous glances their precious booty might attract, the staff of the E.R.R. deliberately chose those rooms in the Louvre that would allow the greatest secrecy to be maintained. The sequestration was only accessible from the Cour Carrée, which could be closed from both of its ends. What went on inside was not visible from the street. The repository also constituted a German enclave within a building belonging to one of France's national museums. Up until the Liberation, the curator of the Department of Oriental Antiquities routinely had to seek permission to gain access to his own rooms.[14]

9. Images nos. 45–48 and 59–64.

10. Images nos.10–12, 17, 18, 22, 32–35, 40–42, 49, 51–54, 62, 63, 66, and 68–72.

11. Images nos. 36–38, 43, 65, and 73–85.

12. Denoyelle, *La photographie d'actualité.*

13. Hellman, *The Auschwitz Album.*

14. AMN, R2 C, correspondence between the directorate of the Musées nationaux and the Kunschuntz from November 1941 to January 1942. Rose Valland's notebooks from the summer of 1943 refer on several occasions to the Germans' demands that the staff of the Jeu de Paume sign "a declaration to the effect that they would swear to absolute secrecy regarding everything that they saw and heard."

The Dienststelle Westen took similar care to hide the nature of the operation being carried out within Lévitan from neighboring residents, who were very numerous in this densely populated area. The window displays of the former furniture store were preserved as before, unloading was only done away from prying eyes in the building's basement, and the windows were sealed shut to prevent any contact with the outside world. People living next to the building were coerced into closing their shutters. Engendered by the awareness that the possession of such rich plunder in these times of scarcity was likely to arouse great envy[15]—a fear that was in fact well founded[16]—this obsession with secrecy leads one to conclude that, however varied their origins may have been, none of these pictures were meant to serve as propaganda. Nor for that matter do they adhere to any of the regime's aesthetic canons, whether in the framing of the shots or in their composition.[17]

Given this tendency, when archive images are used simply as illustrations rather than being considered as actual documents, erroneous interpretations can result. One of the photographs from the E.R.R. series taken on March 31, 1943, was thus reproduced by Cécile Desprairies for her 2009 guide to *Paris dans la Collaboration* (Collaborationist Paris). It is used, quite correctly this time, to illustrate the occupation of the Louvre by the Germans for the purposes of artistic spoliation. However, in addition to giving an incorrect date, which we have already mentioned, the author has captioned it not just as a "propaganda document" but one "produced by the Department for the Protection of Works of Art (*Kunstschutz*)," which was in fact in constant conflict with the E.R.R.[18]

In the context of a polycratic regime and at a time of internecine struggles between various German ministries and dignitaries, all vying to get their hands on a share of the booty,[19] it would be reasonable to speculate that several of the series brought together in this album were produced in order to illustrate and lend weight to reports that both the E.R.R. and the Dienststelle Westen were obliged to write at regular intervals in order to justify their existence and preserve their autonomy. The E.R.R. series of March 31, 1943, might well constitute an internal administrative record intended to demonstrate the scale, organization, and systematic efficiency of the work being carried out. Indeed, under attack and threatened by his rivals, Alfred Rosenberg sent a report to Adolf Hitler in April 1943. This drew up a preliminary list of the plunder: "79 collections seized, including those belonging to the Rothschilds, 10 convoys (92 wagons) sent to Germany between 17 September 1940 and 15 April 1943."[20]

15. Aglan, "L'aryanisation des biens sous Vichy."

16. Garouste and Perrignon, *L'intranquille.*

17. Denoyelle, *La photographie d'actualité.*

18. Petropoulos, "The Polycratic Nature of Art Looting"; and Seibel, "A Market for Mass Crime?"

19. Sophie Coeuré, *La mémoire spoliée,* gives a particularly good account of this infighting in the context of the looting of archives

20. Le Masne de Chermont and Sigal-Klagsbald, *A qui appartenaient,* 10.

Several images showing Operation Furniture may in turn have been used to bolster the various reports that von Behr was obliged to send to Berlin in order to justify continuing an enterprise that was beginning to raise questions regarding the low value and poor quality of the goods arriving in Germany.[21] One potential hypothesis is that photographs nos. 24, 25, and 44, all taken in September 1943, were intended to accompany the report sent by an inspector of the Ministry for the Occupied Eastern Territories, the organization to which the Dienststelle Westen was answerable, dated the 15th of that month.[22] Given that von Behr had led the E.R.R. before being appointed to the head of the Dienststelle Westen in spring 1942, it is possible that he himself may have gathered together, perhaps at first as "souvenirs," the various series that make up the album before eventually storing them in one of his depots, namely 85–87 rue du Faubourg Saint-Martin. Several documents do confirm that, in the first few months of 1943, even though his job with the E.R.R. had officially come to an end, von Behr continued to play a role in this department, in particular on Goering's behalf. He may have been present when the March 31 sequence was shot.[23]

From this point of view, even though the Koblenz album undeniably constitutes an artifact, when taken as a whole the eighty-five images do share a common perspective on these looting operations. Above all, they reveal the shared ideological assumptions of all the actors involved. The mission was, first and foremost, one of dispossession by accumulation, irrespective of the economic gain thus realized. It was not so much a question of making a profit as of achieving mass destruction, not only of the possessions themselves but through it the destruction too of all remaining traces of their owners, who were themselves to be physically exterminated. While the album forms a coherent whole in this respect, photograph no. 31 is particularly telling. The fact that only the backs of the paintings have been photographed shows that these images were meant to testify to the administrative, and thus primarily quantitative, nature of the work carried out and not to the quality of the artworks that had fallen into the hands of the E.R.R. As has already been described, the E.R.R. systematically photographed paintings from the front and assigned them an inventory number, helping with the process of identifying them today. However, it has proved impossible to find any trace of the numbers written on the back of these paintings in the E.R.R.'s archives. These paintings may have subsequently been destroyed, which would explain why their aesthetic qualities seem to have held so little interest for the photographer. For between July 20 and 23, 1943, Rosenberg's experts decided to get rid of those "Jewified" works that were not worth selling on the international market. Family portraits in particular, which by definition depicted Jewish forebears, were earmarked for destruction. The paintings that were to be eliminated were brought before a sort of commission assembled in the rooms of the Louvre sequestration, crossed off the inventories, then cut out of their frames with a knife. The resulting fragments were piled up in a lorry before being discreetly burned in the Tuileries gardens, near the Jeu de Paume. Between

21. On 21 July 1944, von Behr would have to produce another document of this type in order to defend his actions, CDJC, XIII-47.

22. CDJC, CCXXXII-30.

23. Letter from Gerhard Utikal dated 21 April 1943 definitively relieving von Behr of his duties with the E.R.R., AMN, R 20.2 (3).

500 and 600 paintings were probably destroyed on this one occasion.[24] As Rose Valland noted in her diary, "The portraits of the Rothschilds seem to have been intentionally vandalized."[25]

It is possible that this photograph shows some of them. They have no value apart from the sheer mass that they represent, the quantity of objects standing for the quantity of individuals who fell victim to racial extermination. The paintings shown here are in this respect no different from the pile of eiderdowns thrown on top of one another that—in the shapes they create—directly echo the heaps of bodies discovered in the camps that, because of the countless photographs we have seen of them, now loom so large in our collective imaginary.[26] "Preserve in order to destroy." The conclusion here is identical to that reached by Sophie Coeuré in her study of the—in many ways somewhat curious—case of the looting of archives that also occurred during the occupation.[27]

Paradoxically, despite having been initially placed together in an album in order to assist in identifying and restituting looted goods, these images show the extent to which the looting of Jewish possessions in all its various forms was, more than anything else, a process of destruction and anonymization. The extraordinarily mundane nature of the booty that is so proudly inspected by its new masters in these photographs is further confirmation of the ideological objectives of Operation Furniture, which went far beyond the quest for economic gain alone.

It is hard to see how photographs such as those showing von Behr amid the worthless objects put on display in honor of his visit could ever have been used to show off the quality of the plunder and thus justify the existence of Operation Furniture. When looked at from today's perspective, these pictures are, on the contrary, evidence of the meager value of the goods owned by the vast majority of French Jews in 1940.

More importantly, the low value of the goods sorted at Lévitan shows that Operation Furniture did not only have an economic objective. The overarching aim was to destroy all trace of the existence of the Jews. Indeed, the decision to distribute their possessions among the population of the Reich was the subject of some debate. Had objects formerly owned and touched by Jews not themselves become "Jewified"? Were they really suitable for use by Aryans?[28]

This process of anonymization is echoed by the visual treatment of the internees in many of these photographs. Although present, they are somehow transparent: always shown from the back or with their heads lowered. Beyond its status as an artifact, then, the Koblenz album constitutes particularly powerful evidence of the link between racial extermination and economic looting. Yet, paradoxically, while the images in the Koblenz album reveal this desire to achieve the total destruction of every last trace of these men and women, they simultaneously constitute vital evidence of these lost existences for us today. They thus stand in for the archives of the

24. AMN, R 32.1, notes from Rose Valland to Jacques Jaujard, 20 and 23 July 1943 (Valland, *Le Front de l'Art*, 178).

25. AMN, R 32.1, notes from Rose Valland to Jacques Jaujard, 20 and 23 July 1943 (Valland, *Le Front de l'Art*, 179).

26. Images nos. 36 and 37.

27. Coeuré, *La mémoire spoliée*; see also Grimsted, *Returned from Russia*.

28. CDJC, CXLIV-396.

Dienststelle Westen destroyed at the end of the war, which contained inventories of these ma-
tresses, saucepans, pianos, and the rest.

While these images have something to say about the nature and value of the possessions
owned by those who were deported, revealing in particular the state of poverty and material
penury in which the majority of them lived, they tell us very little about another group who are
nonetheless visible therein—the internees of the Parisian camps. Rarely featuring in these pho-
tographs, they clearly did not interest the photographers. They are made all the more visible by
the fact that although, proportionally speaking, a large number of them survived the war, former
internees have seldom spoken about their experiences or told of these events, despite having wit-
nessed them firsthand. These camps have for a long time formed the center of what, based on his
study of African religions in Brazil, Roger Bastide termed a "memory hole."[29] While researching
Nazi Labour Camps in Paris, it was consequently hard for me to find and meet with former detain-
ees. Their silence seemed to me to be directly linked to their sense of isolation, to the absence of
any relations with "deportees" who would, by implication, be "Jews" and so stemming, in other
words—the words of Maurice Halbwachs, to be precise—from their being cut off from the "col-
lective milieux" able to sustain this memory. This is because memory, being a social phenome-
non, only forms through complementary links between the various members of a group who all
share a common past. "A person remembers only by situating himself with the viewpoint of one
or several groups and one or several currents of collective thought."[30] However, the establish-
ment of this contact and the building of these relations becomes less likely when the individual
is situated on the margins of the group in question, or when the group is so complex, comprising
so many distinct modes of belonging, that the individual cannot achieve even a minimal level
of identification. The position occupied by most of these internees at the crossroads between
two groups, "Jews" and "non-Jews," has made it difficult to form a collective memory and, con-
sequently, to speak out on this subject. Several former detainees, along with their families, have
decided to say nothing about this past, not so much because it "sticks in their throats"[31] as because
they themselves are unable to find their own place in relation to it.

More importantly still—and it is this second aspect of their silence that this album goes some
way to making up for—because these detainees had ended up being sheltered from the danger
of deportation, living in much better conditions than those in Drancy, let alone Bergen-Belsen or
Auschwitz, there was a perception that many of the inmates of the Parisian camps had in this way
been "spared." When they did want to speak out, then, as now, this desire came up against the
powerful structuring image that the deportation of the Nazis' political and racial enemies forms
within the "space of the articulable" surrounding the experience of the war in France.[32] Follow-
ing the Liberation, several detainees did in fact speak about what they had seen. Georges Geiss-

29. "Trou de mémoire" (Bastide, "Mémoire collective et sociologie du bricolage," 95).

30. Halbwachs, *The Collective Memory,* 33.

31. This is the sense of the pun used in the title of Eric Conan and Henry Rousso, *Vichy.*

32. "L'espace du dicible." This expression is borrowed from Michael Pollak, *L'Expérience concentrationnaire,* 201.

mann's article in *L'Homme libre,* the organ of the Union démocratique socialiste de la Résistance, and Muriel Schatzman's piece in *Fraternité,* both published in September 1944, were examples of this. This public airing of their experiences ceased with the return of the surviving deportees and the dawning awareness of the reality of the concentration and extermination camps. After April 1945, nothing more would be said about the satellite camps of Drancy, whether in the public arena or in more specialized publications. With the return of the deportees, it no longer seemed legitimate for those former detainees who had finally been liberated on August 18, 1944, to tell their story. One man, when I asked him whether he had spoken of his experiences after the Liberation, either privately or in public, replied: "Well! With the deportees, it was quite simple, if you can say that, they just didn't want to talk any more. They thought no one would believe them. So I felt awkward talking about my own story.... Going to the quai de la Gare [i.e., Austerlitz] represented a haven of hope. Obviously, once you knew what happened to the deportees, it was a privilege."[33] One of his former comrades expressed similar thoughts: "I think I can safely say that it wasn't too bad, except for the feeling of separation. I'm sorry but, when you consider Auschwitz, there's simply no comparison."[34] Filled with a vague feeling of guilt at having escaped deportation in exchange for forced labor in the context of the looting of Jewish property, in a marginal position with respect both to their identification with Judaism and to the group formed by the deportees, the majority of the former detainees of Lévitan, Austerlitz, and Bassano could find no suitable social framework within which to express their memories.

While these social frameworks of memory preside over the expression of individual memories, they also frame their contents. Even today, after all the work that has gone into collecting oral history from former detainees, it is only those from among the 20 percent of the Parisian camps' internees who were eventually deported who have referred to there having been any really harsh aspects to the living conditions they experienced in these camps. Yvonne Klug spoke of the extreme cold,[35] while Vivette Baharlia-Politi described the enormous rats that would crawl into her bed at night.[36] Both women were finally deported to Auschwitz on June 30, 1944. The suffering and fear that, without a shadow of a doubt, the internees who were finally liberated in August 1944 also endured have not once been described in the testimonies that I have recorded.[37] Nor are they any more visible in these photographs, as clear an illustration as any that images do not tell us "every-

33. "Bon! les déportés c'est tout simple, si j'ose dire, ils n'avaient plus envie de parler. Ils pensaient qu'on ne les croirait pas. Donc, moi, j'ai eu pudeur à parler de mon cas.... Aller au quai de la Gare représentait un havre d'espoir. Évidemment quand on sait ce qui s'est passé avec les déportés, c'était un privilège." Interview with M. Roger M., 8 April 2002, Paris.

34. "J'ose le dire ce n'était pas dramatique sauf la séparation. Je m'excuse de dire ça, mais compte tenu d'Auschwitz, c'est le jour et la nuit." Interview with M. Jean L., 17 March 2003, Paris.

35. Yvonne Klug, "Le 8616 revint. Souvenirs d'une rescapée du camp d'extermination d'Auschwitz," 1945, unpublished manuscript, consulted at the CDJC, carton de l'Amicale Austerlitz-Lévitan-Bassano.

36. Vivette Politi, "Mémoires," unpublished manuscript, consulted at the CDJC, carton de l'Amicale Austerlitz-Lévitan-Bassano.

37. For more detailed analysis, see Gensburger, "Essai de sociologie de la mémoire."

thing" about the past. While this album does stand in for the testimony we lack from so many internees, it can do so only partially. Yet I also hope to have shown that the analysis of the pictures it contains can also gain a great deal from listening to the accounts of those few individuals who have been able to tell their stories. And reciprocally, the pictures themselves can offer a place to locate one's memory, however fantasized. A man wrote these words in the visitor book of the 2007 Paris exhibition Retour sur les lieux that was based on the eighty-five pictures of the album: "I recognized a pan from our home (17 Bd du Temple)."

ORIGINAL DIMENSIONS OF PHOTOGRAPHS

Image Number	Dimensions (*in inches*)	Image Number	Dimensions (*in inches*)
B 323-311 n° 1	6.7 × 4.7	B 323-311 n° 44	3.3 × 2.4
B 323-311 n° 2	6.7 × 4.7	B 323-311 n° 45	6.7 × 4.5
B 323-311 n° 3	6.7 × 4.7	B 323-311 n° 46	5.1 × 3.9
B 323-311 n° 4	6.7 × 4.7	B 323-311 n° 47	5.1 × 3.9
B 323-311 n° 5	6.7 × 4.7	B 323-311 n° 48	6.5 × 4.3
B 323-311 n° 6	6.9 × 4.9	B 323-311 n° 49	5.7 × 3.9
B 323-311 n° 7	6.9 × 4.9	B 323-311 n° 50	5.5 × 3.9
B 323-311 n° 8	6.9 × 4.9	B 323-311 n° 51	5.5 × 3.9
B 323-311 n° 9	6.9 × 4.9	B 323-311 n° 52	5.5 × 3.9
B 323-311 n° 10	6.3 × 3.9	B 323-311 n° 53	5.9 × 3.9
B 323-311 n° 11	6.7 × 4.7	B 323-311 n° 54	5.9 × 3.9
B 323-311 n° 12	5.9 × 4.9	B 323-311 n° 55	6.7 × 4.9
B 323-311 n° 13	6.7 × 4.7	B 323-311 n° 56	6.7 × 4.9
B 323-311 n° 14	4.7 × 6.7	B 323-311 n° 57	6.7 × 4.9
B 323-311 n° 15	7.1 × 4.9	B 323-311 n° 58	5.1 × 3.9
B 323-311 n° 16	7.1 × 4.9	B 323-311 n° 59	3.9 × 5.1
B 323-311 n° 17	5.9 × 3.9	B 323-311 n° 60	5.5 × 3.9
B 323-311 n° 18	5.9 × 3.9	B 323-311 n° 61	5.9 × 3.9
B 323-311 n° 19	5.1 × 5.5	B 323-311 n° 62	5.7 × 3.9
B 323-311 n° 20	6.9 × 4.9	B 323-311 n° 63	5.7 × 3.9
B 323-311 n° 21	6.9 × 4.9	B 323-311 n° 64	3.9 × 5.3
B 323-311 n° 22	5.5 × 3.9	B 323-311 n° 65	5.7 × 3.9
B 323-311 n° 23	6.7 × 4.7	B 323-311 n° 66	5.3 × 3.9
B 323-311 n° 24	5.5 × 3.9	B 323-311 n° 67	5.1 × 3.9
B 323-311 n° 25	6.7 × 4.7	B 323-311 n° 68	5.7 × 3.9
B 323-311 n° 26	6.9 × 4.9	B 323-311 n° 69	5.5 × 3.9
B 323-311 n° 27	4.9 × 6.9	B 323-311 n° 70	5.7 × 3.9
B 323-311 n° 28	4.9 × 6.9	B 323-311 n° 71	5.7 × 3.9
B 323-311 n° 29	4.9 × 6.9	B 323-311 n° 72	5.9 × 3.9
B 323-311 n° 30	4.9 × 6.9	B 323-311 n° 73	5.9 × 3.9
B 323-311 n° 31	4.9 × 6.9	B 323-311 n° 74	5.9 × 3.9
B 323-311 n° 32	5.9 × 3.9	B 323-311 n° 75	6.7 × 4.7
B 323-311 n° 33	5.5 × 3.9	B 323-311 n° 76	6.7 × 4.7
B 323-311 n° 34	5.5 × 3.9	B 323-311 n° 77	6.3 × 4.5
B 323-311 n° 35	5.5 × 3.9	B 323-311 n° 78	6.7 × 4.7
B 323-311 n° 36	5.5 × 3.9	B 323-311 n° 79	6.1 × 4.1
B 323-311 n° 37	5.5 × 3.9	B 323-311 n° 80	6.1 × 4.1
B 323-311 n° 38	5.7 × 3.9	B 323-311 n° 81	5.5 × 3.5
B 323-311 n° 39	5.5 × 3.9	B 323-311 n° 82	4.1 × 3.5
B 323-311 n° 40	5.5 × 3.9	B 323-311 n° 83	4.7 × 3.5
B 323-311 n° 41	6.7 × 4.7	B 323-311 n° 84	5.5 × 3.9
B 323-311 n° 42	6.7 × 4.7	B 323-311 n° 85	5.7 × 3.9
B 323-311 n° 43	5.7 × 10		

BIBLIOGRAPHY

Aalders, Gerard. *Nazi Looting: The Plunder of Dutch Jewry during the Second World War.* Oxford: Berg, 2004.

Aglan, Alya. "L'aryanisation des biens sous Vichy: les cas comparés de la France et de l'Allemagne." *Revue d'histoire moderne et contemporaine* 49, no. 4 (2002): 154–169.

Allen, James, Hilton Als, Congressman John Lewis, and Leon F. Litwack. *Without Sanctuary: Lynching Photography in America.* Santa Fe: University of New Mexico Press, 2005.

Aly, Götz. *Hitler's Beneficiaries: How the Nazis Bought the German People.* Translated by Jefferson Chase. London: Verso, 2006.

American Historical Review. "Representing the Holocaust." Special issue, February 2010.

Ancel, Jean. "Seizure of Jewish Property in Romania." In *Confiscation of Jewish Property in Europe, 1933–1945: New Sources and Perspectives,* 43–56. Washington, D.C.: USHMM, 2003.

Andrieu, Claire. "Ecrire l'histoire des spoliations antisémites (France, 1940–1944)." *Histoire@Politique, Politique, culture, société* 9 (2009): 1–17.

Angolia, John R. *In the Service of the Reich.* San Jose, Calif.: James Bender Publishing, 1995.

Arad, Yitzhak. "Plunder of Jewish Property in the Nazi-Occupied Areas of the Soviet Union." *Yad Vashem Studies* 29 (2001): 109–148.

Assouline, Pierre. *Le Dernier des Camondo.* Paris: Gallimard, 1997.

Auslander, Leora. "Coming Home? Jews in Postwar Paris." *Journal of Contemporary History* 40, no. 2 (2005): 237–259.

Azoulay, Floriane, and Annette Wieviorka. *Le Pillage des appartements et son indemnisation.* Paris: Mission d'étude pour la spoliation des juifs de France, La Documentation française, 2000.

Baer, Ulrich. *Spectral Evidence: The Photography of Trauma.* Cambridge, Mass.: MIT Press, 2002.

Barthes, Roland. *Camera Lucida: Reflections on Photography.* Translated by Richard Howard. New York: Hill and Wang, 1981.

Baruch, Marc-Olivier. "Perpetrator Networks and the Holocaust: The Spoliation of Jewish Property in France, 1940–1944." In *Networks of Nazi Persecution: Bureaucracy, Business and the Organization of the Holocaust,* edited by Wolfgang Seibel and Gerald Feldman, 189–212. New York: Berghahn Books, 2004.

Bastide, Roger. "Mémoire collective et sociologie du bricolage." *L'Année sociologique* 21 (1970): 65–108.

Becker, Howard. "Do Photographs Tell the Truth?" In *Doing Things Together,* 273–292. Evanston, Ill.: Northwestern University Press, 1986.

Billig, Joseph. *Le Commissariat Général aux Questions Juives, 1941–1944.* 3 vols. Paris: Les Editions du Centre, 1955–1960.

Bizardel, Yvon. *Sous l'occupation. Souvenirs d'un conservateur de musée.* Paris: Calmoann Lévy, 1964.

Bouchoux, Corinne. "*Si les tableaux pouvaient parler. . . .*" *Le traitement politique et médiatique des retours d'œuvres d'art pillées et spoliées par les nazis (France 1945–2008).* Rennes, France: Presses Universitaires de Rennes, 2013.

Brink, Cornelia. "Secular Icons: Looking at Photographs from Nazi Concentration Camps." *History and Memory* 12, no. 1 (2000): 135–150.

Bruttmann, Tal, ed. *Persécutions et spoliations des Juifs pendant la Seconde Guerre Mondiale.* Grenoble, France: Presses universitaires de Grenoble, 2004.

Cahiers du Judaïsme, Les. "Spoliations: nouvelles recherches." Special issue, 27 (2009): 1–143.

Chéroux, Clément, ed. *Mémoire des camps. Photographies des camps de concentration et d'extermination nazis, 1933–1999.* Paris: Marval, 2001.

Christophe, Francine. *From a World Apart: A Little Girl in the Concentration Camps.* Lincoln: University of Nebraska Press, 2000.

Coeuré, Sophie. *La mémoire spoliée. Les archives des Français, butin de guerre nazie puis soviétique.* Paris: Payot, 2007.

Conan, Eric, and Henry Rousso. *Vichy. Un passé qui ne passe pas.* Paris: Fayard, 1994.

Crane, Susan. "Choosing Not to Look: Representation, Repatriation and Holocaust Atrocity Photography." *History and Theory* 47, no. 3 (2008): 309–330.

Davis, Brian L. *Badges and Insignia of the Third Reich, 1933–1945.* London: Arms and Armour Press, 1999.

Dean, Martin. *Robbing the Jews: The Confiscation of Jewish Property in the Holocaust, 1933–1945.* New York: Cambridge University Press, 2008.

———. "Seizure of Jewish Property and Inter-Agency Rivalry in the Reich and in the Occupied Soviet Territories." In *Networks of Nazi Persecution: Bureaucracy, Business and the Organization of the Holocaust,* edited by Wolfgang Seibel and Gerald Feldman, 88–102. New York: Berghahn Books, 2004.

Dean, Martin, Goschler Constantin, and Ther Philipp, eds. *Robbery and Restitution: The Conflict over Jewish Property in Europe.* New York: Berghahn Books, 2007.

Delage, Christian, and Anne Grynberg. "La Shoah. Images témoins, images preuves." *Les Cahiers du judaïsme* 15 (2003): 61–70.

Denoyelle, Françoise. *La photographie d'actualité et de propagande sous le régime de Vichy.* Paris: CNRS Editions, 2003.

Desprairies, Cécile. *Paris dans la Collaboration.* Paris: Seuil, 2009.

Didi-Huberman, Georges. *Images in Spite of All: Four Photographs from Auschwitz.* Chicago: University of Chicago Press, 2012.

Dingell, Jeanne. "Property and Seizures from Poles and Jews: The Activities of the Haupttreuhandstelle Ost." In *Confiscation of Jewish Property in Europe, 1933–1945: New Sources and Perspectives,* 33–41. Washington, D.C.: USHMM, 2003.

Doulut, Alexandre. *La spoliation des biens juifs en Lot et Garonne.* Albret, France: Terres de mémoire, 2005.

Douzou, Laurent. *Voler les Juifs. Lyon 1940–1944.* Paris: Hachette-Littératures, 2002.

Dowd, Raymond J. "Nuremberg: Nazi Looted Art and Cocaine: When Museum Directors Take It, Call the Cops." *Rutgers Journal of Law and Religion* 14 (Spring 2013): 529–550.

Dreyfus, Jean-Marc. *Pillage sur ordonnance. Aryanisation et restitution des banques en France, 1940–1953.* Paris: Fayard, 2003.

Dreyfus, Jean-Marc, and Sarah Gensburger. *Nazi Labour Camps in Paris: Austerlitz, Levitan, Bassano.* New York: Berghahn Books, 2011.

Drori, Paul. *Matricule 5586: Poèmes.* Paris: Ed. Polyglottes, 1948.

Edsel, Robert M. *The Monuments Men: Allied Heroes, Nazi Thieves, and the Greatest Treasure Hunt in History.* New York: Center Street, 2009.

Fabius, Odette. *Un lever de soleil sur le Mecklembourg. Mémoires.* Paris: Albin Michel, 1980.

Farmer, Sarah. "Going Visual: Holocaust Representation and Historical Method." *American Historical Review* 115, no. 1 (2010): 115–122.

Feldman, Gerald, and Wolfgang Seibel, eds. *Networks of Nazi Persecution: Bureaucracy, Business, and the Organization of the Holocaust,* New York: Berghahn Books, 2004.

Feliciano, Hector. *The Lost Museum: The Nazi Conspiracy to Steal the World's Greatest Works of Art.* New York: Basic Books, 1998.

Fogg, Shannon L. "'Everything had ended and everything was beginning again': The Public Politics of Rebuilding Private Homes in Postwar Paris." *Holocaust Genocide Studies* 28 (2014): 277–307.

Freedberg, David. *The Power of Images: Studies in the History and Theory of Response.* Chicago: University of Chicago Press, 1986.

Garouste, Gérard, and Judith Perrignon. *L'intranquille. Autoportrait d'un fils, d'un peintre, d'un fou.* Paris: L'iconoclaste, 2009.

Gensburger, Sarah. "Essai de sociologie de la mémoire: le cas des camps annexes de Drancy dans Paris." *Genèses* 61 (2005): 47–69.

Goschler, Constantin, Philipp Ther, and Claire Andrieu, eds. *Spoliations et restitutions des biens juifs. Europe XXe siècle.* Paris: Autrement, 2007.

Grimsted, Patricia Kennedy. "The Postwar Fate of Einsatzstab Reichsleiter Rosenberg Archival and Library Plunder, and the Dispersal of ERR Records." *Holocaust and Genocide Studies* 20, no. 2 (2006): 278–308.

———. *Returned from Russia: Nazi Archival Plunder in Western Europe and Recent Resistution Issues.* Crickadarn, Wales: Institute of Art and Law, 2007.

Grossman, Mendel. *With a Camera in the Ghetto [Lodz].* Translated by Mendel Kohansky. Tel Aviv: Ghetto Fighters' House and Hakibutz Hameuchad, 1970.

Gruner, Wolf. *Jewish Forced Labor under the Nazis: Economic Needs and Racial Aims, 1938–1944.* New York: Cambridge University Press, 2006.

Halbwachs, Maurice. *The Collective Memory.* Translated by F. I. and V. Y. Ditter. New York: Harper and Row, 1980.

Hellman, Peter, ed. *The Auschwitz Album: A Book Based on an Album Discovered by a Concentration Camp Survivor, Lili Meier.* New York: Random House, 1981.

Heuss, Anja. *Kunt and Kulturgutraub, Eine Vergleichende Studie zur Besatzungspolitik des Nationalozialisten in Frankreich und der Sowetjunion.* Heidelberg: Universitätsverlag C. Winter, 2000.

Hirsch, Joshua. *Afterimage: Film, Trauma, and the Holocaust.* Philadelphia: Temple University Press, 2004.

Hirsch, Marianne. *Family Frames: Photography, Narrative and Postmemory.* Cambridge, Mass: Harvard University Press, 1997.

———. *The Generation of Postmemory: Writing and Visual Culture after the Holocaust.* New York: Columbia University Press, 2012.

Hirsch, Marianne, and Leo Spitzer. "Incongruous Images: 'Before, During and After' the Holocaust." *History and Theory* 48, no. 4 (2009): 9–25.

Hoffmann, Detlef. "Fotografierte Lager: Unberlegungen zu einer Fotogeschichte deutscher konzentrationslager." *Fotogeschichte* 54 (1994): 3–20.

Hughes, Rachel. "The Abject Artefacts of Memory: Photographs from Cambodia's Genocide." *Media, Culture & Society* 25, no. 1 (2003): 23–44.

Hüppauf, Bernd. "Emptying the Gaze: Framing Violence through the Viewfinder." *New German Critique* 72 (1997): 3–44.

Hutton, Margaret-Anne. "Legacies of the Second World War: Representation of the Theft of Jewish Property in Recent French Crime Fiction." *French Studies* 66, no. 4 (2012): 493–509.

Jungius, Martin. *Der verwaltete Raub. Die "Arisierung" der Wirtschaft in Frankreich, 1940–1944.* Ostfildern, Germany: Thorbecke, 2007.

Kaplan, Brett Ashley. *Unwanted Beauty: Aesthetic Pleasure in Holocaust Representation.* Urbana: University of Illinois Press, 2006.

Karlsgodt, Elizabeth Campbell. *Defending National Treasures: French Art and Heritage Under Vichy.* Redwood City, Calif.: Stanford University Press, 2011.

Keilbach, Judith, and Kirsten Wächter. "Photographs, Symbolic Images and the Holocaust: On the (Im)possibility of Depicting Historical Truth." *History and Theory* 47 (2009): 54–76.

Keller, Ulrich, ed. *The Warsaw Ghetto in Photographs: 206 Views Made in 1941.* New York: Dover, 1984.

Klarsfeld, Serge. *Le calendrier de la persécution des Juifs en France 1940–1944.* Paris: Fayard, 2001.

Kott, Christina. *Préserver l'art de l'ennemi? Le patrimoine artistique en Belgique et en France occupées, 1914–1918.* Brussels: P. Lang, 2006.

Kurtz, Michael. *America and the Return of Nazi Contraband: The Recovery of Europe's Cultural Treasure.* New York: Cambridge University Press, 2006.

Laffitte, Michel. *Un engrenage fatal. L'UGIF face aux réalités de la Shoah, 1941–1944.* Paris: Liana Levi, 2003.

Laloum, Jean. "La restitution des biens spoliés." *Les Cahiers de la Shoah* 1, no. 6 (2002): 13–58.

Langford, Martha. *Suspended Conversations: The Afterlife of Memory in Photographic Albums.* Montreal: McGill University Press, 2008.

Le Bot, Florent. *La fabrique réactionnaire. Antisémitisme, spoliations et antisémitisme dans le cuir (1930–1950).* Paris: Presses de Sciences Po (collection Académique), 2007.

Le Masne de Chermont, Isabelle, and Didier Schulmann. *Le pillage de l'art en France pendant l'Occupation et la situation des 2000 œuvres confiées aux musées nationaux.* Paris: Mission d'étude sur la spoliation des Juifs de France, La Documentation française, 2000.

Le Masne de Chermont, Isabelle, and Laurence Sigal-Klagsbald, eds. *A qui appartenaient ces tableaux?* Paris: Réunion des Musées Nationaux, 2008.

Lensé, Claude, and Anne Roquebert. *Catalogues des peintures MNR.* Paris: Réunion des Musées Nationaux, 2004.

Lewis, Bryan F. "Documentation or Decoration? Uses and Misuses of Photographs in the Historigraphy of the Holocaust." In *Remembering for the Future: The Holocaust in an Age of Genocide,* edited by John Roth and Elizabeth Maxwell, 341–357. New York: Palgrave, 2001.

Liss, Andrea. *Trespassing through Shadows: Memory, Photography and the Holocaust.* Minneapolis: University of Minnesota Press, 1998.

Milton, Sybil. "Images of the Holocaust." *Holocaust and Genocide Studies* 1, no. 1 (1986): Part 1, 27–61, and Part 2, 193–216.

Milton Sybil, Judith Levin, and Daniel Uziel. "Ordinary Men, Extraordinary Photos." *Yad Vashem Studies* 26 (1998): 265–279.

Mission d'étude sur la spoliation des Juifs de France. *Rapport général.* Paris: Documentation française, 2000.

Mitchell, William J. *Picture Theory: Essays on Verbal and Visual Representation.* Chicago: University of Chicago Press, 1994.

———. *The Reconfigured Eye: Visual Truth in the Post-Photographic Era.* Cambridge, Mass.: MIT Press, 1992.

Monde Juif, Le. No. 146 (1993).

Nicholas, Lynn. *The Rape of Europa: The Fate of Europe's Treasure in the Third Reich and the Second World War.* New York: Knopf, 1995.

Olin, Margaret. *Touching Photographs.* Chicago: University of Chicago Press, 2012.

Pillages et restitutions: le destin des œuvres d'art sorties de France pendant la seconde guerre mondiale. Paris: Actes du colloque organisé par la direction des Musées de France, Paris, Adam Biro/Direction des Musée de France, 1997.

Petropoulos, Jonathan. *Art as Politics in the Third Reich.* Chapel Hill: University of North Carolina Press, 1996.

———. "The Polycratic Nature of Art Looting: The Dynamic Balance of the Third Reich." In *Networks of Nazi Persecution: Bureaucracy, Business and the Organization of the Holocaust,* edited by Wolfgang Seibel and Gerald Feldman, 103–117. New York: Berghahn Books, 2004.

Polack, Emmanuelle, and Philippe Dagen. *Les carnets de Rose Valland. Le pillage des collections privées d'oeuvres d'art en France Durant la Seconde Guerre mondiale.* Lyon, France: Fage editions, 2011.

Pollak, Michael. *L'Expérience concentrationnaire. Essai sur le maintien de l'identité sociale.* Paris: Métailié, 1990.

Prost, Antoine, Rémi Skoutelsky, and Sonia Étienne. *Aryanisation économique et restitutions. Mission d'étude sur la spoliation des Juifs de France.* Paris: La Documentation française, 2000.

Rajfus, Maurice. *Drancy, un camp de concentration très ordinaire, 1941–1944.* Paris: Le Cherche midi éditeur (Documents), 1996.

Rayssac, Michel. *L'exode des musées. Histoire des œuvres d'art sous l'occupation.* Paris: Payot, 2007.

Revue d'histoire de la Shoah: Spoliations en Europe 186 (January/June 2007): 1–437.

Rorimer, James J. *Survival: The Salvage and Protection of Art in War.* New York: Abelard Press, 1950.

Roseman, Mark. *The Villa, the Lake, the Meeting.* London: Penguin Press, 2002.

Rossino, Alexander B. "Eastern Europe through German Eyes: Soldiers' Photographs 1939–1942." *History of Photography* 23, no. 4 (1999): 313–321.

Rousso, Henry. "Une justice impossible. L'épuration et la politique antijuive de Vichy." *Annales* 3 (1993): 745–770.

Sebald, W. G. *Austerlitz.* London: Penguin, 2011.

Seibel, Wolfgang. "A Market for Mass Crime? Inter-institutional Competition and the Initiation of the Holocaust in France, 1940–1942." *International Journal of Organization Theory and Behavior* 5, no. 3/4 (2002): 219–257.

Shneer, David. *Through Soviet Jewish Eyes: Photography, War and the Holocaust.* New Brunswick, N.J.: Rutgers University Press (2011).

Simonin, Anne. *Le déshonneur dans la République. Une histoire de l'indignité 1791–1958*. Paris: Grasset, 2008.

Smyth, Craig Hugh. *Repatriation of Art from the Collecting Point in Munich after WWII*. The Hague: Gary Schwartz/SDU, 1988.

Sontag, Susan. *On Photography*. New York: Anchor Doubleday, 1989.

———. *Regarding the Pain of Others*. New York: Farrar, Straus & Giroux, 2003.

Staines, Deborah. "Knowledge, Memory and Justice: Some Grey Areas in Contemporary Holocaust Research." *Journal of Contemporary History* 42, no. 4 (2007): 649–659.

Stoltzfus, Nathan. *Resistance of the Heart: Intermarriage and the Rosenstrasse Protest in Nazi Germany*. New York: Norton, 1996.

Struk, Janina. *Photographing the Holocaust: Interpretation of the Evidence*. New York: I. B. Tauris, 2004.

Thomas, Julia Adeney. "The Evidence of Sight." *History and Theory* 48, no. 4 (2009): 159–168.

Tucker, Jennifer, and Tina Campt, eds. 2009. "Photography and Historical Interpretation." Special issue, *History and Theory* 48, no. 4 (2009).

Valland, Rose. *Le Front de l'Art*. Paris: Réunion des Musées Nationaux, 1997.

Van Dijck, José. "Flickr and the Culture of Connectivity: Sharing Views, Experiences, Memories." *Memory Studies* 4, no. 4 (2011): 401–415.

Verheyde, Philippe. "Propriété bafouée et réorganisation: les spoliations antisémites en France 1940–1944." *Entreprises et histoire* 49 (2007): 41–52.

Wieviorka, Annette. *Les biens des internés des camps de Drancy, Pithiviers et Beaune-la-Rolande*. Paris: Mission d'étude sur la spoliation des Juifs de France, La Documentation française, 2000.

Wieviorka, Annette, and Michel Laffitte. *A l'intérieur du camp de Drancy*. Paris: Perrin, 2012.

Young, James. *At Memory's Edge: After-Images of the Holocaust in Contemporary Art and Architecture*. New Haven, Conn.: Yale University Press, 2000.

Zelizer, Barbie. *Remembering to Forget: Holocaust Memory through the Camera's Eye*. Chicago: University of Chicago Press, 1998.

———. ed. *Visual Culture and the Holocaust*. New Brunswick, N.J.: Rutgers University Press, 2001.

INDEX

SARAH GENSBURGER

studied social sciences at the Ecole Normale Supérieure, the EHESS, and Sciences Po in Paris. A tenured researcher at the French National Center for Scientific Research, she is editor (with Claire Andrieu and Jacques Semelin) of *Resisting Genocides* (2011) and author (with Jean-Marc Dreyfus) of *Nazi Labor Camps in Paris* (2011). She is currently working on the constitution of "memory" as a category of state intervention in Europe.

JONATHAN HENSHER

is a lecturer in French studies at the University of Manchester.

ELISABETH FOURMONT

is a freelance translator in Paris.